BREAKING THE MOULD

new approaches to ceramics

**black dog
publishing**

Contents

Foreword

Cigalle Hanaor

As the craft/design/fine art divides become ever less distinct, the possibilities for artists and makers trained in a specific medium become more and more diverse. This was never truer than in the medium of ceramics. The love-hate relationship of ceramicists with the incredibly rich history of pottery, makes for fascinating conversations between the various makers and within individual pieces of ceramic art. This book is a mere taster of the immense world of contemporary ceramics, profiling some of the most exciting and edgy artists working today, and documenting the bold new directions it is moving in.

The three essays that open the book look at ceramics in different ways. They are written by established makers Natasha Daintry, Rob Barnard and Clare Twomey, each of whom takes a very individual approach to the subject. Daintry's essay "The Essential Vessel" looks at the notions of form and formlessness in the vessel, and attempts to express some of the sheer poetry that the ceramic artist feels when confronted with a lump of clay. Rob Barnard, an American potter, explores "The Idea of the New", examining how ceramics has changed since the Second World War, and raising concerns about the tendency to reject the history of the medium in favour of innovation. Clare Twomey, an artist who works in large-scale ceramic installation, takes a different position, embracing the sheer diversity of work that is happening today, and observing the trends that are emerging in ceramic art of the twenty-first century.

Following the essays, 61 ceramic artists and makers are profiled alongside images of their work. These makers have been divided into seven loose chapters. Most of the ceramicists could sit very comfortably in two or even more of these chapters. These divides are artificial constructs intended to provide a way of seeing the work, rather than an attempt to define it categorically. The first chapter, "Surreal Geometries" looks at makers who are creating large and small scale sculpture that is in some way abstracted or represents a heightened version of reality. "Human Interest" looks at makers who are exploring the human form, or in some cases, human nature. The third chapter, "Earthly Inspirations" presents a selection of ceramicists who turn to nature, and to the natural properties of clay for inspiration, both formally and conceptually. In "Ceramic Environments", the work that is showcased is primarily space-based or time-based—using the clay in large-scale contexts, in gallery and outdoor spaces to create a fully immersive moment that challenges the common perception of what clay is capable of. "The Vessel" and "Beyond

the Vessel" look at how ceramic artists relate to the traditional concept of functional ceramics. The former section presents an infinitesimal fraction of the makers who are creating practical pots, bowls and vases, often with a very personal take. The latter looks at makers who are deconstructing the idea of the vessel, exploring the meanings and emotions embedded within it. Finally, "Surface Pleasures" looks at some of the ceramicists who are making the 'skin' of their work and its reaction to glazes, etching and embellishment, the focus for their investigations.

The ceramicists featured in *Breaking the Mould* are at the forefront of their field, defining and re-defining the cultural positioning of ceramics, looking back at its past, and forward to the unending possibilities of its future. Looking at them as a group, we can see the themes and motivations that dominate their work, the ways in which the technical and conceptual territory of ceramics is changing, and how this medium holds as much significance today as it has throughout the centuries.

The Essential Vessel

Natasha Daintry

1 Peter Voulkos throwing on the wheel—
raising the wall of the cylinder, c 1955
photograph courtesy of the Voulkos & Co Catalogue Project,
www.voulkos.com

2 Grayson Perry
Precious Boys, 2004
glazed ceramic
collection Warren and Victoria Miro, London
© The artist

In 1956 Peter Voulkos talked about throwing pots on the 4,000 year-old invention of the wheel:

> When you are experimenting on the wheel there are a lot of things you cannot explain. You just say to yourself, "the form will find its way"—it always does. That's what makes it exciting. The minute you begin to feel that you understand what you are doing, it loses that searching quality....[1]

This essay is my attempt to search the form of the vessel, and its attendant formlessness. One comes about as a result of the other, and this search has a particular resonance at the beginning of this fledgling millennium as technological progress masks a perilous sense of physical and psychological uncertainty.

Firstly why should we consider the vessel at all? At a time when so much diverse work is being made in ceramics, why should we keep the pot in mind? The vessel acts as a sort of pulse-taking: where are we, what do we value, what are we thinking? The vessel is persistent and keeps being made down through the ages, mute and compliant but articulate in the way it reflects us back to ourselves. It sits still while we contort around different ways of thinking. And so it is our attitude towards the vessel, which is as revealing as its qualities of form, line and colour. In 1931, the great art critic Herbert Read said that pottery is so fundamental an art, so bound up with the elementary needs of civilisation, that a national ethos must find its expression in this medium. He went so far as to say: "Judge the art of a country, judge the finesse of its sensibility, by its pottery."[2] The outlook over the past 70-odd years has changed dramatically. Our current sensibility shows that the vessel may be useful but not valued. We do not, for example, rate vessels like we do conceptual art. We've put it at the bottom of the boring pile because a vessel may be acquiescent and pretty with lift and verve, but it doesn't have anything to *say*. Our culture places talking and thinking above all things, in fact equating thinking with being.

But what if you don't buy the idea that thinking is everything? That there might be something in other states like sensing, doing and being? Perhaps this way of looking at things might help open up the arena again, loosen the grip on the crafts' insecurity about whether or not it's in the art camp. I think that part of our problem is that it's not easy to talk about sensing, doing and being. They're not concepts as such, neat little fixed shiny packages of ideas, but more existential states which shift and move as you inhabit them—more amorphous, like clay.

1. Brown, Conrad "Peter Volkos", *Craft Horizons* 9, vol. 2.
2. Read, Herbert, *The Meaning of Art*, London: Faber and Faber, 1984.

1

2

Formlessness

When you think of the word 'vessel', a vase or urn-like pot probably springs to mind, the sort used on those brown and white council signposts in Stoke-on-Trent, which tell you that you are in 'pottery land' and the Wedgwood Museum is getting closer. This is the sort of pot, which Grayson Perry calls "the invisible shape". The shared and universal image of the vessel can be useful as a kind of global logo when explaining what you do to people, but can also be an albatross around the neck of a ceramicist. Despite lengthy and complex explanations of what we do, relatives continue to ask how the crockery is going.

I think this is what happens when something is so ubiquitous that everyone owns it. We take ceramics for granted. We all have china in our cupboards. There's an assumption that a piece of china is a calm and quiet object, ordinary, inert and fixed. We know what to do with it. The plastic, fluid qualities of the clay and the movement involved in its making are now stilled. The well-behaved cup or saucer is now suitably compliant and ordered to carry out its duties. But I'd like to show how this is not the end of it, how the object can have a more flexible life. Herbert Read also said, "Pottery is at once the simplest and the most difficult of all arts. It is the simplest because it is the most elemental; it is the most difficult because it is the most abstract."[3]

Perhaps the vessel isn't quite so straightforward after all.

3. Read, Herbert, *The Meaning of Art*.

3

In his writings on contemporary artists, the writer Umberto Eco explains how artists seek to create models of the universe. He calls this a structural metaphorisation of a certain vision of things. It involves taking a variety of phenomena and reducing them down to a few simple relationships. This kind of model differs from a scientific model in that it must be capable of imaginative expansion in a viewer's mind.[4] A small tale of mud illustrates this well. The Boyle family, all artists, scooped up a few tablespoons full of street dirt in the Spring of 2006. It included fag ends, wrappers and scrappy bits of earth. They planted it and videoed the planter over the next few months and showed the video in the Construction Gallery in London. The gunk flowered and blossomed. Seeds which had been invisible in the tiny sods of earth grew to nasturtiums and daisies among the disintegrating flaps of paper.

This little clod of earth teemed with possibility. With a little expansion in perception, a vessel can move from prose to poetry and back again. That 'invisible shape' becomes a departure, not an end point.

Throwing pots on the wheel, or making a small pinch pot in the palm of my hand, I am attending to the simplest things potters do every time they hollow a solid lump of clay. But this simple making of a cup or bowl is also an essay into abstraction, a clothing of emptiness. For a vessel is as much defined by the negative space in and around it, as the skin of ceramic itself. This skin is a sort of negotiation between inside and outside, between solid and fluid, and where they intersect. A vessel embodies something and nothing and is an effortless three-dimensional manifestation of form and formlessness. We take it so much for granted that we no longer see it that way, we only see the material bit that holds our coffee. But really it is a benign existential riddle sitting on our breakfast table.

A pot is a container of opposites. It is both practical and mundane, and also abstract and symbolic. A vessel is both a hollow receptacle for liquid, and also a place where "the mind of man balances and reconciles opposites".[5] The Tao

4. Quoted in Brett, Guy, "The Century of Kinesthesia", *Force Fields: Phases of the Kinetic*, London: Hayward Gallery Publications, 2000.

5. Chetwynd, Tom, "Vessel" entry, *Symbols,* London: Paladin Books, 1984.

Te Ching says: "We turn clay to make a vessel; but it is on the space where there is nothing that the usefulness of the vessel depends."[6] A vessel seems to occupy space but simultaneously be occupied by space. It defines emptiness as presence. It feels like a push-me, pull-you perfect oxymoron of a 'no-thing'. It is a fundamental expression of being and non-being, a three-dimensional version of Jean Paul Sartre's observation that "nothing haunts being".[7]

I put before you a beaker half-filled with water. It appears so contingent, palpable, and *there*, easily understood. A container for water, for drinking. Nothing to it, really. But water itself, this fugitive substance, which makes clay plastic on its way to becoming ceramic, is a useful metaphor for looking at ideas of form and formlessness. Its transparency is such an effective and startling conjunction of opposites: matter exists but it is as if it did not because one can see through it.

In Native American mythology, the hieroglyph for water is a vase full of water into which a drop from a cloud is falling. Here, the container has become synonymous with the liquid it holds. The symbol of something which can contain the flowing forces of nature has become interchangeable with water itself. In his *Patterns in Comparative Religion*, Professor Eliade explains water's symbolism. Although formless, it is the source of all possible forms. "It is the primal substance from which all forms come. Although fluid, it is supremely germinative and represents the condition of all potential."[8]

This fluid way of knowing the world was felt intuitively by our earliest thinkers. The first recorded philosopher Thales (600 BC) thought that everything was made of the same substance and concluded that it must be water. It was his near contemporary, Heraclitus, who coined the phrase "everything is flux".

For the pagan, the world was permeable. Matter was plastic, fluid and changeable. Ovid tells us at the beginning of his *Metamorphosis*, "now I am ready to tell how bodies are changed into different bodies".[9] The body was plastic with perimeters defined not only by individual consciousness, but in relation to other realms of the physical world. The pagan participated in a vast mythology where his identity changed according to narrative fantasies that combined and recombined human and animal activity endlessly, weaving together memory, reason and sensation. In Ovid's world nymphs become trees, statues become women and weavers become spiders. In this permeable world there is no sharp division between things or between life and death. It is a world of energetic flow where bodies can indifferently become attached or unattached from myriad objects and forms.

This flexible way of seeing the world links directly to the making of vessels. Consider a lump of clay on the wheel. As the wall rises in a straight cylindrical 'V', you might think 'flower pot', but as the wall is softened and curved it becomes 'bowl', and as the clay is pushed in again and upwards, the form becomes 'vase'. Exactly at what point does one become the other? The dividing line between bowl and vase is a convenient conceptual and linguistic distinction that cannot be found in nature. Things cannot be pinned down with certainty: they trigger perplexity, amazement and doubt. Ken Eastman explains why he makes his vessels the way he does: "... a large part of the reason for making is to see things that I have never seen before, to build something which I cannot fully understand or explain...".[10]

6. Tzu, Lao, *Tao Te Ching 25th Anniversary Edition*, London: Vintage, 1997.
7. Quoted in, Barrow, John D, *The Book of Nothing*, London: Vintage, 2001.
8. Eliade, Mircea, *Patterns in Comparative Religion*, London: Sheed and Ward, 1983.
9. Quoted in Hughes, Ted, *Tales from Ovid*, London: Faber and Faber, 1997.
10. From Ken Eastman's artist statement.

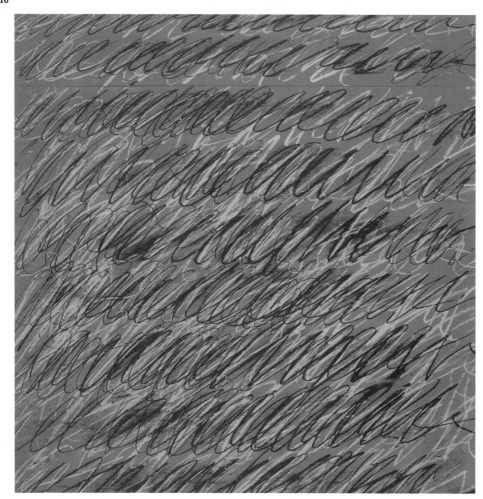

How could early writers and thinkers anticipate that twentieth century scientific discoveries would prove the theory of flux to be fundamentally true? Today we have our scientific knowledge of minute particles such as atoms, DNA impulses, neurons and quarks to show what constitutes apparently fixed entities. Theories of relativity and uncertainty have shown that all matter, even the airy oxygenated void inside a vessel is energy, and that it is composed of the same building blocks generated from exploded stars.

The writer Italo Calvino points out an ancient thread between today's scientific knowledge of minute particles and the thinking of the pre-Socratic poet-philosopher, Lucretius. He was preoccupied with infinitesimal entities, which Calvino equates to a philosophy of 'lightness'. Calvino describes Lucretius's *De Rerum Natura* (*On the Nature of Things*) as the first great work of poetry in which knowledge of the world tends to dissolve the solidity of the world. He is "the poet of physical concreteness, viewed in its permanent and immutable substance, but the first thing he tells us is that emptiness is just as concrete as solid bodies".[11]

Lucretius' delicacy when describing visible aspects of the world combined with his awareness of conjoining the concrete with emptiness, offers a poetic model for describing vessels and some of the subtlest art works of the twentieth century. Roland Barthes's writing on the scratchy, all-over drawings of the American artist Cy Twombly illuminates one's understanding of the synchronic flow between form and emptiness, solid and fluid. He said that the

11. Calvino, Italo, *Six Memos for the Next Millennium*, London: Vintage, 1996.

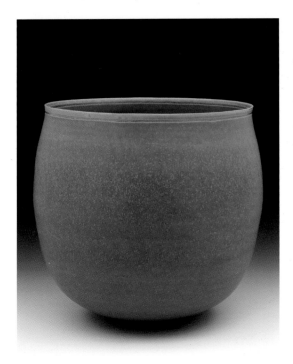

5

"appearance of a form testifies to its simultaneous ineluctable disappearance" and that his work produces a single effect, "life-death in a single thought and gesture". He called Twombly's drawings 'graphisms', a semblance of writing. He describes how they press down but at the same time erase themselves. The shadow where a flower has been written and then unwritten is referred to as two movements remaining vaguely superimposed.[12]

The painted bottles of Giorgio Morandi share a similar quality where reality floats somewhere between inscription and erasure. He dedicated his life's work to the close and fierce observation of a dozen or so domestic objects on a small square of table-top. And his conclusion? "I believe that nothing can be more abstract, more unreal than what we actually see." Sometimes his line drawings are so delicate that the original object yields to the surrounding space and disintegrates. The brushstrokes of his paintings after the 1960s increasingly dissolve precise details. The diluted paint produces ambiguities as forms overlap and coalesce. His nuanced adjustments between series of paintings create a highly charged psychological content. In *Still Life*, 1952 he crowds the objects together so they confront the gaping chasm of the blank empty space around them. The recent commentary to the Morandi exhibition at the Tate in 2001 declared that the objects' "precipitous position can be seen in psychological terms as a confrontation with the void of existence".[13]

Morandi's tremulous objects engender a sense of instability and vibrate the surrounding space with their own emptiness. They are "made up of such vibrations in vacancy, of seeing solid in void and void in solid, and of inter-resonating intervals eventually so fine that it takes a lengthy viewing to analyse their discrimination". The Turkish potter, Alev Ebüzziya Siesbye, a master of the reductive bowl, described her first encounter with a Sung horse and how it stood perfectly still, yet shaking the earth and the air around it.

Garth Clark has described Ebüzziya Siesbye's hand-built bowls and how they levitate volume and float in space. He says:

> The didactic boundaries of the outer pot surrender to an informal space within that seems far larger than the vessel itself. It is as though this is an entrance to a vast, limitless space—an inner landscape... her turquoise bowls provide the sensation of access to a voluminous underwater cavern in the Aegean or Caribbean seas.[14]

This *interlockingness* is explored by Gaston Bachelard in a discussion of the dialectic of 'outside' and 'inside' in his *The Poetics of Space*. Is *outside* vast and fluid and *inside* concrete and small? Is there a 'border-line surface', a sort of membrane, separating the two states? One speaks of the duality of inside and outside but the real experience is more kinetic, more fluid and interchangeable. Bachelard argues that imagination or mind blurs and inverts the experience of in and out. "Everything, even size, is a human value... miniature can accumulate size." He explains: "Being does not see itself. It does not stand out, it is not bordered by nothingness: one is never sure of finding it, or of finding it solid when one approaches a center of being.... We absorb a mixture of being and nothingness."[15]

4 Cy Twombly
Untitled, 1971
screenprint, colours on heavy weave paper
image Courtesy of the Gagosian Gallery, New York © Cy Twombly

5 Alev Ebüzziya Siesbye
Blue Vessel, 2001
stoneware
image Courtesy of the Garth Clark Gallery, photograph by Noel Allum

12. Barthes, Roland, "Cy Twombly: Works on Paper", *The Responsibility of Forms*, Los Angeles: University of California Press, 1991.
13. Morandi, Giorgio, quoted in notes to the gallery tour of Morandi's exhibition at the Tate Modern, London, May–August 2001.
14. Garth, Clark, *Shards; Clark Garth on Ceramic Art*, New York: Ceramic Art Foundation, 2004.
15. Bachelard, Gaston, *The Poetics of Space*, Boston: Beacon Press, 1994.

Form

It is at this point that I want to move from the abstract to the concrete, from nothingness to somethingness. We have looked at how the vessel inhabits rich, liminal territory of uncertainty and abstraction. But now I am curious to get more physical with the vessel. We have given it anthropomorphic qualities. A pot has feet, belly, shoulders and lips. What is this about?

There's a vivid description in Yasunari Kawabata's *Thousand Cranes* of a small cup used most days for tea by a female character in the book. This daily use seeps into the lip of the cup itself—the glaze near the part of the rim where she drinks becomes stained with the redness of her lips, darkening and deepening over time. It is this connection between the vessel and its relationship to the human body, which is peculiarly unique to the potter.[16] The term vessel can describe both the object of use and the user.

I think this corporeal angle is dismissed because it is non-conceptual. It is not about ideas, but bodily stuff. We live in a culture, which places intellectual achievement at the apex: we're not happy unless there's something to think about. People say to me when they know I make things, "but you don't get to use your mind, do you?". The body is seen as secondary to the mind. This has a long history, of course, reaching back from Descartes ("I think therefore I am") to the Enlightenment and pre-Christian thinking. It was the great St Augustine who was probably the single most influential thinker of the early Christian church and a pivotal architect of its view of the nature of reality. He stood on the cusp of the two worlds, the sensual, fluid pagan one and the incipient Christian. He was born in 354 AD and his father was a pagan and his mother a Christian. It was he who succeeded in steering the church into absorbing the essentially Platonic philosophy of a timeless and non-material self, existing alongside the fleeting and decaying material world of the sensory body. This view of reality as divided into two, the material and non-material, is now so familiar a part of Christianised Western cultures that few are aware that it has its origins in pre-Christian thinking. The pagan life which St Augustine sought to reorganise was too complicated, sensuous and unsettling to be contained within a monotheistic belief system.

So is there any connection between the parts of a body like hair, nails, teeth, skin, muscle, tendons and bones and the ingredients in a clay workshop like potash feldspar, cornish stone, kaolin, bentonite and flint?

I think that ceramics has a potent and underused language of material sensuality. It asks that you notice the minute differences between textures, tones of colours and forms. This attending to the physicality of things has the effect of locating you in the world and connecting you to your own physicality. It represents a way of felt experience, of being known and knowing the world through the corporeal. Elaine Scarry's *The Body in Pain: The Unmaking and Making of the World* theorises how creative efforts—making both stories and objects—construct the world. She describes tools and manufactured objects as extensions of the body into the world and thus ways of knowing it. Scarry documents how tools become increasingly detached from the body over time. So we can see how cupped hands which began scooping up water went on to develop pinch pots and then technically brilliant wheel-thrown Sung vases.

16. Kawabata, Yasunari, *Thousand Cranes*, London: Vintage, 1996.

6

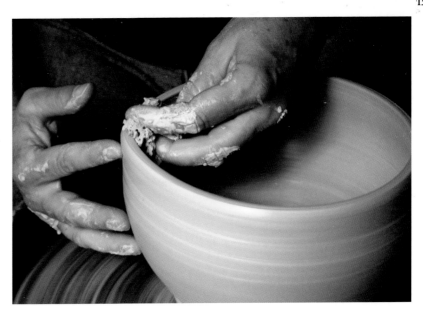

The problem is when we become so detached from our bodies that we end up disembodied. Rebecca Solnit explores this idea in relation to that most basic of human activities, walking. In her chapter entitled "The Mind at Three Miles an Hour" in *Wanderlust,* she examines Susan Bordo's claim that, "if the body is a metaphor for our locatedness in space and time and thus for the finitude of human perception and knowledge, then the postmodern body is no body at all". Solnit theorises how the pale and insipid body described over and over in postmodern theory is not a universal human body but the white-collar urban body, even a theoretical body. It doesn't get very physical, suffer the elements, encounter other species, experience primal fear or much in the way of exhilaration. It is more of a passive object, appearing most often laid out upon an examining table or in bed: "A medical and sexual phenomenon, it is site of sensations, processes, and desires rather than a source of action and production. Having been liberated from manual labour and located in the sensory deprivation chambers of apartments and offices, this body has nothing left but the erotic as a residue of what it means to be embodied. Which is not to disparage sex and the erotic as fascinating and profound, only to propose that they are so emphasised because other aspects of being embodied have atrophied for many people."[17]

So perhaps the tables have turned. We used to make objects as a way of feeling our way into the world, but now it could be objects, which lead us back to ourselves. Clay in particular has such resonance for us. We talk of 'feet of clay'. Its soft, yielding quality is universally familiar, we've all had a go with it at school or night class. It does literally link us with our planet, with its earth, with our earliest ancestors making vessels to dry in the sun and wind. It's elemental stuff.

Consider this piece of writing in *The Garden of Eden* by Ernest Hemingway. The young couple David and Catherine are on an extended honeymoon in late Spring in Aigues Mortes on the coast of France. They swim and walk and drink aperitifs. They're always hungry, especially for breakfast, which they always eat at the cafe near their hotel:

6 Emmanuel Boos
Detail of *Crumpled Drum*, 2005
white porcelain, white matte glaze
29 x 11 cm
photograph by be-attitude/jousseentreprise, Paris

17. Solnit, Rebecca, *Wanderlust, A History of Walking*, London: Verso, 2002.

On this morning there were brioche and red raspberry preserve and the eggs were boiled and there was a pat of butter that melted as they stirred them and salted them lightly and ground pepper over them in the cups. They were big eggs and fresh and the girl's were not cooked quite as long as the young man's. He remembered that easily and he was happy with his which he diced up with the spoon and ate with only the flow of the butter to moisten them and the fresh early morning texture and the bite of the coarsely ground pepper grains and the hot coffee and the chicory-fragrant bowl of cafe au lait.[18]

The writing has a kinetic, fluid quality as it flows with little punctuation in and around the objects. It feels similar to roving around the contour of a pot, up the complex line of its silhouette, around and up the swelling wall of an abrupt edge and down into a voluminous interior. It is so physical and palpably present.

This attempt to convey the beautiful simplicity of physical sensation is popular amongst contemporary artists. The minimalist ceramic artist Nick Rena said of his vessels in 2001:

> I think my work has been an evolution and a distillation of the primary characteristics of the vessel form: an attempt to make these characteristics—Mass, Tactility, Colour, Scale and Form—as apprehensible as possible. Research as distillation and clarification. We take these characteristics, and by notching them up from what one is familiar with, we make the object's presence as emphatic and palpable as possible.[19]

7

To make something emphatic and palpable implies a process of simplification on the part of the artist, an attempt at resolving complexity into a reduced but assertive form. The wheel-thrown porcelain containers of the Dutch ceramist Geert Lap are pared down to an extreme. His passionately cool controlled forms are precise with knife-edges and monochrome surfaces of unglazed pigmented slip. Their sensuality is shocking. Their internal tautness is like a balloon and makes you aware of your own breathing. Like an inflated pause between an in and out breath, they teeter on that tense rounded edge before the lungs collapse. The silk matte surface of the thinly stretched wall is soft and bare like skin. At first glance the vessels appear static. But like the subtle rise and fall of the abdomen, Lap's vessels continue the movement first begun on the wheel with the way the colour of one vessel continuously refers to the next. A neighbour might be a lighter or deeper version of the one before and so they flow visually like liquid.

Less physically perfect are the recent hand-built pots of Felicity Aylieff. Compared to her previous highly polished moulded work, these are awkward. The huge, thigh-high vessels' surfaces are not smooth but tentative. They may take the classic amphora shape but subvert this easy stereotype when one learns that they were made blind, with eyes deliberately closed. They are a sensory map of action slowed-down. The viewer also slows down their own act of looking and instead feels their way inch by inch over the pot's terrain. It is though she is undoing the conceptual knowledge built up over a career and coming back to the starting point—what is a vessel? How does it feel from the inside out? Although visually edgy in acid yellow or sharp lapis blue, these brave giant diaphragms evoke a physical response of intimacy and tenderness.

18. Hemingway, Ernest, *The Garden of Eden*, New York: Grafton Books, 1988.
19. Rena, Nicolas, "Subject Matter in Ceramics: Everything and Nothing", presented at *A Research Culture for Ceramics* conference, University of Westminster, London, 2001.

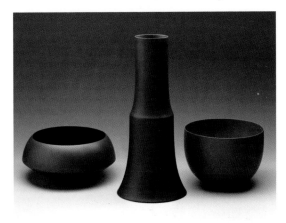

8

9

Artists and potters who make reduced forms often work in series. They seemingly go over and over the same territory, in minute but varying detail. There is a flavour of monomaniacal repetitiveness about this obsessive reworking. Repetition is a sort of immersion in formlessness. Graham Gussin, curator of the recent exhibition of *Nothing* in Sunderland, argues that endless repetition can take you nowhere, to a non-state, a kind of Utopia—meaning literally 'no place'. He quotes the philosopher, Gregory Bateson, who calls this a plateau, a "continuous, self-vibrating region of intensities whose development avoids any orientation toward a culminating point or external end".[20]

Andy Warhol understood the intensity of repetition and how it can diffuse one's sense of self. He said: "I don't want it be essentially the same—I want it be exactly the same. Because the more you look at the same thing, the more the meaning goes away, and the better and emptier you feel."[21] His *Christ 112 Times* becomes void by surrendering its uniqueness.

So is emptiness actually a fullness? Moving out of our heads and away from thinking into doing and being may actually be a form of utopia after all. Intriguingly, WH Auden compared paying attention to something—a landscape, a poem, a geometrical problem, God—to praying. The leader of the December 2006 issue of *The Economist* was "Happiness (and how to measure it)". Economics thinks of labour as a chore: people sell it to pay the rent, at the expense of their leisure time. But Mihaly Csikszentmihalyi, an economics researcher at Claremont Graduate University, handed out pagers to thousands of people who agreed to log their mood whenever prompted to do so. People were at their happiest eating, carousing or pottering around the garden and some found deep satisfaction from losing themselves in their work or as WH Auden said "forgetting themselves in a function". In Auden's poem, surgeons manage it "making a primary incision", as do cooks "mixing their sauce" and clerks "completing a bill of lading". Csikszentmihalyi calls this 'flow'.[22]

In JA Baker's *The Peregrine* first published in 1967, the writer sets out to track the daily comings and goings of a pair of peregrine falcons across the flat fenlands of Essex between one Autumn and Spring. He followed the birds obsessively, observing them in the air and on the ground, in pursuit of their prey, making a kill, eating and at rest. Very little happens, over and over again. The man waits, the man watches, the bird hunts, the bird feeds and so on from morning until dusk for seven months. As a description of attention, of losing oneself in something, it has no peer. The obsessive absorption of one man matters sharply. His fierce compound of words jolts this frail, distracted vessel of a human and reminds me what it means to be present—right here, right now—growing limbs like a rooting tree, pierced by colour and time:

> The hunter must become the thing he hunts. What is, is now, must have the quivering intensity of an arrow thudding into a tree. Yesterday is dim and monochrome. A week ago you were not born. Persist, endure, follow, watch.... Hawk-hunting sharpens vision. Pouring away behind the moving bird, the land flows out from the eye in deltas of piercing colour. The angled eye strikes through the surface dross as the obliqued axe cuts to the heart of a tree. A vivid sense of place grows like another limb. Direction has colour and meaning... time is measured by a clock of blood.[23]

7 Nick Rena
Egyptian Eye, 2006
press-moulded white earthenware, paint, polished
image courtesy of the Barrett Marsden Gallery

8 Geert Lap
Three Vessels, 1989
stoneware
image courtesy of the Garth Clark Gallery, photograph by John White

9 Felicity Aylieff
Citrus Yellow and Blue, 2005–2006
hand-built vessel, painted with pigmented slips

20. Gussin, Graham ed., *Nothing*, Sunderland; Birkhauser Pap, 2001.
21. Warhol, Andy, quoted in Gussin, Graham ed., *Nothing*.
22. Auden, WH, "Horae Canonicae", *The Complete Poems of WH Auden*, Princeton: Princeton University Press, 2003.
23. Baker, JA, *The Peregrine*, New York: New York Review of Books, 2005.

The Idea of the New

Rob Barnard

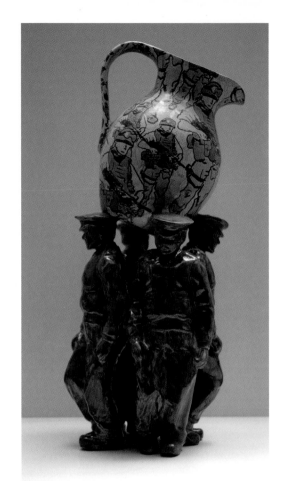

Everything made now is either a replica or variant of something made a little time ago and so on back without break to the first morning of human time.[1]

George Kubler

The problems facing contemporary ceramic art are the same problems that face contemporary art in general. There is one difference though and that is that contemporary fine art, regardless of its problems holds the predominant position among all the visual arts in Western culture. That is to say it is the most celebrated—it is collected by more people, commands higher prices and has more institutions devoted to reinforcing its role in culture. While ceramic art has a history that is every bit as rich and has played just as important a role in the world's cultures as painting and sculpture, modern ceramic art is not taken as seriously by contemporary culture as painting and sculpture. The desire by modern ceramics to be seen as an art form that is just as significant as painting and sculpture has been its driving goal since the end of the Second World War. Modern ceramic art wants, in other words, what the fine arts has. There is, however, some confusion and tension within the field between, on the one hand, the goal of being accepted into fine arts as a separate but equal partner, and on the other the desire to hold on to the iconography of its history while still making work that speaks to what it means to be human in the twenty-first century. One of the major issues that define the debates in the ceramics field as to what type of ceramic expression is the most relevant in modern culture can be traced to a larger cultural issue. And that is the idea of the new. Part of the problem for both the fine arts and the ceramic arts is that the idea of the new presupposes that 'progress' is linear—new styles and approaches eclipse previous ones until they themselves are replaced. This perception leaves room for only one type of ceramic art occupying a predominant position in culture at any given moment.

Human beings are fixated with the idea of the 'new'. The idea of 'newness' as a marketing tool runs across cultures. We are told we can find happiness in new relationships, and new environments. Inherent in the idea of the 'new' is an escape from our present predicament to one that is more pleasurable and more secure. The United States is a country that was built on this premise. There is, of course, a reason that this idea is so powerful. It is at the core of our evolution as a species and is what gives human beings not only hope for their future, but also hope for the future of their offspring as well. So, what about the idea of the 'new'—when it comes to ceramic art, how do we measure 'newness', what are its qualities? Is it a worthwhile pursuit even?

1

1. Kubler, George, *The Shape of Time*, New Haven: Yale University Press, 1962.
2. Dewey, John, *Art As Experience*, New York: Perigee Books, 1980.

1 Carol McNicoll
Secure Jug, 2005
clay
44 x 18 x 16 cm

2 Malcolm Wright
Cinched Form, 2006
wood-fired brick clay
photograph by John Polak

3 Malcolm Wright
The Space Within, 2006
wood fired brick clay
photograph by John Polak

Art for Art's Sake

> When artistic objects are separated from both conditions of origin and operation in experience, a wall is built around them that renders almost opaque their general significance, with which aesthetic theory deals. Art is remitted to a separate realm, where it is cut off from that association with the materials and aims of every other form of human effort, undergoing and achievement.[2]
>
> John Dewey

As the fine arts world changed after the Second World War, the small insular field of ceramics was also struggling to make sense of itself and its relationship to modern culture. In the United States there was a new government programme—the GI Bill—which gave returning veterans, who prior to the war might never have considered or could not have afforded a college education, access to the country's university system. This bill transformed academe. Art departments, which included ceramics, sprung up in universities across the country and with them the need for instructors. Academe became a greenhouse for ceramic art, a place not only where it could be protected from the harsh judgments of culture but also where it could be nourished by the economic security and social status found in university teaching positions and the funded studios that accompanied those positions. With the establishment of these university arts programmes, the goal of ceramic artists began to shift away from the economic uncertainty of making a living as a potter, dependent on the commercial marketplace for recognition, to the much more lucrative and secure position of a university instructor.

In this new setting, ceramic artists also found themselves competing within the university system with their new colleagues—painters and sculptors—for academic and cultural recognition, in other words, for success. Painting, which had brought unprecedented attention to the arts and created cultural heroes out of its practitioners, became the yardstick for that success. In retrospect, it seems

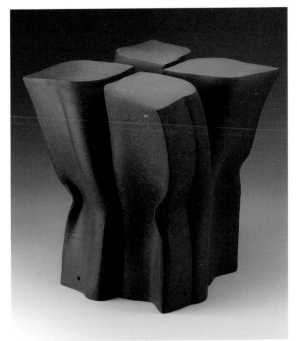

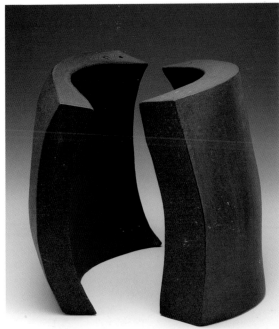

2

3

that it was inevitable that modern ceramics would try to imitate the early success of Abstract Expressionism by rejecting its own past—the historical language of ceramics—and replacing it with a 'new' form of ceramic expression that focused on appearing rebellious, heroic and outside the mainstream.

This shift away from ceramic art's history in favour of modern painting was first argued for in the United States by Rose Slivka, the editor of *Crafts Horizon*. In the 1961 July/August issue of that magazine, Slivka argued for the shift of structure away from ceramic arts historical language to the language of modern painting, writing that;

> It is corollary that the potter today treats clay as if it were paint. A fusion of the act and attitudes of contemporary painting with the material of clay and the techniques of pottery.... Today, the classical form has been subjected and even discarded in the interests of surface—an energetic, baroque clay surface with itself the formal 'canvas'.[3]

She went on to give three extensions of clay as paint in contemporary pottery;

> 1. The pot is used as a 'canvas'; 2. The clay itself is used as paint three-dimensionally—with tactility, colour, and actual form; 3. Form and surface are used to oppose each other rather than complement each other in their traditional harmonious relationship—with colour breaking into and defining, creating, destroying form.[4]

In a footnote, Slivka stated that, "The writer does not wish this article to be interpreted as a statement of special partisanship for those potters working with new forms and motivations."[5] However, statements further on in the body of her article such as, "The fact that the validity of the 'accident' is a conscious precept in modern painting and sculpture is a vital link between the practice of pottery and the fine arts today", made it clear to American ceramic artists that the critical framework under which their work would be examined and discussed in *Craft Horizons* had shifted.

The following issue of *Craft Horizons* contained responses from the two most prominent practitioners of functional pottery in the United States. The first was from Marguerite Wildenhain, a Bauhaus trained émigré. She wrote:

> *Quousque tandem*, Rose Slivka, *abutere patientia nostra*. For God's sake and the 'arts', quit corrupting the young generation with your fake double standards. On one side in the July/August issue the excellent Northwest coast artifacts and the plain speaking Anni Albers' equally excellent speech—and in between, that article and the photos of the *Big Pile*, etc. Nobody in his senses can continue to subscribe to *Crafts Horizons*, supposedly the magazine of the ACC (American Crafts Council), without blushing with shame or getting blue with fury.[6]

The second was from Warren MacKenzie a former apprentice of the renowned English potter Bernard Leach, who commented:

> For the longest time we had thought the *Big Pile* (the title of a piece illustrated in the article) was only good for enriching the fields. Now we find that if you pile high enough with the written word, or in the visual field, it can pass for art. In the future we will give up any attempt to make functional ceramics an expressive form since apparently, 'Containers make almost no demands on our sensibilities, leaving us free'—free to concentrate on getting the cow to cooperate for higher and larger works of 'ART'.[7]

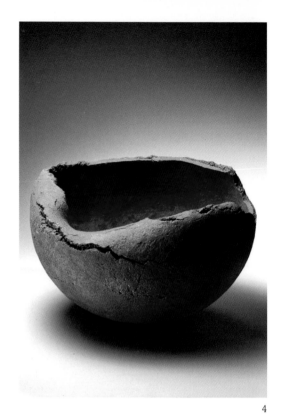

4

4 Ogawa Machiko
Vessel (Utsuwa), 2006
stoneware
26.7 x 41.9 x 38.7 cm
Halsey and Alice North Collection © Ogawa Machiko
photograph by Richard P Goodbody © Halsey and Alice North

5 Bernard Leach
Leach Pottery Standard Ware of the 1950s and 1960s
Selection from promotional brochure c 1965

The acrimonious tone in both of these letters is still palpable today. Contemporary ceramic art began to not only reject outright the idea that functional pottery could express meaning in modern culture, but also to insinuate that any references to the history of ceramic art by a contemporary ceramic object was enough to have an object rejected as irrelevant.

At the time, this 'new ceramic presence' was portrayed as a unique phenomenon that would forever free ceramic art from the enforced bondage of functionalism. What in fact was taking place was that modern ceramic art—sculpture and the ceramic 'vessel'—began mimicking fine arts trends in the hope that this would quicken the acceptance of ceramic art into the fold of the more prestigious fine arts. Ceramic art ceased referencing its own rich history, its basic material nature and to that degree it lost touch with its own language. The question that needed to be addressed but that was never voiced was "what was it that made modern ceramic sculpture different from wood, metal or bronze sculpture?" If there was no difference, if ceramic sculpture was the same as other types of sculpture, then why did it separate itself from the intellectual and critical dialogue of the fine arts world? If it was indeed special and therefore different from other types of sculpture then why was it not able to form believable intellectual arguments that convinced the fine arts world and culture in general of its unique position.

Function for Function's Sake

But here delicate issues of truth and falsehood may be raised. For whenever it has become possible merely to purchase brilliant images of other people's cultural identity without any knowledge of their meanings, first a loss of authenticity, later perhaps corruption and pretence, have inevitably followed; and it has become possible to treat what was originally a live existential discourse with a condensed meaning, as pure convention at the level of mere chatter. This has happened especially, of course, when one culture has adopted the forms and symbolisms of an alien culture.[8]

Philip Rawson

5

27 28 29 30 33 34 35 36

47 46 42 43 45 26 44 48

39 31 32 40 41 25 37 38

It was Bernard Leach, who in his *Potters Book,* 1940, first popularised the making of functional pottery (what he called standard ware) as the ideal art form of ceramic artists. Leach was an Edwardian who grew up in China, graduated from the Slade School of Art and then went to Tokyo to teach the Japanese the Western style of printmaking. He became a potter after attending a poetry party in Tokyo where pre-made bowls were given to guests to decorate and then fired before their eyes. The England to which Leach returned to in 1920 saw artist-potters being crushed between the ceramics industry on the one hand and the rapidly changing fine arts market, that was beginning to see and consume art in dramatically different ways. Leach started to create an intellectual construct based to a large degree on William Morris and the Arts

3. Slivka, Rose, "The New Ceramic Presence", *Craft Horizons*, no. 4, 1961.
4. Slivka, "The New Ceramic Presence".
5. Slivka, "The New Ceramic Presence".
6. Wildenhain, Marguerite, "Letter to the Editor", *Craft Horizons*, no. 5, 1961.
7. MacKenzie, Warren, "Letter to the Editor", *Craft Horizons*, no. 5, 1961.
8. Rawson, Philip, *Ceramics*, Oxford: Oxford University Press, 1971.

and Crafts movement that would support his philosophy of handmade everyday functional ware. The *Potters Book*, which was a formal attempt at addressing those problems, found a fertile audience, one that was looking for a way to fit into this new reality. After the Second World War, Leach's influence began to manifest itself in the United States when in the early 1950s, American potters, lacking what they felt was a vital indigenous ceramic tradition, turned almost *en masse* to the ceramic art of Japan for inspiration and aesthetic sustenance. Leach's ideas were furthered when he and his friends, the Japanese philosopher Soetsu Yanagi, Japanese potter Shoji Hamada and German émigré Marguerite Wildenhain toured the United States in 1952. Among their stops was Black Mountain College where notable American artists and poets like Robert Creely, Charles Olson, Robert Rauschenberg, Josef and Anni Albers, John Cage, Merce Cunningham and Buckminster Fuller all taught. It came to full fruition, however, in the early 1970s when he published *The Unknown Craftsman* which was a quasi-Zen approach to William Morris' ideas written by Soetsu Yanagi. A section of the book was devoted to Yanagi answering posed questions. The one which follows is an example of the style in which Yanagi's arguments were presented:

Q. Why do fine crafts so often fail?

A. To the extent to which they become separate from use, they are stripped of craftmanslike content. The nearer to uselessness, the nearer to sickness. They seldom escape from the affliction of self-consciousness. They fall so easily into the pitfall of themselves.[9]

The ideas expressed in *The Unknown Craftsman* became, to the young Americans of the "baby boom" generation who flocked to universities and found themselves studying pottery at the height of the Vietnam War, the moral justification for making handmade pottery.

American potters seemed particularly susceptible to two aspects of the philosophy that Leach and Yanagi shared and espoused: *Tariki-do* and *Chokkan*. The first is a Buddhist concept. As applied by Yanagi to ceramics, it was interpreted to mean that beauty is the result of the surrender of self to a higher order like one's craft rather than the self-conscious effort of an individual craftsman. To this group of young American potters, this theory, when put into practice became their justification and rational for the making of copious amounts of functional pottery that could be sold for a very low price. *Chokkan,* Yanagi's theory of direct perception, stated that an individual's intuitive, non-intellectual confrontation with an object is the basis for determining beauty. This became for this group of functional potters the justification for a subjective, non-critical approach to making, thinking and talking about pottery. The ideas in *The Unknown Craftsman* gave many functional potters a sense of moral superiority that still lingers today.

As a consequence of these cursory adaptations of Yanagi's philosophy on *mingei*—only one of the many schools of aesthetic thought in Japan—Japanese pottery was romanticised, popularised and commercialised to the point that it was stripped of any real meaning. Japanese shapes with *kaki, shino* and celadon glazes over imitative brushwork were soon found at every craft fair across the United States. As a result Japanese-inspired ceramics became so trivialised that now any visual or verbal reference to it is enough to make many collectors, critics and dealers of modern ceramic art roll their eyes and walk away.

6 Kouichi Uchida
Bottle, 2005
ceramic
photograph by Kouhei Wakamatsu

7 Warren Frederick
Ellipse Vase
stoneware, natural ash glaze, anagama woodfired
42 x 33 x 30 cm

8 Kazuo Yagi
Untitled, 1952
stoneware jar with white slip
photograph by Robert Yellin

6

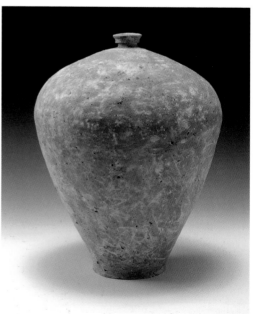

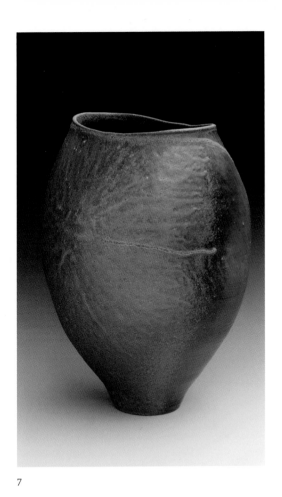

7

8

While large numbers of potters were content merely to borrow from books and publications the shapes, glazes and decorative techniques of Japanese ceramics that they found pleasing, apprenticeship in Japan become for hundreds of Americans a preferable alternative to the *laissez-faire* approach to pottery education found in academic institutions in the United States. However, the tendency to use a narrow, romantic view of Japanese ceramics—like Yanagi's *mingei*—to determine the worth of all ceramic art as well as the propensity to judge ceramic art entirely by the standards acquired from their teachers in Japan resulted in a idiom that stressed overt references to traditional Japanese forms and techniques as a goal in itself. This limited focus not only kept these potters from making intellectual inquiries into the nature of the beauty they originally found so compelling in Japanese ceramic art, but also kept them from questioning the relevance of such work in modern Western culture. The result was a glut of predictable pottery that exhibited what Philip Rawson, one of the most important writers on ceramic art in the twentieth century, described as, "first a loss of authenticity, later perhaps corruption and pretence".[10] The reality, of course, is that function alone—no matter how much pseudo-moralistic posturing that might accompany it—cannot guarantee that an object will be aesthetically compelling. Pottery must ultimately be judged like all art on its ability to create a riveting moment that causes us to transcend our mundane existence and experience another reality previously hidden.

That is what the best historical ceramic art from Japan or any other culture for that matter does. The late Kazuo Yagi, often called the father of modern Japanese ceramics and perhaps the most important ceramic artist of twentieth century Japan, pointed out in an essay on Kenzan:

> ... those elegant designs that are Kenzan at his best are still being repeated in today's ceramics world. But I feel that they have no significance as the formal 'patterns' they have become. Instead it is worth experimenting with them as a means of returning to the process through which they were developed, or even to the invention itself.[11]

Yagi urged contemporary potters to go beyond the superficial and obvious to an understanding of the very nature of the work itself, back to the human conditions that led to its invention. Philip Rawson asked us to do the same:

> If possible we must try and discover, through active use of our imagination, how live meanings of works of ceramic art which played some role in the life of every patron can be revived in our minds.[12]

It is through the active use of the imagination that one can begin to perceive, for example, the nature of historical ceramic art's beauty. And with that perception, modern functional ceramic art can start to echo that beauty, not by imitating the designs of the past, but by addressing the same basic philosophical and aesthetic concerns that moved those ceramic artists and that make their work as powerful and relevant in our culture today as it was when it was made.

9. Yanagi, Soetsu, *The Unknown Craftsman*, Tokyo: Kodansha International, 1972.

10. Rawson, *Ceramics*.

11. Yagi, Kazuo, quoted in Sato, Masahiko, *Chinese Ceramics,* Tokyo: Kodansha.

12. Rawson, *Ceramics*.

The Pursuit of Technique

Now when it happens that a single art is given the dominant role, it becomes the prototype of all art: the others try to shed their proper characters and imitate its effects. The dominant art in turn tries itself to absorb the functions of the others. A confusion of the arts results, by which the subservient ones are perverted and distorted; they are forced to deny their own nature in an effort to attain the effects of the dominant art. However, the subservient arts can only be mishandled in this way when they have reached such a degree of technical facility as to enable them to pretend to conceal their 'mediums'. In other words, the artist must have gained such power over his material as to annihilate it seemingly in favor of 'illusion'.[13]

Clement Greenberg

Historically, we in the West had to play catch-up with the Orient in the area of ceramic technology. We did it with a vengeance, not only industrially, but also in the handmade, artist-potter arena. In the 1880s, American artists-potters were primarily decorators, intent on reproducing Japanese export ware they had seen in Paris. Much of this activity took place around the Cincinnati Pottery Club and the Rookwood Pottery both in Cincinnati, Ohio. During this period both of these clubs were threatened by a legal injunction from producing slip-painted underglaze by another artist-potter who had taken out a patent on the process. Although this claim was thrown out in court, it shows how seriously nineteenth century American artist-potters identified the technical aspects of ceramic art as the primary direction for development of ceramic art and the yardstick by which it would be measured.

There is another reason, however, for this obsession with technique. The overwhelming majority of contemporary ceramic artists in America—potters as well as sculptors—were trained in the university milieu. One aspect of this academic setting was that ceramics instructors found themselves in the position of having to teach something that could be learned and measured, i.e. technique. This focus on technique—the consequence of having to make

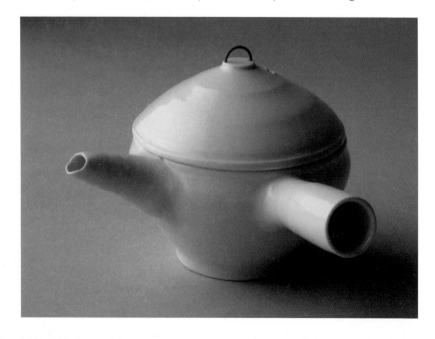

9

9 Sandy Simon
Porcelain Teapot, 2006
image courtesy of the Flux Gallery, Los Angeles

10 Akira Yagi
Faceted covered vessels with pale blue glaze
(Seihakuji mentori futamono), 2004
stoneware
photograph by Richard P Goodbody

evident to students all the means used in creating their work—became a hallmark of academic ceramic art education, which is to say American ceramic art in general.

Technical achievement became a proxy for intellectual investigation. That is why for the past 40 years ceramic artists have sought to entertain each other and the public with how they can make clay look like anything. As if making objects out of clay that looked like they were cast in epoxy resin, or built out of leather, wood, or bronze was some sort of aesthetic accomplishment in and of itself. There has even been an attempt at 'virtual' ceramic art. Both of the previous approaches that I have mentioned—"Art for Art's Sake" and "Function for Function's Sake"—were seduced by this tendency to pursue the idea of the 'new' by using technical expertise to create effects that amounted to little other than visual titillation for their audience. This over-reliance on technique ultimately resulted in ceramic art that appeared self-conscious, that is created with a pre-determined vision in mind. Risk and emotion were all but eliminated from the equation because they threatened the final outcome with a sense of uncertainty and vulnerability.

Ceramic art, of course, is defined by its material and that material has a certain nature and rules that dictates its use. Humans have had to develop, from the time the earliest ceramic object was first created, techniques that allowed them to manipulate and fire clay to achieve a successful outcome. Throughout the history of the ceramic arts we see ceramic artists engaged in a never-ending dialogue with clay, being seduced by its plasticity and jewel like beauty when fired and at the same time challenged by its stubborn, unyielding fragility when it is not handled with care and respect. It is, quite simply, an art form that is limited.

Anni Albers, the Bauhaus trained textile artist who emigrated to the United States prior to the outbreak of the Second World War with her husband, the painter Josef Albers, spoke of this in 1961 in an article titled "... more serving, less expressing", which was published in the same issue of *Craft Horizons* in which Rose Slivka published "The New Ceramic Presence". In it she wrote:

> Today it is the artist who in many instances is continuing the direct work with a material, with a challenging material, and it is here I believe that the true craftsman is found—inventive as ever, ingenious, intuitive, skillful, worthy of linking us with the past. His work is concerned with meaningful form, finding significant terms for newly unfolding areas of awareness. And dealing with visual matter—the stuff the world is made of—inherent discipline of matter acts as a regulative force; not everything 'goes'. To circumvent the 'no' of the material with the 'yes' of inventive solution—that is the way new things come about, in a contest with the material. It is this knowing—that rules are the nature of nature, which chaos is senseless—that is thus transmitted to and through a work of art.[14]

Albers' argument which I believe it is even more relevant now—was that unrestrained expression in obedient mediums neither provides the artist with enough stimulation, nor is a source of inventiveness. Without the "compelling rules of matter" she argued, we are left with an entirely subjective art that springs from unfiltered introspection. Artists' convulsions, therefore, are often mistaken for revelation.

10

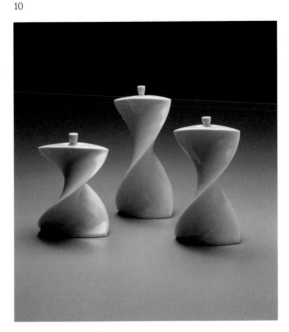

13. Greenberg, Clement, "Towards a Newer Laocoon", *Partisan Review*, vol. 7, no. 4, 1940.
14. Anni Albers, "... more serving, less expressing", *Craft Horizons*, no. 4, 1961.

Alternatives to the 'New'

No poet, no artist of any art, has complete meaning alone. His significance, his appreciation is the appreciation of his relation to the dead poets and artists. You cannot value him alone; you must set him, for contrast and comparison, among the dead. I mean this as a principle of aesthetic, not merely historical, criticism. The necessity that he shall conform, that he shall cohere, is not one-sided; what happens when a new work of art is created is something that happens simultaneously to all works which preceded it.[15]

TS Eliot

Perhaps, the greatest problem facing modern ceramic artists today is how to create work which conveys or comments somehow on the complexities of modern life. For a ceramic artist's work to be relevant today it somehow must find its meaning in the issues that surround and confront humans daily. Some assume that any and all references to historical work have no place in the iconography of modern ceramic art. TS Eliot suggests however, that to be modern is to be, for want of a better word, traditional. This struggle for relevance in one's own time is in itself traditional—something all serious artists have been engaged in throughout history. Truly creative work is not realised by the timid and blind adherence to specious standards set by previous generations. Nor is it found in the plundering of other culture's ceramic traditions by recreating old masterpieces from those cultures and passing them off as modern interpretations. A truly meaningful historical investigation has to be grounded in a questioning and probing dialogue with the past about the very nature of human existence.

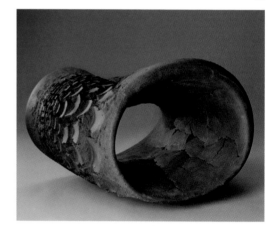

11

Any new approach to ceramic art should begin with recognising that the modern approaches of the past 50 years that centre on "Function for Function's Sake" and "Art for Art's Sake" are no longer viable. Neither approach has resulted in contemporary ceramic art becoming a force in modern culture. To a field that seems at this point to be without any coherent philosophy that can reconcile the extreme camps that currently exist in the ceramics field, Philip Rawson's argument for seeing ceramics as a visual language offers the most promise. Rawson suggested that because our minds share a common abstract structure of language we are able to understand each other even though we may never have heard that exact utterance before. Furthermore, and this is key, he argues that nothing we say ever exhausts all the possible utterances a human being can make. It is the artists of language— the poet and the novelist—who actually say things which exploit the possibilities and richness of meaning waiting in language. The ceramic language, Rawson offered, is expressed through ceramic signs which ceramic artists assemble as utterances. So he says, "unless, we develop our language of ceramic signs, recognise what they are and how they work, we will remain ceramically illiterate."[16] Clay is full, he says,

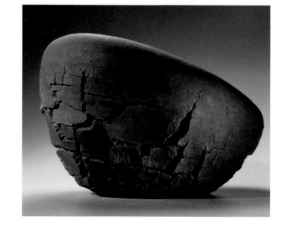

12

... of half-formed thoughts, inconclusive shapes, rough manufacture and brushwork, casual fantasy. It can be very eye catching form a distance, but it will only build into strong statements when the character in variations in shape and placing also carry meaning—when a pot doesn't have to be a generalised ripple or texture, but shaped ripple or texture; when each of the ceramic signs connects logically with all the others.[17]

11 Akiyama Yô
Metavoid 4, 2004
thrown, gas-burned, cut, folded and slip-assembled clay
image courtesy of the Museum of Fine Arts, Boston
© Akiyama Yô © Halsey and Alice North

12 Akiyama Yô
T-028, 2002
thrown, gas-burned, cut, folded and slip-assembled clay
28.6 x 33 x 50.1 cm
image courtesy of the Halsey and Alice North Collection
photograph by Richard P Goodbody
© Akiyama Yô © Halsey and Alice North

13 Robert Brady
Porcelain Dishes with Brushwork, 2005
image courtesy of The Flux Gallery, Los Angeles

Rawson's idea of a ceramic language gives us a way out of the dead-end approaches that modern ceramic art has clung to over the past 50 years. It does not pit the past against the future, the useful against the purely artistic and puts the technical aspects of ceramics into their proper perspective.

There is still the question of how to recognise those qualities in modern work "which exploit the possibilities and richness of meaning" waiting in the language of ceramic art. What standards, for example, should be employed to measure modern ceramic art? On its face, it appears to be a complex problem. Virginia Woolf, however, addressed this exact concern.

> The thing that really matters, that makes a writer a true writer and his work permanent is that he should really see. Then we believe, then there arise those passionate feelings that true books inspire. It is possible to mistake books that have this life for books without it, hard though it is to explain where the difference lies. Two figures suggest themselves in default of reasons. You clasp a bird in your hands; it is so frightened that it lies perfectly still; yet somehow it is a living body, there is a heart in it and the breast is warm. You feel a fish on your line; the line hangs straight as before down into the sea, but there is a strain on it; it thrills and quivers. That is something like the feeling which live books give and dead ones cannot give; they strain and quiver. But satisfactory works of art have a quality that is no less important. It is that they are complete.[18]

The kind of completeness Woolf describes cannot be realised if ceramic artists approach their work with either the myopic view that ceramic art must be understood and explained in the narrow cultural context of Western modernism, or the notion that functional ceramic art is somehow more moral and pure than other types of ceramic art. It can exist only in the work of ceramicists that have immersed themselves in the language of ceramic art and drawn on their knowledge of that language to create poetic statements that make us reflect on the tenuousness of our existence. This is what makes a work of ceramic art both modern and historical—in a word, complete.

13

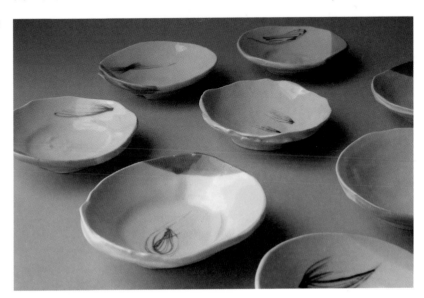

15. Eliot, TS, *Selected Essays*, London: Harcourt, 1932.

16. Rawson, Philip, "Keynote Address", *Contact*, Issue 58, 1984.

17. Rawson, "Keynote Address".

18. Woolf, Virginia, *The Essays of Virginia Woolf*, New York: Harvest Books, 1989.

Contemporary Clay

Claire Twomey

Investigative, non-conventional approaches to clay are endemic of our time. Over the past century, the role of the practitioner has experienced radical change, and this shift in the outlooks and the economics surrounding craft practice has profoundly reshaped the role of the crafts-person. It leaves crafts divided in its indulgences and necessity to our society. This ranges from the bespoke potter to the avant-garde makers who are committed to art production with craft-making at its core, all creating the necessary languages and contexts in which to be relevant and active.

This is an emancipated continuance for clay practitioners who are fully engaged and immersed in current debates in the wider visual arts. This intelligent making in clay is part of a much larger dialogue, placing the principles and dialogues of craft into a relevant role in our visual culture.

This relevance can be seen in the diverse trends of clay activities that fall under this handed-down title of craft practice. There are potters, object-makers, hybrid craft makers, sculptural artists, installation clay artists and temporary time based works. These titles and terms have been borrowed and stolen from other art disciplines to give an identity and relevance to the activities undertaken. This embracing of terminology is vital in forming a context for the artists to place themselves within, the identification through terminology forming a knowledge-base of peers. It helps galleries, critics and collectors recognise what they are invited to be taking part in. It bundles relevant histories together, informing the viewer and artist how to behave, and what references to draw upon when assessing these works. How else could the contemporary clay maker identify their work if not by finding relevance in contemporary terminology?

Craft has now past the point where new makers see an amassed division between terminologies from craft or fine art or many other areas of practice; all references to terminology are, when applied intelligently, inclusive and transferable to practice as a whole—the terminology references the maker's intentions, not a discipline. However, it is vital to acknowledge that the recognition of materials is intrinsic to the content and conceptual language of a piece, and by extension to our reading of the piece as an audience.

The ever more complex and sophisticated uses of clay in today's visual culture leaves us in no doubt that as a material, it has transcended its role as a mere modeling material. The breadth of practice and variety of forms that clay has embraced has led us to fundamentally question our understanding of such practices. There are artists expending great craft knowledge in studios, there are practitioners working in collaboration with others, there are those commissioning the making of objects by artisans and industry, there are those who borrow and construct. All of these drift in and out of the world of contemporary clay practice.

1

1 Jessie Flood Paddock
Trocadero Tickets, 2005
clay, acrylic paint, 20 x 15 x 12 cm

2 Michael Geertsen
White Wall Object, 2003
earthenware and glaze
image courtesy of Garth Clark Gallery, New York

3 Hans Stofer
Maria Orange
porcelain, ball chain, steel

Object-Making

Object development and all its concerns provides an alluring and endless source of established art dialogue as well as a historical model in clay practice. Over the centuries, clay objects have evolved to suit the needs of the culture they serve. Simple vessels were first used to carry water and foodstuffs and to play a role in the ceremonial rituals of ancient cultures. The forms and surfaces of the vessels developed in order to accommodate changes in culture and usage, maintaining through the centuries a fundamental functionality, whose ghost remains ever present. For an object to forge a new trail, it must reflect some truth in its cultural context, and in the instance of clay, this required some kind of break from its functional milieu. In 1900, the Martin Brothers began making vessels influenced by Celtic, medieval and Persian pottery. By the early years of the twentieth century, however, they had branched off into small sculptures of "Wally Birds" and grotesque face jugs, influenced by the Gothic Revival, reflecting the indulgence of the Victorian decorative object. 80 years later, Modernists Lucie Rie and Hans Coper took the object even further away from functionality, focusing on the spaces inside and outside the vessel.

Object-making and its history provides a diverse commentary that holds relevance to all forms of practice. This is especially true when comparing work, which exclusively uses clays, referencing its specialist history, to work that is more hybrid-ised, using clay in and amongst other materials.

This dialogue can be seen in the works of artists such as Jessie Flood-Paddock and Laura Morrison, from the 2006 Bloomberg New Contemporaries, who both discuss clay-use in their work as a matter-of-fact, and not as a specialised craft tool. In the work of Hans Stofer (United Kingdom) we see clay used as providing a context within which to discuss domestic and personal histories, and Chad Curtis (USA), who uses clay as a context of place in his miniature landscapes. Maxim Velcovsky (Czech Republic) uses clay as a flexible and locally accessible production material, and as a placement tool for his design objects.

A purist clay object-maker such as Michael Geertsen from Denmark can be seen to be in a long investigation with material and a highly specialist dialogue with form. His work draws on the historical discussion in clay practice of spatial

2

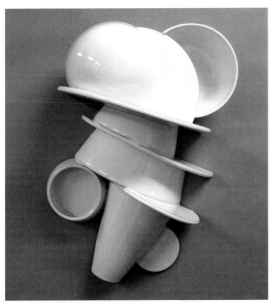

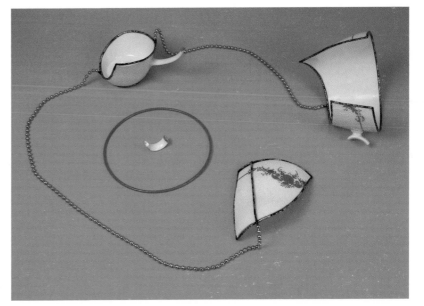

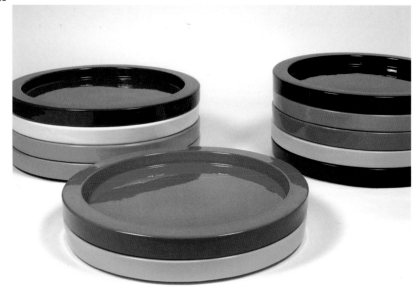

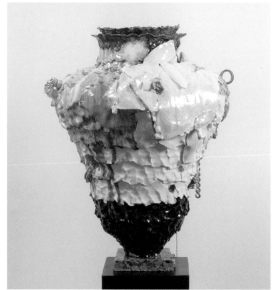

containment, but his abstracted, sliced, rotated and skewed forms reach beyond this discussion to the greater concerns of an artist looking at formal relationships in aesthetics and minimalist languages. The scale and placement of the works create interruptions in perceived understanding of ceramics practice. They are often meandering structures stretched across a wall or peeking from some far off corner, observing rather than seeking centre stage.

In contrast to this exclusive relationship, another maker of objects is Nicole Cherubini. As Mark Dean writes in his exhibition catalogue for *One Part Clay: Ceramic Avant-Garde and Mixed Media*, which took place in New York in 2006: "Nicole Cherubini's over-accessorised and adorned coil sculptures clearly address the current blurred boundaries between social class and status in our society." In her work, Cherubini accesses a known ceramic metaphor—that of the vase—and embellishes it with lavish additions of chains, beads and found materials, creating a chaotic and indulgent form. These accessories allow the work to transcend notions of use, and other well-trodden discussions of functionality, into discussions of decoration, celebration, and excess. The vases now read as a canvas on which Cherubini has built her dialogue.

From the objects produced in the 2006 Albisola Art Biennale the object authored by the artist Liam Gillick was a truly subversive clay object. Liam Gillick is an artist who is internationally revered for his articulate and geometric understanding of space and composition. He was invited by the Arts Biennial to take advantage of the ceramic craftsmen in Liguria, an area in Italy renowned for its ceramic workshops. The resulting design was a ceramic column of boldly coloured interlocking forms. The scale of this work tantalisingly reaches just beyond domestic understanding and conformity, yet the individual plates are of a generous but standard scale. Liam Gillick's trademark attention to material and detail was carried out by the local ceramic craftsmen of the 'fabricas' (small factories) in the town of Albisola, who carried out instructions conveyed by Gillick via e-mail. The result is a striking convergence of two histories. The sharp lines and contemporary sculptural forms are complemented by the craftsmanship evident in the quality of the surface and substance of the material. The merged world of concept and craft knowledge can produce exceptional results.

4 Liam Gillick
Multiple Revision Structure, 2006
glazed ceramic
courtesy the artist and Corvi-Mora, London

5 Nicole Cherubini
G-Pot with Rocks, 2006
ceramic, fake gold and silver jewellery, chain, white feathers, luster,
white ice, marble, wood, blue foam, targel
40.6 x 40.6 x 104.1 cm
photograph by Jason Mandella

6 Anders Ruhwald
Social Piece of Furniture #5, 2006
glazed earthenware
99 x 29 x 24
Shelf/Lamp, 2006
glazed earthenware, cord, bulb, plug
Beginning/Ending, 2006
glazed earthenware
photograph by Soren Nielsen

7 Richard Slee
Top Hat and Wand, 2006
ceramic, metal, rubber, pyrex glass, water

In contrast to this collaboration but still focusing on the forming of a contemporary ceramic object is the work of Richard Slee. With his relentless intelligence and sensitive wit, Slee has dipped in and out of dialogues of craft practice, enriching clay's understanding of itself. His diverse skills as a clay manipulator have allowed him to engage in a broad-ranging discussion on the various aspects of the 'object', and the way we relate to it. Rather than relying on a constant theme in order to give coherence to his practice, Slee's work is in a state of perpetual motion, constantly searching for new vehicles with which to engage in conversations about the domestic realm. In some of his work, he makes use of materials and technologies outside of clay practice to further blur our understanding of craft and art. He extends his syntax of materials beyond the realm of clay, not because of the shortcomings of the material, but because he is on a constant quest for a new language with which to express his intentions.

Clay practitioners that work in object-making often become associated with a language of the domestic. The association of decorative objects in the home, the scale that these objects and environments usually adhere to, and the intimacy and warmth of the domestic environment, all become an intrinsic part of our reading of the object. The sculptures of Anders Ruhwald (Denmark) play on our understanding of the domestic by drawing on an intelligent understanding of scale and the role of domestic objects. From his physical observations of the body's relationship and interactions with its immediate environment, he creates objects that suggest furniture space and imagined domestic activities. Ruhwald questions the role of the object and our presumptions of forms, creating a sense of discomfort by generating an illusion of softness to touch where only hardness prevails. His pieces deliberately encourage a discussion that echoes from the field of fine art to design, forming contact with the broadest possible range of practices.

6

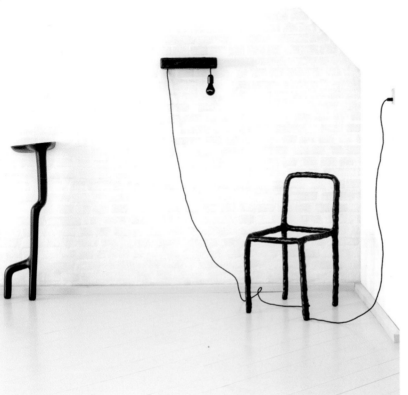

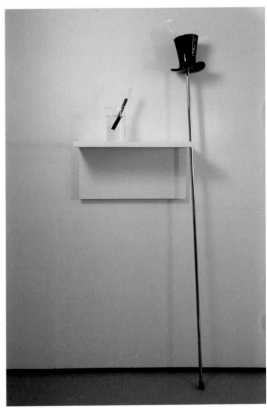

Hybrid Craft-Makers

We can explore the trends in current practice further, by looking at the hybrid work of Barnaby Barford, Jaime Hayon and Marek Cecula. In the same way that other material-specific disciplines are breaking from known formats, these artists are borrowing and lending to and from industry, design and craft practice, creating a buoyant and free-flowing environment of hybrid objects in art, design and consumer products in clay.

Artist and designer Barnaby Barford places clay at the centre of his practice, but often makes use of and designs in other materials. The hybridity in his practise stems from the materials he uses, and the way in which he slips effortlessly from the role of artist to designer to crafts-person and back again, challenging preconceptions in each arena. In his sculptures, Barford cuts and re-assembles ready-made ceramic objects into new formations, creating sophisticated and subversive statements on topical social issues. He is a highly skilled crafts-person, but chooses not to highlight this asset when focusing on the ready-made. He appeals to a new audience-base, which is fluent and engaged in many different aspects of visual culture, and which is becoming the target audience for more and more makers. This confidence and unwillingness to adhere to the traditional rules of crafting is a major departure point in current clay practice, linking people like Barford to the works of artists such as Picasso, Antony Gormley and Rebecca Warren in a pact of high material regard and application rather than a limiting, historical approach to clay. By eroding this boundary, a new generation of makers is broadening the dialogues of application, to a vast sphere with the intelligence of the material application at its heart.

The artist designer Jaime Hayon from Spain has collaborated with ceramics manufacturer, Lladro, to broaden the application of material in his work. He has produced design-esque objects that have the finesse of industry yet the dialogue of art, leaving them more in the design camp than Jeff Koons' sculptures, but less in the art camp than Barnaby Barford's collage ornaments. The hybridity of the objects in this case results from the manufacturing process and how it relates to the product. Hayon's enquiries have created a wonderful and strange new place. His well-understood concepts and well-produced clay application have opened up a genre of endless possibilities to new makers.

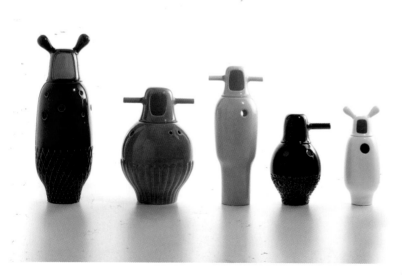

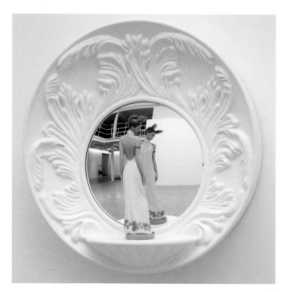

8 Jaime Hayon
Vases Colors from the *Showtime Collection*, 2006
ceramic

9 Barnaby Barford
Don't Worry Love, No-one Will Notice, 2005
fibreglass frame, mirror, porcelain

10 Marek Cecula
Burned Again from the *In Dust Real Exhibition*, 2005
industrial porcelain, wood fire
photograph by Sebastian Zimmer

11 Marian Heyerdahl
detail from the *Terracotta Woman Project*, 2006
clay

The work of Marek Cecula also spans art, craft and design. However, his approach to the collaborative process of creation is a much more concerted one. He deliberately assumes an ambiguous role in the work, creating a layered approach to the creative process. In his *In-Dust-Real* exhibition at the Garth Clark Gallery, New York, he re-fired elegant Royal Copenhagen porcelain dinnerware, in a Japanese-style anagama wood-firing. This traditional approach warped the forms and disfigured the fine surfaces. The craft-aspect to the work indubitably stamped its mark on the ubiquitous product, reversing the 'normal' balance of power between craft and industrial manufacture. The exhibition created a commentary on the nature of mass-production and questioned perceptions of beauty in different cultures.

Sculpture

The above works of small-scale sculpture are the tipping point into an area of larger scale sculptural works. Historically this has been dominated by classical sculpting techniques, but there is a group of artists and crafts-people who, through a liberation of thinking and gallery practice, are making large-scale sculptures in clay. Some of these are stable, some temporal, some using a vast array of clay application skills. Artists using clay and other materials to make works are driving forward the possibilities and contextual understanding of how clay is used and by whom. Marian Heyerdahl, for example, has long used clay as an instrumental part of her exploration of sculpture. She has recently completed a project in China, in which she reproduced 60 replica terracotta army figures as females. The sculptures are contemporary in their historical impossibility—identical to the original finds in scale and material but contentious in their brazen femininity and in the violence and anger that they present to the viewer. Heyerdahl has incorporated site-specific elements in the work, creating and exhibiting it in the location that the terracotta army was found, and going so far as to produce the figures in a factory across the road from the archaeological site.

11

10

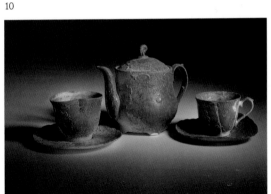

The American artist, Kristin Morgin takes the fragility and temporality of clay to create sculptures that convey a commentary on contemporary concerns in American culture. The frail and fractured surfaces of her work bind together the complexity of other materials, creating a rich material collage. Morgins writes of her sculptures: "my works are reminders of what it is to be mortal". The clay is a key material for its easily interpreted condition, and for its reflection of continual change, which mirrors that of the fading and decaying icons that comprise the work.

Looking more broadly at sculptural clay work being produced, Thomas Schütte is an artist with a dedicated understanding of many materials. His use of clay has contributed significantly to the perception of clay as contemporary sculptural material. His pieces could have been produced in any material, and his choice of clay is one that contributes to the conceptual language of the work. He relates to the connotations of classical crafting that the material carries with it, the elemental nature of the material, and the aspect of the hand-made.

When craft-application borrows concerns and approaches from the world of fine art, the result is a conceptual approach to the work, which needs to be examined using the dialogues that have influence both fields of practice. With this in mind, it is difficult not to mention the works of eminent sculptors such Andy Goldsworthy, Richard Long and Richard Wentworth. These artists' understanding of material is sensitive and its application is executed with the finesse of a fine crafts practitioner. It is this sensitivity that has enabled the crafts to appreciate the multifaceted dimensions of application of material and concept.

To examine this broadening of dialogues in clay-based work, it is vital to recognise this influence of the wider visual arts on critical thinking within a specific discipline. This is necessary for viewers, makers and curators alike. For all disciplines to remain 'current' they require an immersion within society and an intelligent understanding about their context.

13

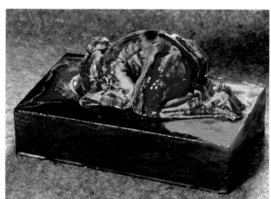

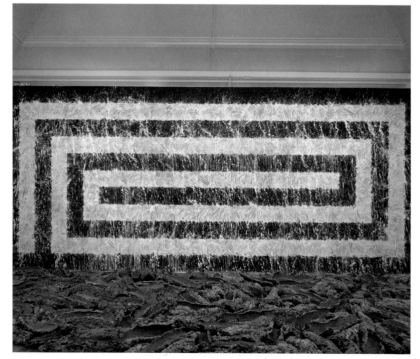

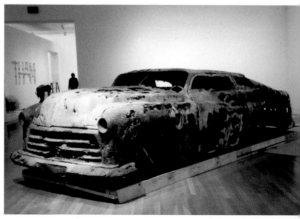

12

14

12 Richard Long
Mountain, 2003
white china clay applied to a black painted wall
image courtesy of Haunch of Venison, copyright the artist

13 Thomas Schütte
Untitled #4, 1999
clay
image courtesy of the Marian Goodman Gallery, New York

14 Kristin Morgin
Sweet and Low Down
clay, wood, wire

15 Keith Harrison
Last Supper, 2006
cooker elements, Egyptian paste, insulation blocks, fireproof board
photograph by Chris Smith

Gallery as Context

In clay practice, the developments in the way that clay is used has been influenced by the shift in the role of the gallery from container of objects to context. The all-consuming dialogue of site-specific work has had a highly influential role on the understanding of craft as an immersed destination, placing it firmly in the context of the broader visual arts.

Antony Gormley's iconic work *Field* is an example of how gallery space is being used as part of artwork. Comprising 35,000 clay figures made by an extended family of brickworkers in Mexico, this work is conceptually and physically dependent on the gallery space for the work and its relationship to be validated. In this installation, the viewer is forced outside of the space, and is permitted only to peer into areas occupied by the artwork and now made physically redundant to the viewer. The artwork itself discusses occupation and population as the invasion of figurines sweeps through the space.

To draw a comparative development in craft gallery practice we can look at the work of Piet Stockmans. This artist was exhibited for the first time in the United Kingdom in 1999 in *UN-Limited*, an exhibition curated by Emmanuel Cooper at the Crafts Council in London. Stockmans' work was placed as part of a group show that explored the concept of multiples. His main work was a piece entitled *Floor Installation* ('installation' is a term that will be discussed in depth later on). It consisted of thousands of blue-rimmed white porcelain bowls sitting next to each other, filling the gallery floor. This created a wash of blue lines, and the impression that the rims were floating above the floor. Only one viewing area was created, with no walkways through the work, resulting in a sense of exquisite, but unattainable beauty. In 1999, in the context of craft gallery practice this work was subversive to the core—bowls with no active function, the bare floor as a display area—it broke all the rules of the sacrosanct singular object. Emmanuel Cooper and Piet Stockmans addressed the future with clear intentions, expanding the edges of crafts-thinking by paying their respect to the craft-object whilst simultaneously subverting it with a thoroughly art-driven motive.

15

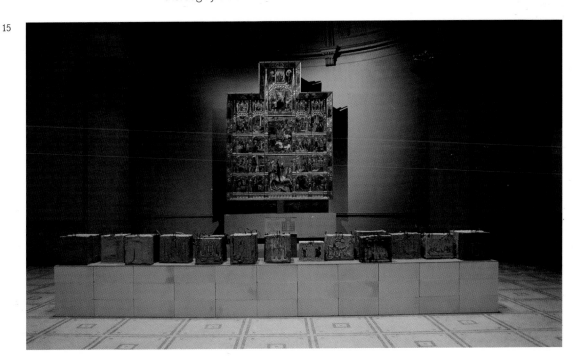

What the works of Gormley and Stockmans do is to converge the audience together, at a point in which they are forced to question the use of gallery space. These artists were able to present a sumptuous narrative before us thanks to the preparedness of galleries to move beyond the object. It is a reflection on the current outlook in art-production that such elaborate works can be created, and that such colossal investments are made in the production of art as a social transcript.

The development of the use of intervention, full-scale installation, construction and environmental art has continued to develop and can be seen as progressing gallery interaction from the works of non-clay artist Felix Gonzalez-Torres to that of the clay work of Keith Harrison. Gonzalez-Torres's exhibition, *The Sweetness of Life*, in the Serpentine Gallery in 2000, helped define a moment when the liberation of interaction became part of the common language in art practice, and by extension in other disciplines. In this exhibition, the artist used wrapped sweets as his material of choice, placing them in various colour groups and formations. The visitors to the gallery were invited to participate by helping themselves to sweets, thus depleting the artwork. Gonzalez-Torres's intention was that 'authorship' of this work was a collaboration between the maker, presenter, owner, and viewer.

This combination of the conceptual alongside firm gallery support can be seen in the work of Keith Harrison as well. In many of Harrison's works, he asks the audience to bear witness to a performance of clay transition as the raw clay is fired, using experimental and public methods, and by this act of watching, the audience become participants in the piece. Similar to Gonzalez-Torres, the performative aspects of Harrison's work means that the work's only remaining outcome is in the memory of the audience. The experimental and temporary nature of Harrison's work can be observed in a five hour exhibition at the

17

16

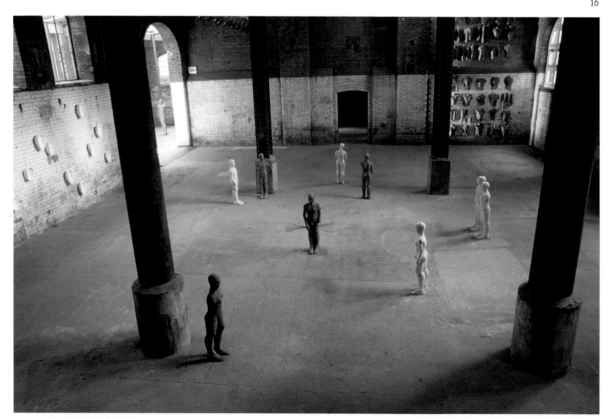

16 Christie Brown
Fragments of Narrative, installation at the Wapping Power Station,
London, 2000
photograph by Kate Forrest

17 Carol McNicoll
Detail from the *Bergen Kunsthall Installation*, 2001

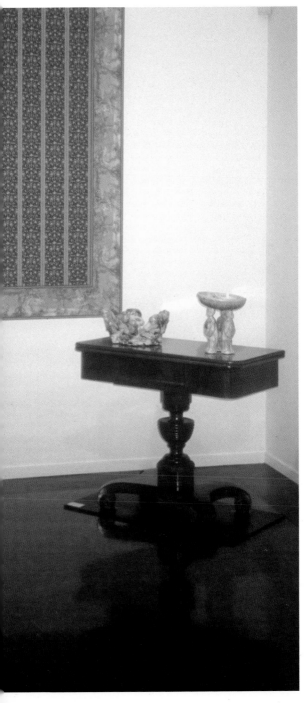

Victoria and Albert Museum in September 2006. The first of two works was *Last Supper*, a time-based site-specific work located in the Raphael Room and consisting of 13 electric cooker elements and 20 clay blocks arranged by colour and formation in the pattern of Da Vinci's *The Last Supper*. Over the course of three hours, the elements heated the clay blocks, causing chemical changes in the space and the work. Steam gently left the clay and entered into the atmosphere of the room, creating a physical sense of change and evolution within the audience's perception and understanding of what they were witnessing. As Harrison himself states, "the process of transformation is an intrinsic part of the work". In the second piece for this exhibition, *M25 London Orbital*, Harrison constructed a replica of the M25 ring-road around London using 167 scalextric track sections. *Orbital* negotiated the internal and external spaces of the sculpture court and the central courtyard of the museum. This work was also publicly fired over a five hour period, addressing issues of time-based and performative aspects in clay.

The site-specific aspect of interaction is part of the dialogues concerning the clay practices of Christie Brown, Carol McNicoll and Edmund De Waal. All of these artists have explored the narrative of venue in some depth. In *Fragments of Narrative*, Christie Brown's installation in the massive industrial space of a converted power station in Wapping, East London, she explored craft-dialogues in a 'non-craft' space. Writing about her sense of the space, Brown describes it as follows: "the scale of the space was daunting and challenging. The structure of the main interior echoed a Romanesque church with high windows and columns and the whole site was filled with the traces and memories of its previous existence as a place where steam power was generated to animate bridges and lifts." Responding to the industrial enormity of the gallery, she filled the space with life-sized clay figures and torsos representing characters such as Pygmalion, Prometheus and Golem, who had some kind of power association at the heart of their story. This complex concept elevated the figures beyond sculpture into the realm of installation, as the work's dialogue was with the very core of the buildings identity.

In 2001, Carol McNicoll was invited to exhibit in the rather grand exhibition space of the Bergen Kunstall. In order to challenge the lofty atmosphere, she papered the walls with patterned wallpaper, and exhibited her work on pieces of historical furniture from the museum's collection, rather than plinths. She then scattered store-bought ceramics and domestic objects throughout. "the domestic setting, which visual art's avant-garde left behind some time around 1945 is the context I find most interesting", states McNicoll of her work. In this piece, craft acts as a bridge between ornament and art, home and gallery.

Three years later, in 2004, Edmund De Waal made his site-specific museum intervention in the National Museum of Wales. De Waal took on the role of curator of objects from the museums applied arts collection, as well as that of a site-specific artist working within the gallery space. The catalogue accompanying the exhibition identifies that "in this exploration of the collection he selects and arranges part of the eighteenth century porcelain collection and places new work of his own in dialogue with it in the frame of a domestic place setting. It is not only the applied arts that have engaged in rearranging collections…. In 1997 at the British Museum, [Richard] Wentworth juxtaposed Egyptian drinking vessels with that of drinks containers from the museums rubbish bins."[1]

1. From the exhibition catalogue *Arcanum: Mapping Eighteenth Century European Porcelain*, National Museums and Galleries of Wales, 2004.

Installation

This brings us to the undefined area of installation, which can of course take on the above concerns of site-specificity, but also could be a work that fully encourages the audience into a space, encompassing them and starting to blur the boundaries of art and theatre. In some attempt to give a definition of this practice, which is broad ranging and ever applicable to many different art works of many scales, I look to the critical work of Michael Archer and Claire Bishop. Michael Archer on his view of the term installation writes "to call some disposition of materials, objects or artifacts an installation with any degree of authority presupposes familiarity with a clutch of related terms: location, site-specificity, gallery, public, environment, space, time, duration. Consequently, a definition of installation must also shed light upon the contemporary significance of this surrounding vocabulary."[2]

This openness to definition is furthered in Claire Bishop's view of installation art: "'Installation Art' is a term that loosely refers to the type of art into which the viewer enters, and which is often described as 'theatrical', 'immersive' or 'experimental'. However, the sheer diversity in terms of appearance, content and scope of the work produced today under this name, and the freedom with which the term is used, almost preclude it from having any meaning. The word 'installation' has now expanded to describe any arrangement of objects in any given space, to the point where it can happily be applied even to a conventional display of paintings on a wall."[3]

With it clearly established that there is an open interpretation to how this term is used in both clay work and other areas of practice, it is vital to look at works that can demonstrate the rigour and awareness that Archer alludes to. In clay practice this is becoming more and more of a demand, as the term must be understood within the context of making from a broader perspective, rather than multiples and decorative concerns alone. It is also important to recognise that many of the previously mentioned artists who are dealing with temporal and site-specific works have made a considerable and intelligent contributions to this area of practice.

The work of Canadian artist Linda Sormin reaches out to this rigour of contextually understood installation work, with a language so fresh and dynamic it is hard to type. Renaissance-punk is somewhere close to where I find the intentions of her crawling, sprawling structures, which seem to consume the very space they occupy. The effortless chaos that searches to identify itself with the domestic but as an action of conflict to this harmony, leaves the viewer in a blissful hunt for clues and anchors in the work. Linda Sormin states "the work demands that I negotiate my presence before it, around it, under it, through it. The site looms above and veers past, willing me to compromise, to give ground. Overbearing and precarious, its appetites mirror my own. I roll and pinch the thing into place; I collect and lay offerings at its feet. This architecture melts and leans, it hoards objects in its folds. It lurches and dares you to approach, it tears cloth and flesh, and it collapses with the brush of a hand. What propels the desire to make and compulsively make? Is this how I reassure myself, prove that I am here? If a tonne of clay is in the room, and over time it is transformed–behaving and misbehaving–because of me, is it through making that I perform identity and establish presence?"

2. De Oliveira, Nicolas, Nicola Oxley and Michael Petry, *Installation Art in the New Millenium: The Empire of the Senses*, London: Thames & Hudson, 1994.

3. Bishop, Claire, *Installation Art*, London: Tate Publishing, 2005.

18 Phoebe Cummings
Landscape I, shown as part of *Contain Memory* at the Crypt,
St Pancras Church, London, 2005
unfired earthenware clay, metal

19 Linda Sormin
Detail of *Celephant*, 2006
ceramic and found materials

Another artist identifying with installation is Phoebe Cummings. Cummings' work responds to environment and space, playing with expectations of materials and scale, and the psychological space of everyday objects. Often working with unfired porcelain, her work envelops the space and lures you into the notions it creates, encouraging you to find out more about the role of the room. Cummings raises questions regarding the function of a space by playing with time, and with the space as a whole. As Cummings states of her work "the fragile constructions become impossible objects where the viewer is confronted with their physical presence, and made conscious of their behavior within the room."

Clay artists working within a contemporary cultural context must have a constant awareness of conscious behaviour. By regarding its audience as sensitive and curious, the objectives of the artists, designers and crafts people must deliberately take command of material concerns and concepts. With the future of all artists becoming hybrid, it is vital that craft makers and material specific makers realise their relevance to making environments.

The acknowledgment that investigative, non-conventional clay making has shifted the role of the practitioner, means that the future is unclear. This is a critical time, an enabling time for makers to redefine their roles in a way that will serve future generations of makers in a hybrid, intelligent and sensitive arts culture.

Surreal Geometries

Rebecca Catterall
Isobel Egan
Stine Jespersen
Christin Johansson
Mimi Joung
Tae-Lim Rhee
Anders Ruhwald
Richard Slee
Maxim Velcovsky

1 *Sheer Black Tubiform*, 2003
stoneware clay, commercial stains
37 x 34 x 34 cm
photograph by Incameraphotography
2 *Grey Vine*, 2005
stoneware clay, commercial stains
14 x 19 x 18 cm
photograph by Incameraphotography
3 *Cleave (Blue)*, 2004
stoneware clay, commercial stains
24 x 38 x 18 cm
photograph by Incameraphotography

Rebecca Catterall

Rebecca Catterall's ceramic sculptures are comprised of hundreds of geometric shapes joined together with delicate seams that almost have more in common with sewing and carpentry than they do with traditional ceramics. Her regimented use of repeating forms in ordered systems, together with dark, saturated colours, creates an impression of industrial blandness, reminiscent of the grey factories and multi-storey carparks of her Lancastrian home. However, in the overall movement of these structures, and the spaces in between the intricate lattices, there is a quiet energy, that reflects the place of humanity in the post-industrial world.

Catterall's work deals with containment in all its forms; the hard edges of the triangles and kite-shapes, together form an undulating quilted surface that opens and closes to reveal spurts of activity within the rigid forms. When placed together, the geometric shapes, dark colours, modular contours and staunch outlines merge to capture, restrict and absorb motion and excess. In her *Sheer Tubiform* series, a 'flexible' shield is constructed, where the 'in between' spaces are at once labyrinthine prisons and protective environs—places of captivity and freedom. The *Vine* series on the other hand, takes the form of twisted, abstracted tesseracts that seem to have been blown open, revealing a new inside space. The mathematic precision of the conjoined geometric forms is a statement of harsh restraint and discipline that by virtue of its uncompromising blandness, reveals something quietly sensual.

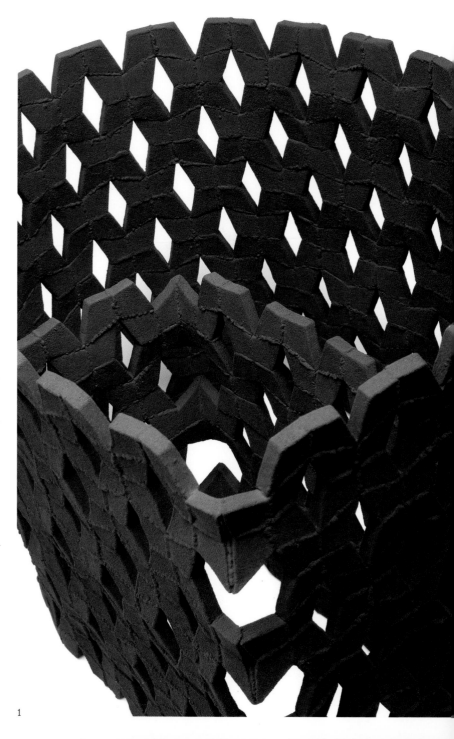

1

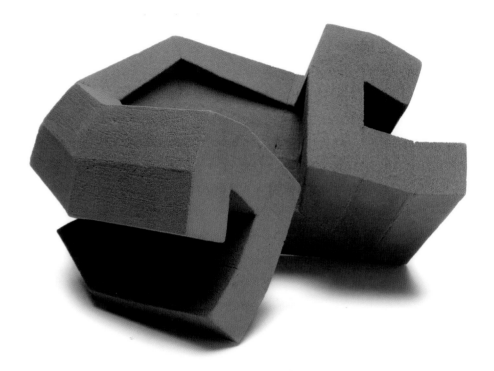

2

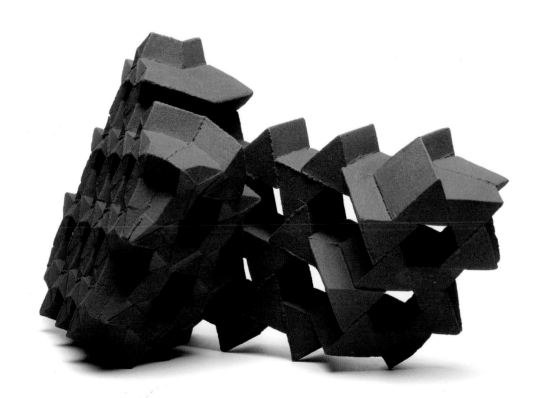

3

Isobel Egan

Born and educated in Ireland, Isobel Egan is one
of Ireland's bright young ceramicists. Her delicate
structures, in exquisitely crafted porcelain, explore issues
of fragility, personal space and memory. Using shards
of material so thin, they could almost be slips of paper,
Egan constructs miniscule environments—abstracted
rooms, cities and houses. Citing the writings of Phyllis
Richardson on architecture, Peter Gray on psychology
and Gaston Bachelard's *The Poetics of Space* as
inspirations for her work, Egan's delicate structures
explore the fragility of life, personal space and memory.

The little box rooms of her sculptures recall the
cardboard box houses and other fantastical environments
of childhood—flimsy structures made robust by force of
imagination. They also suggest trinket boxes and secret
compartments where items of personal value are stored,
or taking this one step further, the places where we hide
our memories. They question the stability and durability
of our homes and our environments, the reality of the
walls that we construct around us. These references
invite the viewer to contemplate their own experiences
of space, childhood and memory. In her own words:
"The box structures are like micro works of architecture.
They represent environments for the nurturing of
imagination…. The walls in these pieces, although
somewhat malleable, represent the essential boundaries
that define personal integrity."

Egan is drawn to the pallor and delicacy of porcelain,
which she enforces by mixing fibres into the porcelain
slip. Many of the structures are balanced on copper
shelves, the worn green of the copper highlighting the
whiteness of the porcelain.

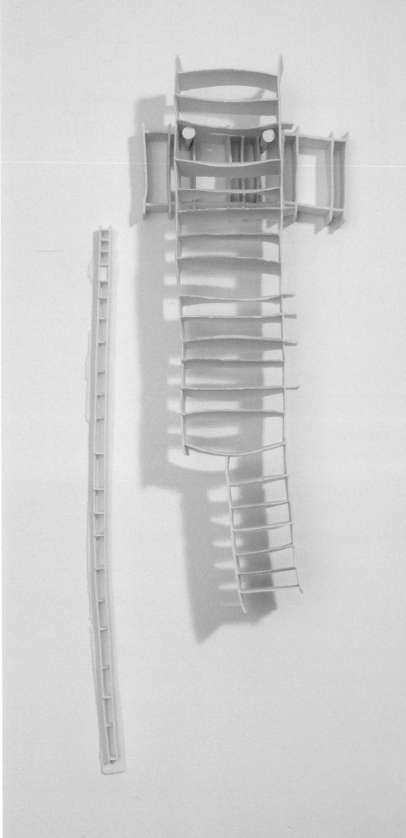

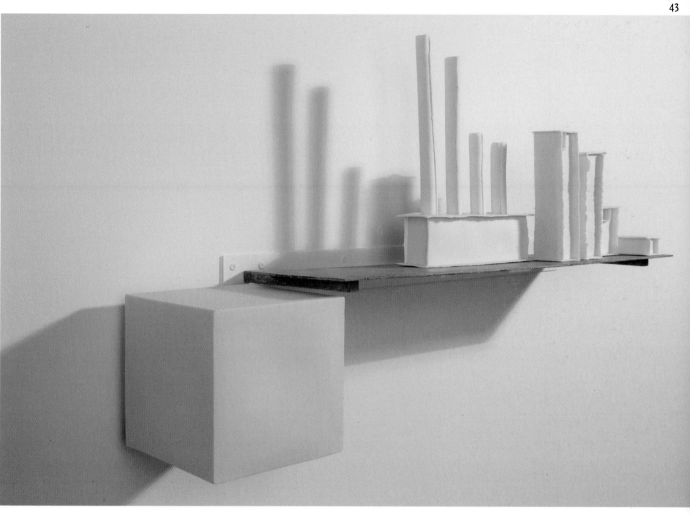

2

3

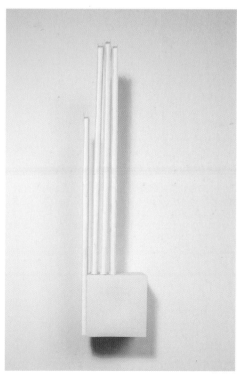

1 From ***Intimate Spaces***, 2005
hand built, slip-cast porcelain (ceramic fibres
combined with porcelain slip)
20 x 50 cm
photograph by Phillippe Lauterbach
2 From ***Intimate Spaces***, 2005
slip-cast porcelain
62 x 29 cm
photograph by Phillippe Lauterbach
3 From ***Intimate Spaces***, 2005
slip-cast porcelain
12 x 55 cm
photograph by Phillippe Lauterbach

Stine Jespersen

Stine Jespersen's work deals with repetition and variation. A graduate of St Martin's College and the Royal College of Art, this Danish artist constructs elaborate pieces by intricately layering small repeating shapes into geometric curves and vessels. Jespersen plays with our expectations of form and her pieces' sweeping curves draw the eye in a variety of unexpected directions. The culturally pre-formed expectations of the viewer—received 'knowledge' of what lines and shapes are supposed to do—allow Jespersen what she calls an "access point", a beginning from which she can manipulate her audience. In *Attempt to Control,* for example, a series of slip-casted porcelain tubes are arranged around an inside 'former' which works as 'the controller' for the inside of the curve, which is cleanly and smoothly arranged. The 'outside' of the curve is allowed to find its own shape, thus leading to a dichotomy of 'controlled and uncontrolled' within a single piece.

This aspect of contrast is even more apparent when the pieces are examined up close. The slight variation between the repeated elements draws the viewer in as he/she discovers the unexpected in the regulated and familiar.

Given the structural nature of Jespersen's work, its clean lines and expert command of shape, it is no surprise that she has, in the past, been commissioned to make jewellery. Jespersen is currently working as an artist in residence at Bath Spa University.

1

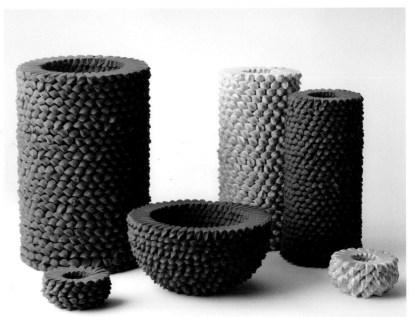

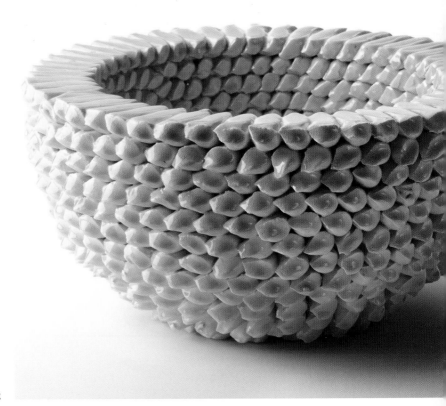

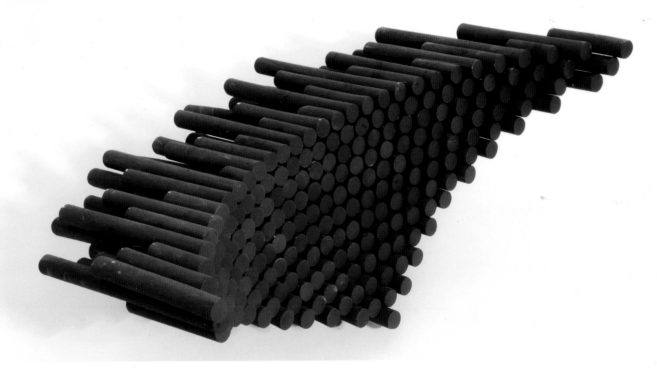

3

1 *Big Black Vase, Yellow Vase, Black Vase and Yellow and Black Bowl*, 2006
earthenware, oxide
35 x 23 cm, 32 x 16 cm, 31 x 15 cm and
13 x 23 cm respectively
2 *Small Yellow and Black Bowl*, 2006
earthenware, oxide
6 x 11 cm
3 *Black Attempt to Control*, 2006
red earthenware, oxide
30 x 53 x 40 cm

Christin Johansson

Christin Johansson's work has an unsettling quality about it. The objects she sculpts look at once familiar and alien—utilitarian and purposeless. The borders between functionality and art are blurred, and the viewer's frame of reference is disrupted. Before turning to ceramics, Johansson worked for many years as a nurse, and the pastel shades and industrial glaze of her pieces suggest a clinical purpose, the handles and holes demanding interaction—like brutal medical contraptions of a bygone era.

The industrial aspects of ceramics are often overlooked when discussing the medium. The waterproof, hygienic properties of glazed stoneware make it a useful material for sanitary purposes. The material can carry with it, therefore, connotations of institutions and by extension authority. By distorting the forms that we are familiar with, but maintaining the overall veneer of authority and establishment, Johansson's work takes on a perversity that carries with it a distinct sexual aura.

Her works have no titles, their anonymity a statement within itself. Their overall ambiguity calls into question the viewer's need to interpret and understand the world. Her work recalls Duchamp's famous *Fountain*. In this piece Duchamp placed a urinal in a museum and stated "this is not a toilet". Johansson put pieces of industrial ceramic-ware in a gallery space and asks the viewer: "Is this a toilet?"

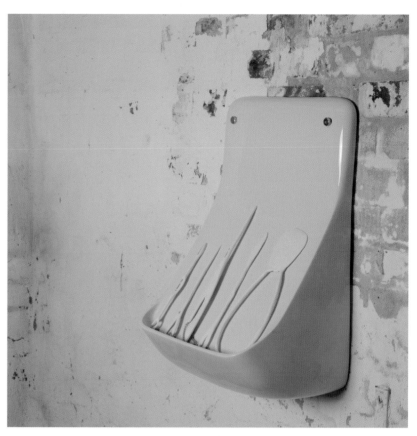

1

1 *Untitled*, 2005
hand built earthenware, car paint
photograph by Kira Brandt
2 Installation with *Untitled Works*, 2005
hand built earthenware, car paint
photograph by Kira Brandt

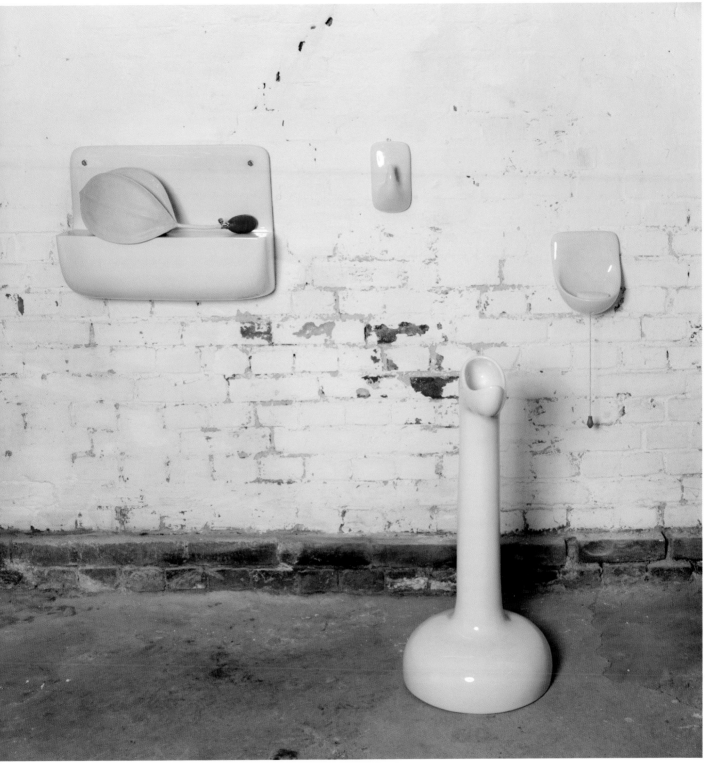

Surreal Geometries
Christin Johansson

3 *Untitled*, 2005
hand built earthenware, car paint
photograph by Kira Brandt
4 *Untitled*, 2005
hand built earthenware, car paint
photograph by Kira Brandt
5 *Untitled*, 2005
hand built earthenware, car paint
photograph by Kira Brandt

3

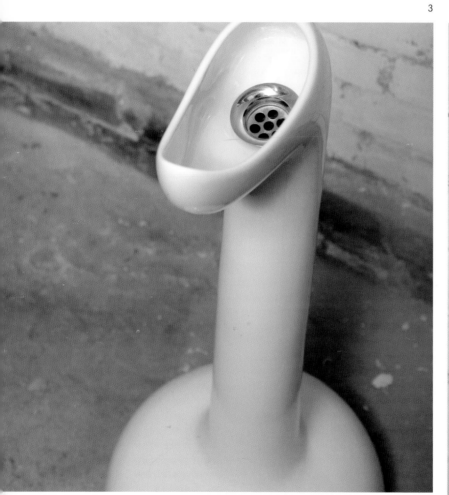

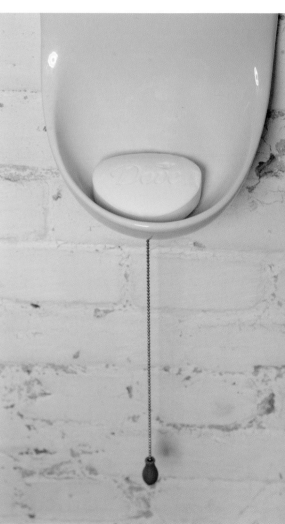

4

5

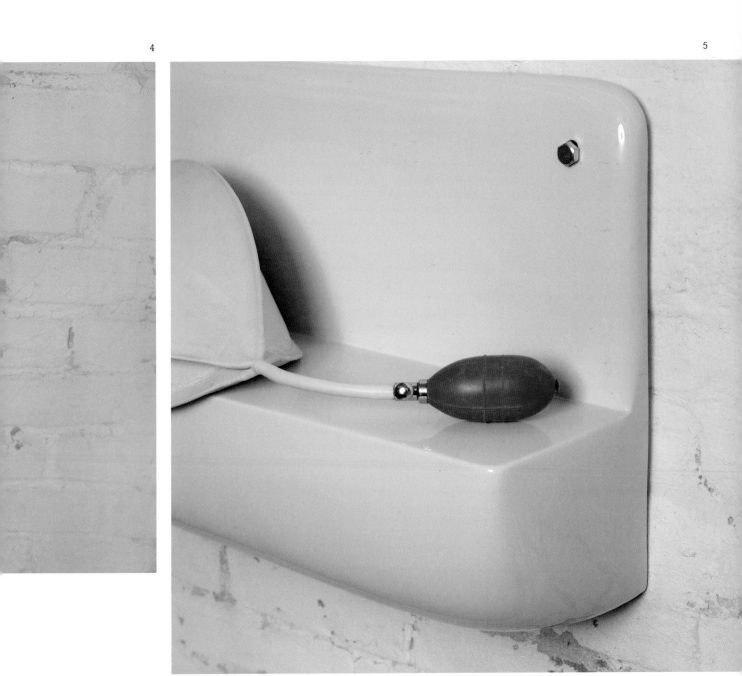

1

Mimi Joung

Mimi Joung's work focuses on the concept of displacement. Born in South Korea, she has lived and studied all around Canada and the United Kingdom, and this nomadic background provides the inspiration for her work. In her *Day Collector* series, lengths of porcelain, embodying anything from a shepherd's crook to a branch, are bundled together, delicately bound in place with knitting wool or an elastic band. In other pieces, she uses a recurring theme of a 'graffiti tag'. Abstracted, distorted letters form a narrative of identity, symbolising the traces and scars that life has left upon the artist and the viewer. This is clearest in *Between*, a wall mounted installation of casting slips and glass tubes, which take on the form of a tear-soaked love letter, the words, bloated and indistinguishable, have to be filled in by the viewer, as they project their own histories and personal interpretation onto the letters. Joung takes the malleability of the material to its natural conclusion. Her work has an almost liquid feel to it, the statements fluid and feminine, a narrative that defies interpretation.

Joung describes her work as a "journey without maps and without a beginning or end". She cites Italo Calvino's book, *Invisible Cities*, as an influence. In a certain passage, Marco Polo describes to Kublai Khan the cities he visited in his expeditions. The narrator and the reader seek resolution in the fragmented non-definitions of his imaginary places. Joung aspires to create a similar ambiguity. The stories she tells are at once her own and those of the viewers. Their conjectures and interpretations become part of the piece, enriching it and lending it depth.

2

1 **Between**, 2006
casting slip, glass tube, nail
300 x 200 cm
2 From the **Day Collector Series**, 2006
porcelain, knitting wool
55 x 16 cm and 58 x 14 cm
3 Four pieces from the **Day Collector Series**, 2006
porcelain
42 x 38 cm

3

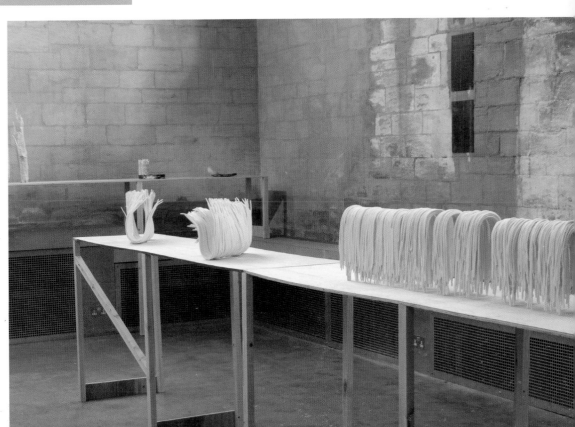

Surreal Geometries
Mimi Joung

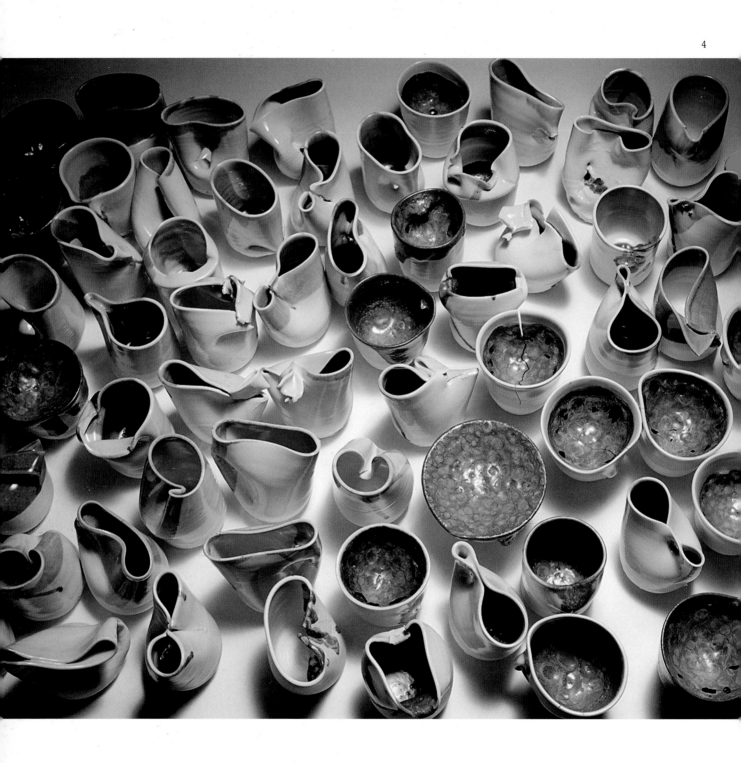

4 From the **Mute-Noon Series**, 2005
porcelain
15 x 6 cm (390 multiples)
5 From the **Day Collector Series**, 2006
porcelain, knitting wool

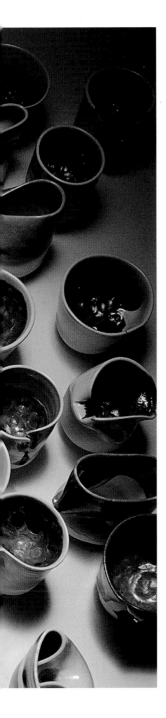

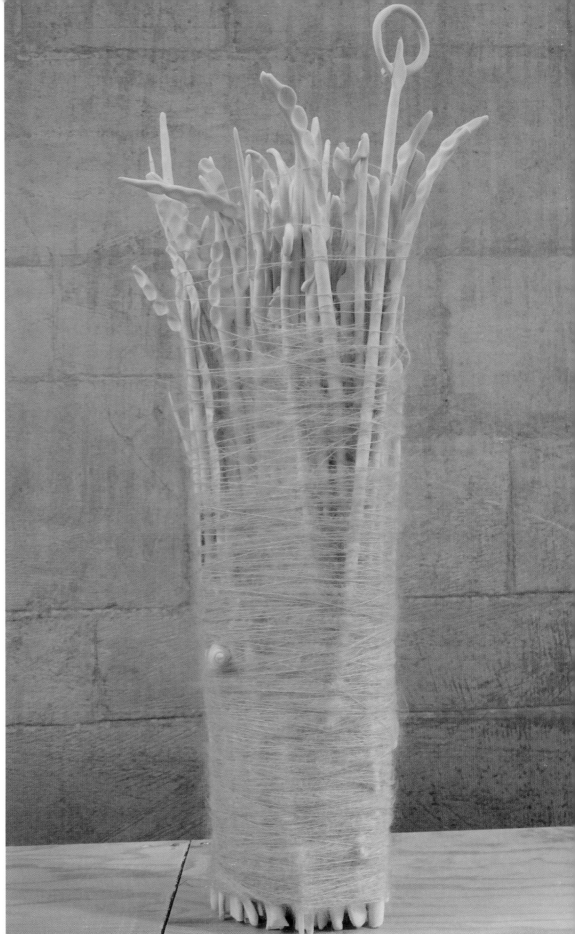

Tae-Lim Rhee

Tae-Lim Rhee's journey to becoming the ceramic artist he is today has been a long and arduous one. In accordance with his father's dying wish, he became a potter in his homeland of Korea. Starting off in a factory environment he made *onggi* pots and sake bowls, but soon grew restless, and set up a small studio workshop making design-based tableware. This too soon wore thin, and he moved to New York to pursue a more artistic approach to ceramics. Here he was exposed to the work of the ceramic Modernists; Hans Coper and Lucie Rie. Inspired, he began to take a more minimal, precise approach to his work. The final breakthrough to his current work came during a trip to Egypt, where the powerful geometric architecture left a deep impression on him.

Rhee now works using computer 3-D modelling and maquettes to find the proportions for his sculptures, and experimenting with mould-making and grinding surfaces to achieve sculptural compositions of precision and balance, as evident in his *Sphere* series. This series of sculptures was inspired by the rounded, eroded stones that Rhee encountered in the Sinai desert. The sculptures are comprised of smooth balls, representing nature, and frame-like structures delineating space. In Rhee's words: "I see spaces in architecture, and just as photographs contain frames, my structures frame space: this is perhaps a fundamental human desire."

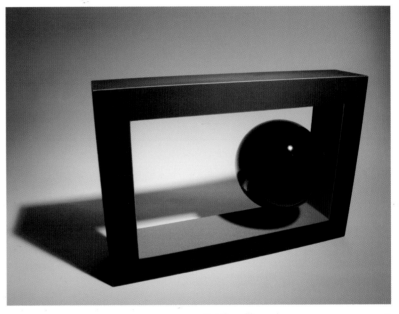

1

1 **One**, 2006
fired clay
76 x 12 x 42 cm
2 Detail of **Architectural Form**, 2005
fired clay
44 x 44 x 32.5 cm

2

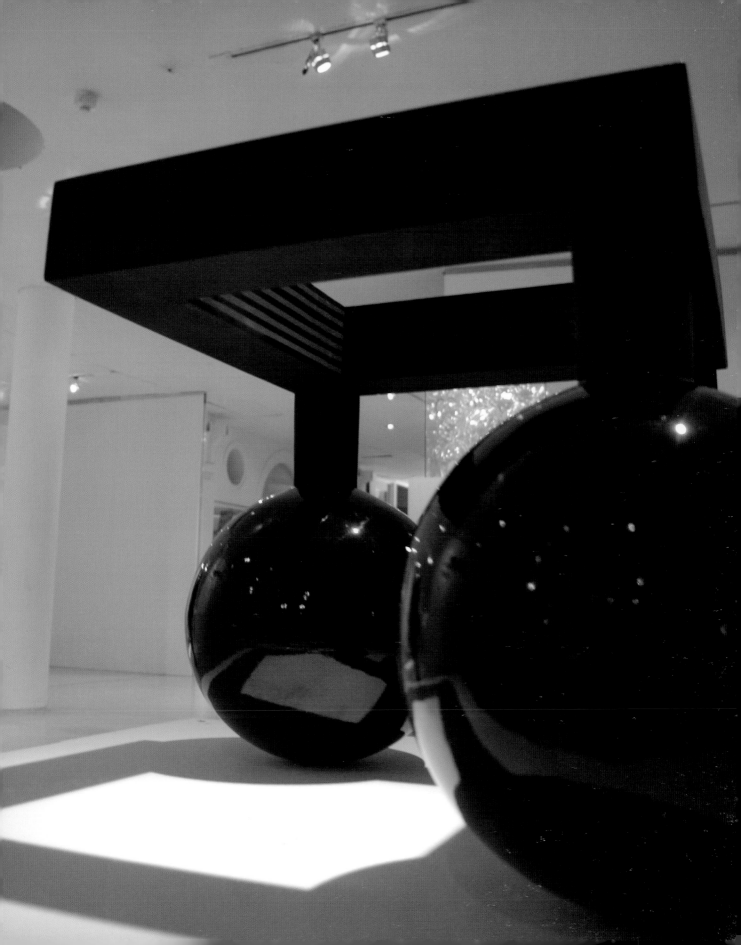

Anders Ruhwald

"I have never worked in any other material but clay", says Danish artist Anders Ruhwald; "I have never painted, never drawn—I am a ceramicist. The history and the context of ceramics are my main frame of reference." Starting as a thrower, Ruhwald established a pottery in Copenhagen making functional stoneware. He has come a long way since then, and his large amorphous sculptures at first impression bear no resemblance to his traditional training. However, taking a closer look, one can see the extent of the craftsmanship that has gone into these dynamic beast-like shapes. Each piece is hand-built, using clay and glazes that he mixes himself. The texture of the clay bears a very human imprint, but the glazes are smooth and rubbery with an industrial feel.

In concept as well, Ruhwald's background is apparent. There is a strange sense of functionality to his work. As though the sculptures are domestic objects and furniture, which have mutated beyond recognition. Imprints of household objects within the clay cement this sense of a familiar subject only just beyond our reach. "My interest is focused on the field where the interaction between humans and the physical environment comes into play.... The individual pieces are embodiments of the fragmented identity that we create through our relationship with the material world." The sculptures seem to float above the gallery floor. Leaning gently on walls and each other for support.

Anders Ruhwald is one of the foremost emerging ceramic artists, and his work has been highly acclaimed at exhibitions around the world.

1

1 *Social Piece of Funiture #4*, 2005
vitreous china, rubbercab, and brass
33 x 130 x 27 cm
photograph by John Michael Kohler Art Center
2 *Piece of furniture #2*, 2005
glazed earthenware, iron tubes, paint, varnished plywood, screws
63 cm

Overleaf
3 *Between Thought and Expression*, 2006
glazed earthenware
58 x 41 x 74 cm and 58 x 43 x 85 cm
4 *Interior #6*, 2006
glazed earthenware
17 x 49 x 12 cm
A Marked Space (Lost), 2006
glazed earthenware
34 x 34 x 34 cm
5 *Interior #5* , 2006
glazed earthenware
70 x 31 x 32 cm
Prop, 2006
glazed earthenware, vinyl, painted steel tube, plastic cap
56 x 91 x 80 cm
photographs by Søren Nielsen

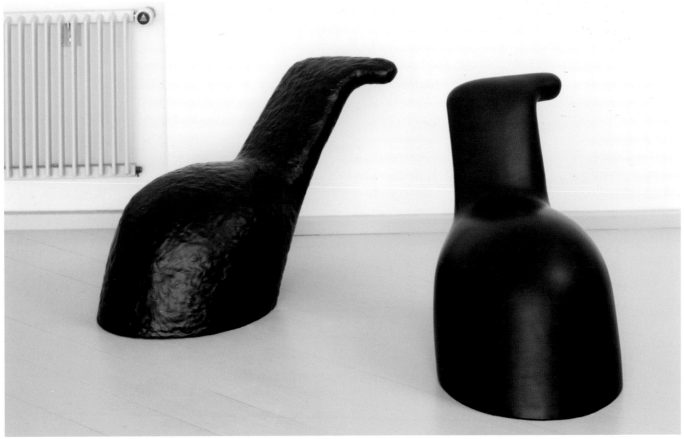

3

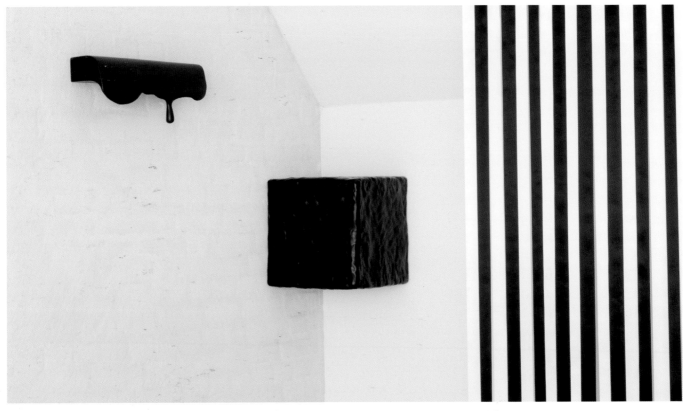

4

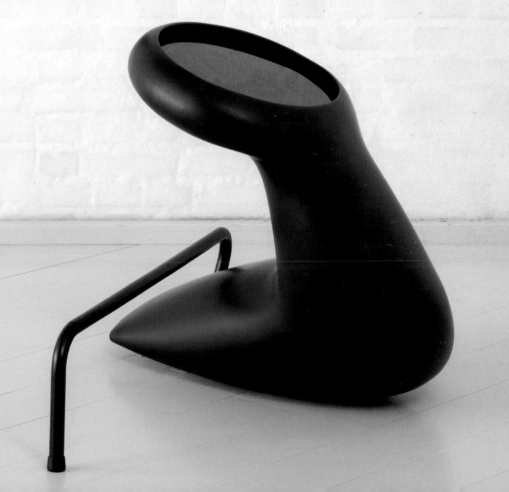

Richard Slee

One of the most celebrated ceramic artists in Britain, Richard Slee's work ties into the deep decorative and ornamental heritage of Northern England. Drawing inspiration from post-Victorian kitsch, Slee's work is a fond reference to the escapist, idyllic suggestions of those novelty *objets d'art*. Highlighting the importance of these personal effects, Slee suggests that our daily contact with domestic ornaments makes them equally worthy of consideration as any piece of high art.

Slee cites early Disney animation as a key influence and that dark magic is evident in much of his work. Bold, solid colours and slick glaze give his pieces a cartoon-like quality that occasionally sits uneasily with the political and sexual overtones of some of these pieces, often highlighting the humour of the subject matter. *Dog* is simply a sculpture of a phallus that turns into a nose, upon which is placed a rubber nose mask. *Dog (Naked)* is an identical sculpture, except that the mask is now placed alongside the sculpture. The free, playful, almost child-like surrealism of this type of work is reminiscent of Dadaism and Fluxus.

Richard Slee has been working as a studio ceramic artist for over 30 years, and was one of the first ceramicists to call into questions those boundaries between craft and fine art. He is currently a professor and lecturer at the London Institute and Camberwell College of Arts.

1 *Dog*, 2005
ceramic, rubber nose, elastic
26 x 7 x 7 cm
photograph by Philip Sayer
2 *Dog (Naked)*, 2005
ceramic, rubber nose, elastic
26 x 7 x 7 cm
photograph by Philip Sayer

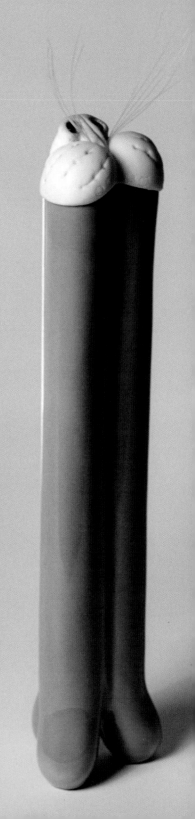

Surreal Geometries
Richard Slee

3

3 **Mushrooms**, 2006
ceramic, pewter dish, frying pan
9 x 45 x 26 cm and 8 x 23 x 16 cm
photograph by Philip Sayer
4 **Stamper**, 2005
ceramic, metal stamper
135 x 14 x 14 cm
photograph by Philip Sayer

Maxim Velcovsky

Czech designer Maxim Velcovsky makes functional ceramics with a quirky twist. Drawing on the sea changes that swept his country before and after the dissolution of the iron curtain, his work is a comment on the excesses of consumerism and the reverence of Eastern countries for the culture of the West. In his *Moneybox* collection, kitsch ornaments traditionally produced in Soviet Czech porcelain factories, have been reproduced as moneyboxes. There is only a slot at the top of the moneybox, and no way of removing the cash apart from smashing the object. The consumer has to choose which is more valuable—the moneybox or the cash inside. In *Ornament & Crime,* a bust of Lenin is mass-produced in industrial porcelain, with a Delft print.

There is a contrariness to much of Velcovsky's work—a stubborn refusal to accept the norms of function and form. In *Waterproof Vase,* a Wellington boot is cast in porcelain. A form that is associated with keeping water out, is now used to keep water in. His decision to mass-produce his highly conceptual works—to present them as design rather than art—was a conscious one. The unchanging palette of communist design, suddenly breaking into the enormous variation that there is today, highlighted for him the impact that design has on society. His father was an artist, and he felt strongly that art was too insulated from the rest of the world for him: "I always thought that it's nonsense to divide, for people to be artists and applied artists and fine artists."

His work is locally produced in Czech porcelain factories, and is sold around the world, as well as in Qubus, the Prague-based studio and shop that he established.

1

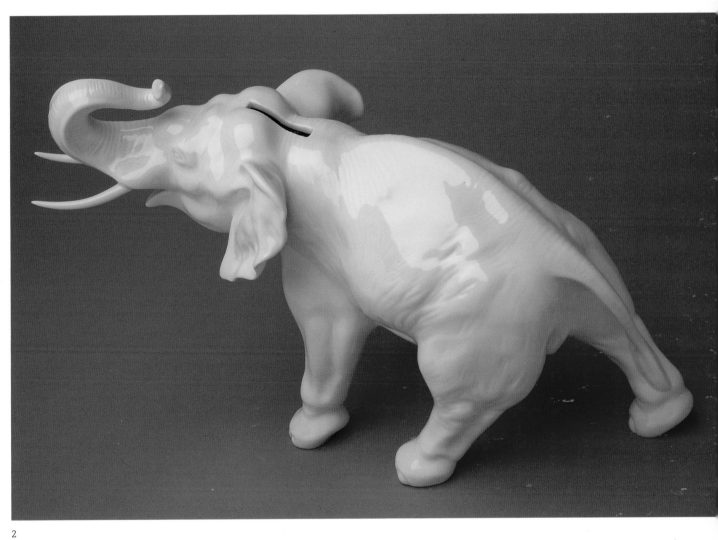

2

1 **Bird Moneybox**, 2005
porcelain
17 x 30 x 17 cm
photograph by Marek Novotny
2 **Elephant Moneybox**, 2005
porcelain
50 x 25 x 30 cm
photograph by Marek Novotny

Surreal Geometries
Maxim Velcovsky

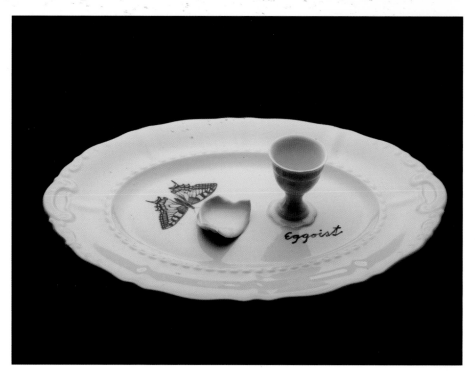

3

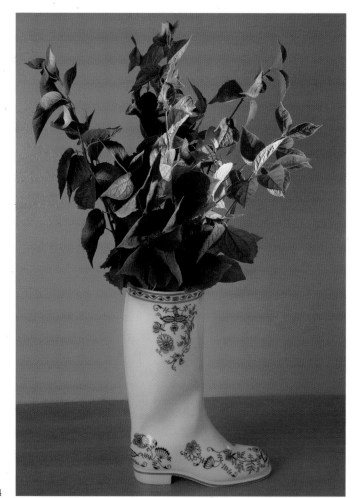

3 *Eggoist*, 2006
porcelain, limited edition plate
photograph by Gabriel Urbanek
4 *Waterproof Vase*, 2002
porcelain
14 x 7 x 38 cm
photograph by Marek Novotny
5 *Ornament & Crime*, 2001
porcelain
19 x 29 x 28 cm
photograph by Garbriel Urbanek

4

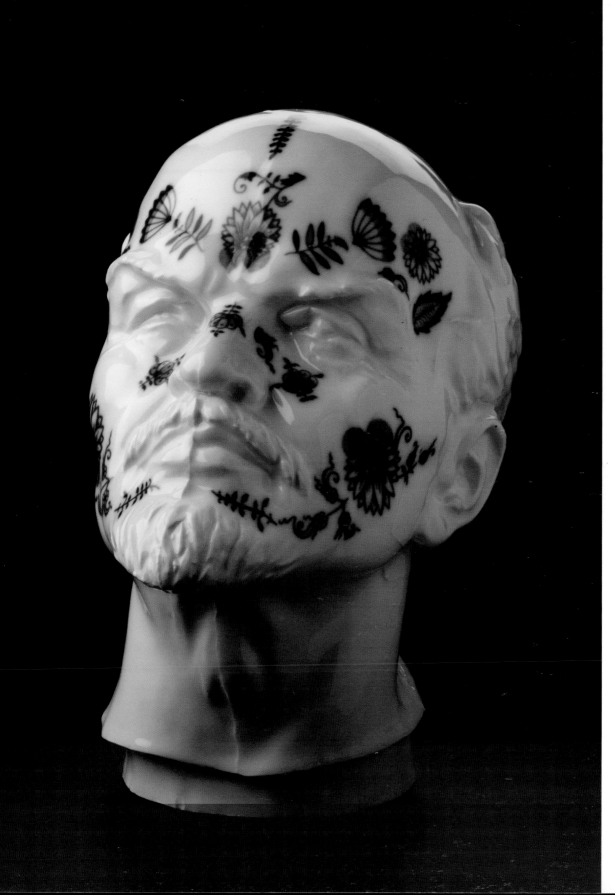

Human Interest

Daniel Allen
Barnaby Barford
Tiziana Bendall–Brunello
Claire Curneen
Edith Garcia
Justin Novak
Damien O'Sullivan
Conor Wilson

Daniel Allen

Daniel Allen's life-sized figures are at once playful and disturbing. Largely autobiographical, the sculptures are sometimes richly glazed, and sometimes left bare, representing different aspects of the artist's personality. They resemble dolls, puppets and clowns, posing on their own or in a tableau, projecting their pride, humility, insecurity, masculinity and self-awareness to the viewer. "The figures are always posing. I am dressing myself up in role play", says Allen of his work. The frozen gestures give the figures an air of anticipation—of waiting for something to happen—a response or a judgment of sorts.

Working with a combination of glazes, overlaid with ceramic transfers, often of Pre-Raphaelite romaticised images of cherubs and landscapes, as well as Renaissance paintings, he positions his work and ceramics in general in a fine art context. In *Self Portrait with Chair*, the images on the chair have seeped up the arm of the artist, the two caught in the process of becoming a single object. In other pieces, such as *Self Portrait with Ears*, *Curtain Call* and *Fashion Victim*, glazes and slips are casually splashed across the figures, highlighting the ridiculousness and tragedy of the human condition, and blurring the distinctions between external and internal perception.

Daniel Allen lives in Wales, and works at the University of Glamorgan as well as running Fireworks, a co-operative ceramics studio that he established in 1995.

1 **Curtain Call**, 2004
stoneware, paperclay, barium slip, enamel
110 cm
2 **Self Portrait with Ears**, 2004
stoneware, paperclay, barium slip
130 cm
3 **Self Portrait with Chair**, 2004
stoneware, leadless glaze, glass eyes, ceramic decals
120 cm
4 **Fashion Victim**, 2003
stoneware, lead glaze
85 cm

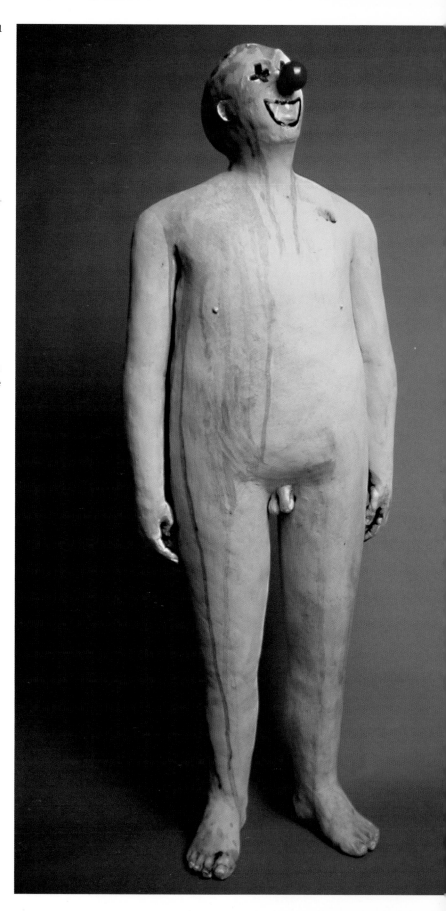

2

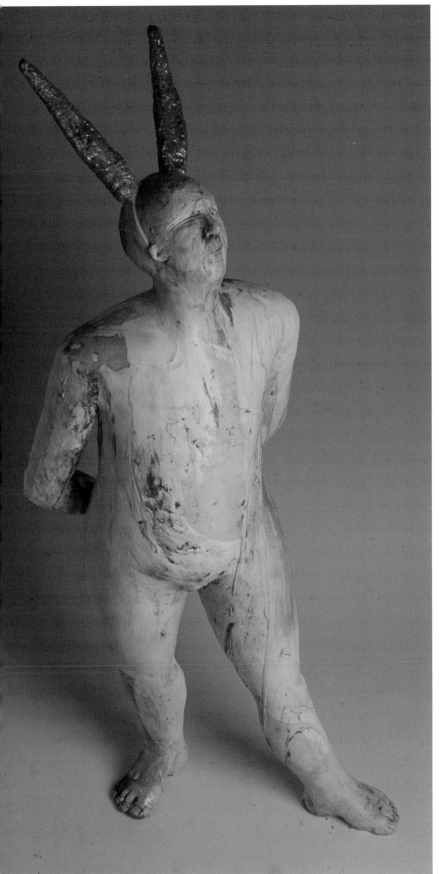

3

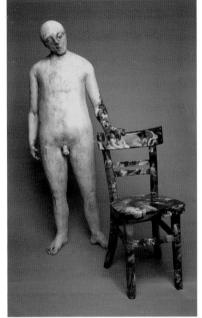

4

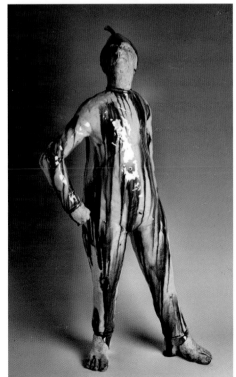

Barnaby Barford

Barnaby Barford takes a unique approach to his
work with ceramics. Despite being an accomplished
craftsman, Barford chooses to work primarily with
found objects, rather than raw ceramic material. Starting
off with a selection of mass-manufactured figurines and
antiques, he starts to chop and change them—adding
pieces on, and gluing them together to create sinister
and deeply ironic tableaus. A cat lies playfully on its back
sporting a lurid pink erection in *Mum! The Cat's Doing
That Thing Again*. In *Oh Mummy, Please Can We Keep It*,
a mother and two children dressed like Ronald McDonald
stand around a comic-book cow, beneath the arches
of the trademark 'M'.

By using kitsch sentimental figurines as the characters
in these twisted narratives, Barford is turning their
perceived vulgarity on its head—into a different, more
explicit vulgarity. The hackneyed sensibility of traditional
ornament becomes the language of political and personal
protest. A procession, a story, a new conglomerate is
the result. Tradition is reworked and edited. The viewer
identifies a familiar object, but must engage with its
context, because it is so foreign to that which he/she is
familiar with. The phrased titles are an implicit part of the
work—they clarify this new context. There is no room for
misinterpretation, and the impenetrable loftiness of fine
art is countered by the accessibility of the statements
and the low art nature of the objects.

2

1 *Mum! The Cat's Doing That Thing Again*, 2006
porcelain, bone china, milliput, enamel paint
17 x 10 x 10 cm
2 *Oh Mummy, Please Can We Keep It*, 2006
porcelain, enamel paint, painted wooden base
31 x 42 x 42 cm

Human Interest
Barnaby Barford

3

3 *Pay Up! Did You Think You Could Get In For Free?*, 2006
earthenware, wooden frame, enamel paint, mirror
70 x 45 x 12 cm
4 *Shit! Now I'm Going To Be Really Late!*, 2006
porcelain, milliput, enamel paint, painted wooden base
38 x 43 x 31 cm

4

Tiziana Bendall- Brunello

Using porcelain as her primary medium, Tiziana Bendall-Brunello creates flowing children's garments, with accentuated folds. Reminiscent of Italian Rennaissance sculpture, these delicate structures have an eerie, fossil-like quality to them, their empty shapes representing the movement and the fragility of what is not there—the human body.

Born and raised in Italy, Bendall-Brunello cites Italian sculptor and conceptual artist of the Arte Povera movement, Guisseppe Penone as her main influence. In particular, she says his *Breath* series, in which he defines the body by the space surrounding it, has been an inspiration for her work. Bendall-Brunello's pieces portray the body as an architectural form, with the clothes as facade in which the form is contained. They mourn the fleeting nature of childhood and eternalise its innocence. In *Proud*, the absent model is puffed up with infant satisfaction, the movement of the dress indicating a moment of joyous confidence.

To create her pieces, Bendall-Brunello dips actual dresses in porcelain slip. In the kiln, the fabric of the dress is incinerated, leaving only its porcelain impression. She then uses a wooden modelling tool to accentuate the natural folds. The process is labour intensive, and four out of five sculptures crumble in the kiln. More recently Bendall-Brunello has made use of these shards in combination with glass, to create fractured impressions of the dresses. Her work has been exhibited in London, New York, Chicago, Germany and Italy.

1

2

1 **Proud**, 1999
porcelain
35 x 30 x 12 cm
photograph by James Austin
2 **Baby Shoes**, 1999
porcelain
8 x 12 x 7 cm
photograph by James Austin

Claire Curneen

Claire Curneen's melancholic, reflective figures are inspired by the spirituality and folklore of her Irish Catholic upbringing. Her work explores the fragility of the human condition and the constant quest for spiritual fulfillment. Her stylised characters, which she describes as "vessels for the spirit" are at once deeply emotive and strangely anonymous, their naked simplicity conveying a contemplative essence that is hard to pin down.

In *Angel and Tree* and *St Sebastian*, the Catholic connotations are clear, and a fascination with martyrdom, with self-restraint, and by extension self-sacrifice is apparent. In *Self Portrait*, the luscious gold spot glaze dripping down the face and the hands also implies holiness—a baptism or a blessing. The abrasive surface of the clay seems to be in direct opposition to the smooth patina of the glaze—the earthly and the sacred contradicting and simultaneously complementing one another. As well as human figures, a recurring motif in Curneen's work is trees; their powerful, primitive forms conveying a sense of magic and wisdom. In *Figure In Branches*, the tree surrounds the figure, simultaneously restraining him and becoming part of him—man and nature finding an awkward peace with one another.

Curneen works primarily with terracotta and porcelain, rolling the individual pieces of the sculptures in her hands. The result is an eerie skin-like effect, with gentle bulges and wrinkles. The thin slivers of clay that she uses often crack in the kiln, enhancing their fragility, allowing the viewer a glimpse into the darkness beneath.

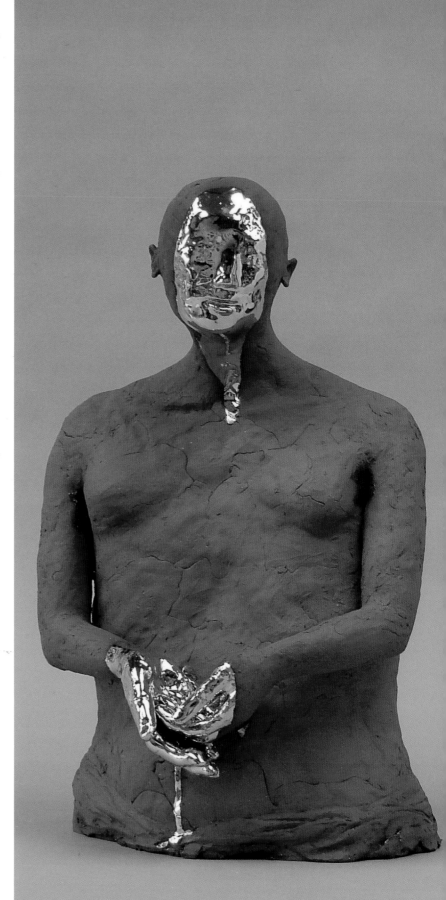

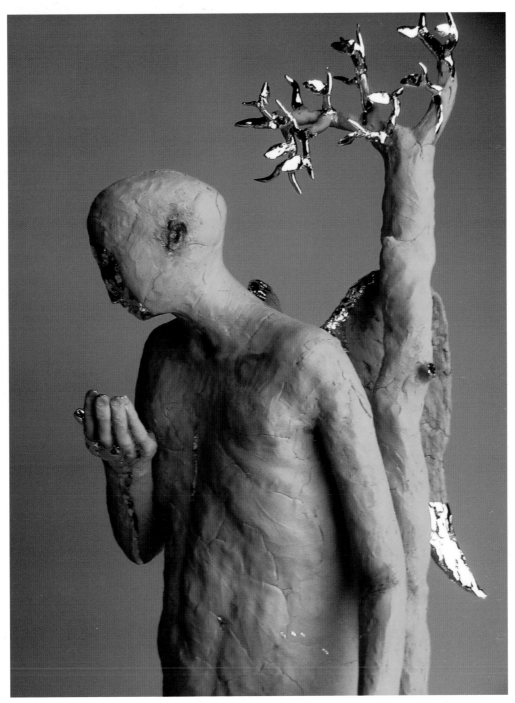

2

1 *Self Portrait*, 2005
terracotta, gold lustre
50 cm
2 *Angel and Tree*, 2006
terracotta, gold lustre
85 cm

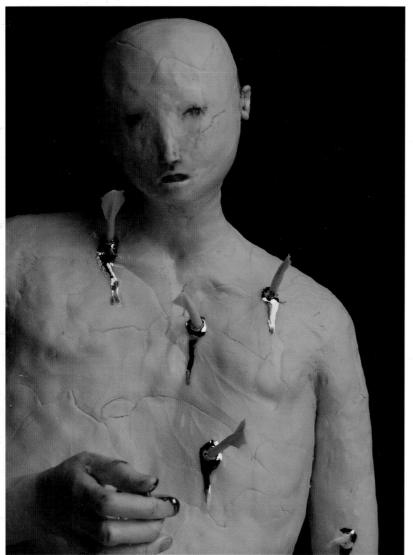

3

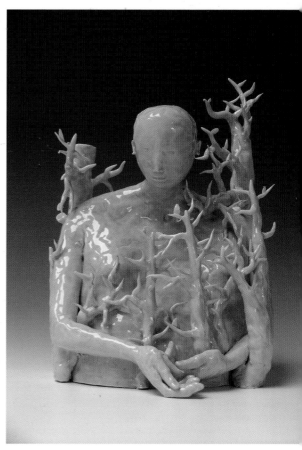

4

3 *St Sebastian*, 2005
porcelain, terracotta
4 *Figure In Branches*, 2006
porcelain, celadon glaze
5 Detail of *Iznik*, 2004
porcelain, earthenware clear glaze, gold flower decals, blue lustre

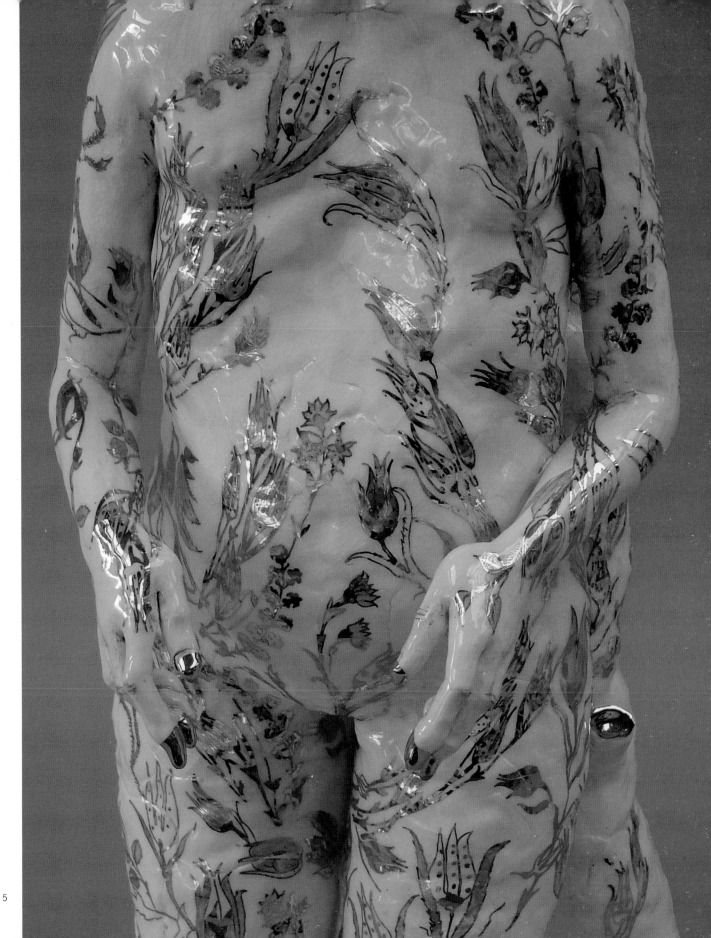

Edith Garcia

Edith Garcia's sculptures, figurines and large-scale installations have a dream-like quality to them reminiscent of Latin American Magic Realism, so prevalent in literature, but less common these days in the visual arts. Her pieces deal with aspects of the human condition—the amorphous fears of childhood, the building blocks of self-control and self-esteem, nostalgia, dislocation and the beasts we harbour within. Using a unique combination of painting and ceramic sculpture, she translates her personal experiences and emotions into surreal animal-human hybrids, distorted, magnified body parts, eerie, childlike representations of houses and abstracted figures with cactus-like heads and curling rope shackles around their legs.

In her earlier work, such as *Soy Yo* (*It's Me*), a permanent installation was constructed, consisting of 500 porcelain black and white doilies mounted on the ceiling of an outdoor structure. The piece examined memories of home, and the relevance of idealised domesticity. In *Milk-ed*, a series of heads morph into udders, accompanied by the faint sounds of suckling—a visceral illustration of the evils of exploitation. In her more recent *Displaced Series*, she explores "our everyday animals or our monstrous selves". In this collection of figurines, mutant humanoid-beasts ooze subversive sexuality, challenging the viewer to examine the aspects of themselves they suppress in order to accommodate the pressures of civilised society.

Born in Los Angeles, California, Garcia has studied in Mexico, Florence and California and exhibited extensively throughout the United States, Europe and the United Kingdom.

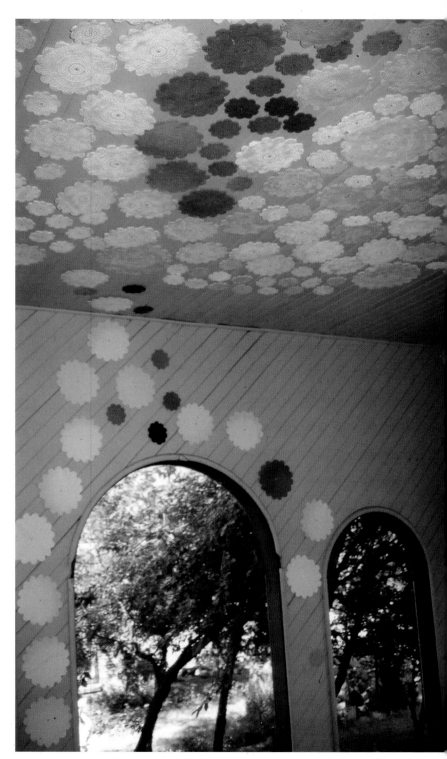

1

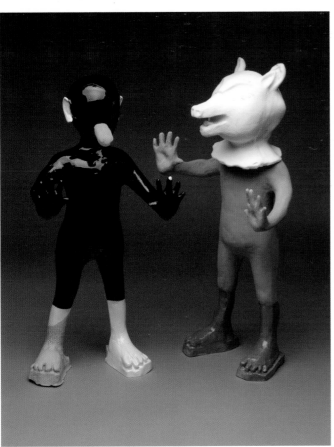

2

1 *Soy Yo/It's Me*, 2001
black and white porcelain
2 *Fearless II*, 2006
slip-cast clay and cast silicone
15 x 33 x 10 cm
photograph by Jerry Mathiason
3 Detail from the ***Milk-ed*** installation, 2002
raku, leech white and celadon glaze

3

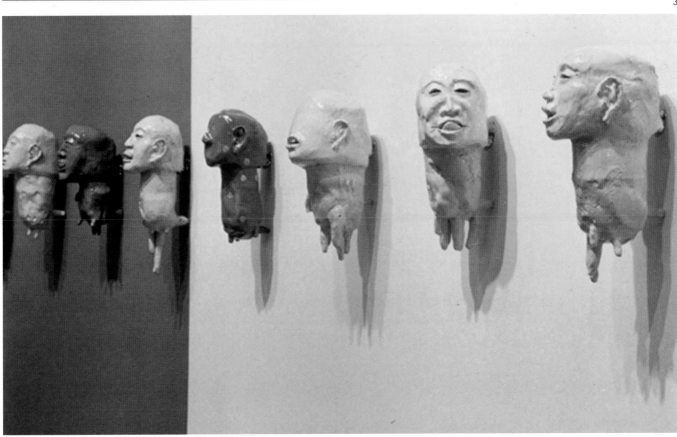

Justin Novak

Porcelain figurines, argues American artist Justin Novak, are representations of the conformist ideals which promote a vision of bourgeois identity. Drawing on the opulent traditions of the early eighteenth century Rococo period, Novak uses the same aesthetic to craft savage, visceral figures for expressly the opposite purpose. The graphic physical wounds of his *Disfigurine* series are a metaphor for the psychological damage inflicted by a dominant ideology that stifles difference. By exposing this damage, his work not only outlines his radical political agenda, but also forces the viewer to rethink the subtle politics of familiar decorative sculpture; what it says and fails to say under the veil of apolitical beauty. His work also mirrors directly the rhetorical strategies associated with beauty in these traditional figurines, such as the placement of the protagonist on an ornamental pedestal or their use of strong, emotive gestures. As Novak himself explains, "The fact that these traditional conventions of beauty have been compromised by their service to racist and sexist rituals of the past only renders them potent aesthetics with which to explore enduring societal rituals, or brand new ones."

What lies behind such an openly political and subversive look at the meaning of figurines is a conscientious belief in the importance and power of the decorative tradition. Novak's work, therefore, promotes a holistic socio-cultural outlook in which even art that claims not to serve a political purpose must be seen in the context of the power structures that surround it.

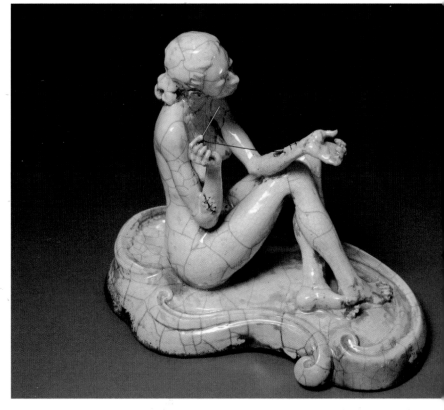

1

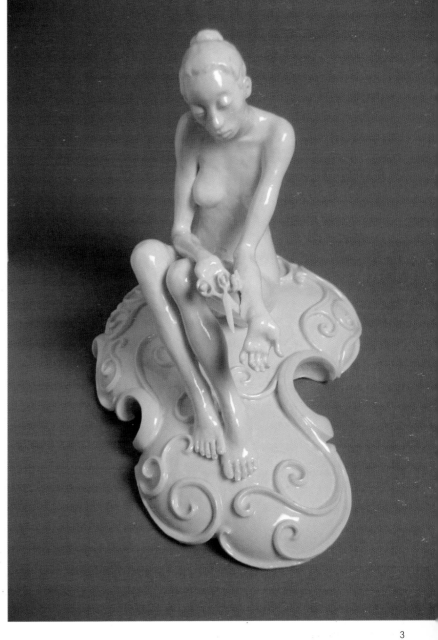

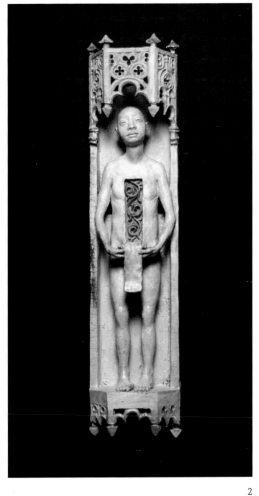

2

3

1 *Disfigurine 46*, 2006
Raku-fired ceramic
22.9 x 27.9 x 20.3 cm
2 *Canopied Figure 7*, 2000
Raku-fired ceramic
61 x 15.2 x 12.7 cm
3 *Disfigurine 32*, 2004
porcelain
33 x 25.4 x 40.6 cm

1

Damian O'Sullivan

Pity them who have broken their leg, not for the inconvenience of their condition, but for the sheer ugliness of the prosthetic devices they have to contend with. Why can't we offer more solace in such moments of need, be exalted to latter-day-dandies instead of having to traipse around with such plastic contraptions.

Damian O'Sullivan

When Damien O'Sullivan's grandfather broke his hip, the imposed indignities of age and disability were literally embodied for the artist in the ugly, inhuman plastic crutches his grandfather was made to use. O'Sullivan's *proAesthetics* attempts to address the disparity between the impersonal aesthetics of prosthetics and their very human function. In this series he produces casts, braces and crutches out of delicate floral-patterned porcelain. The innovation lies not in the shape of these aids, but in the material. The result is more poetic than practical; the strength yet fragility of the porcelain reflects that of the human body, the delicate patterns mirroring the beauty of the healing process. The broken bones become not a thing of shame but of pride. Upon healing, the objects are not cast aside, but displayed in china cabinets—the scars of our mortality are presented as things of beauty.

O'Sullivan runs his own design agency, Damien O'Sullivan Design, in Rotterdam, and works with a broad range of mediums on both functional and conceptual projects including solar lamps, water sculptures and a perfume bottle. His good-humored, warm approach is apparent in all his work.

2

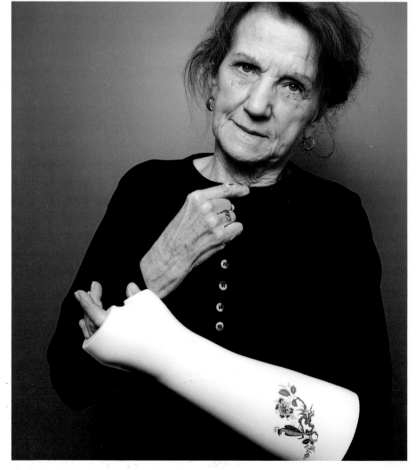

1 *Elderly Lady With Porcelain Crutch*, 2003
porcelain
photograph by Adriaan van der Ploeg
2 *Elderly Lady With Arm in Porcelain Cast*, 2003
porcelain
photograph by Adriaan van der Ploeg
3 *Elderly Man With Porcelain Eyepatch*, 2003
porcelain
photograph by Adriaan van der Ploeg

Conor Wilson

Conor Wilson's work relates to the human form, in particular the male form, and how it can become manifest in the objects we use on a daily basis. His fetishistic sculptures are highly finished, perfectionist creations with smooth industrial glazes, and clean, geometric lines and shapes.

Works such as *Holster*, a highly phallic meat-cleaver type object and *LemonSqueezer*, a juicer with clear connotations of both male and female genitalia, indicate a function that is both mundane and deeply sexual. These works are indicative of Wilson's fascination with the apparent 'maleness' of particular objects and how this can transform an ordinary object into one of dominance and violence. This interplay, combined with what he perceives to be the vulnerability of the human form, forms the crux of his work. Wilson also addresses the act of making itself, specifically how the combination of tradition and technology can be used to create a contemporary aesthetic that connects sexual desire to creation, to cooking, to every aspect of our daily lives. There is a playful cheekiness in Wilson's work. The viewer must imagine or at the very least, wonder what the alternate uses of the objects could be. In doing so, he/she enters into a dialogue of voyeurism, engaging with and completing the creative process.

Wilson's interest in creating functional works has also resulted in brick reliefs for the doorways of City of Bristol College, and ceramic seats for Oldown County Park, Gloucestershire. In the mid-1990s he collaborated with architects to establish a studio geared towards the production of large-scale ceramic objects. His work has been exhibited in galleries worldwide.

1

1 *HandController*, 2003
black clay, white slip, beeswax
14 x 8 x 6 cm
2 *LemonSqueezer*, 1998–2001
white clay, yellow glaze, gold lustre
35 x 35 x 23 cm
3 *Holster*, 2003
white clay, beeswax
30 x 12 x 6 cm
4 *Shubutt (prototype)*, 2002
white clay, pink glaze, digital imagery
28 x 33 x 18 cm

2

3

4

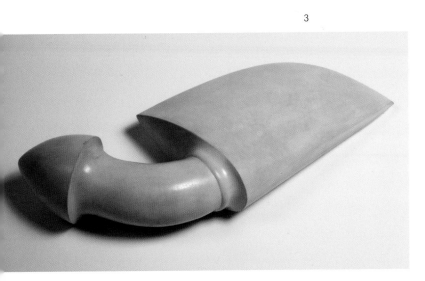

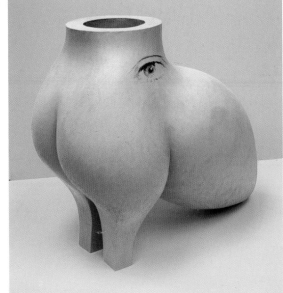

Earthly Inspirations

Elaine Hind
Suzanne King
Margaret O'Rorke
Deborah Sigel
Chris Wight
Annie Woodford

Elaine Hind

Based on the forms of flowers, coral and shells that caught her imagination in childhood and through to today, Elaine Hind's delicate structures are quiet meditations on the forces and energies of the natural world. Using delicate porcelain (or a porcelain/T-material mix), she illuminates the structures from within, creating pieces that occasionally function as a light source, and at other times provide a purely ambient focal point for a room. She describes herself as being "firmly in the decorative arts category", and her pieces are as simple, self-contained and aesthetically appealing as the flowers and sea creatures they are based on.

To create these intricate compositions, Hind uses a combination of throwing, slip-casting and slab-building. She incorporates different materials, such as glass and patinated copper, into her process, and covers the final piece in a semi-matte dolomite glaze, with additions of oxide and under-glaze colour, which she applies on top of the glaze.

Her most well-known series, the *Leek Flower* lamps, represent the leek flower in full bloom with their big, illuminated heads balanced on tall, articulated stalks. Continuing this blossom theme, her most recent work, *Seed Heads*, was inspired by the geometric constructions of everlasting flowers gone to seed.

The Sudbury Hall Collection, The Rutherstone Collection of Manchester City Art Gallery and the Birmingham Museum and Art Gallery have all collected pieces of her work, and her work is regularly on display at Cecilia Coleman's Gallery in London.

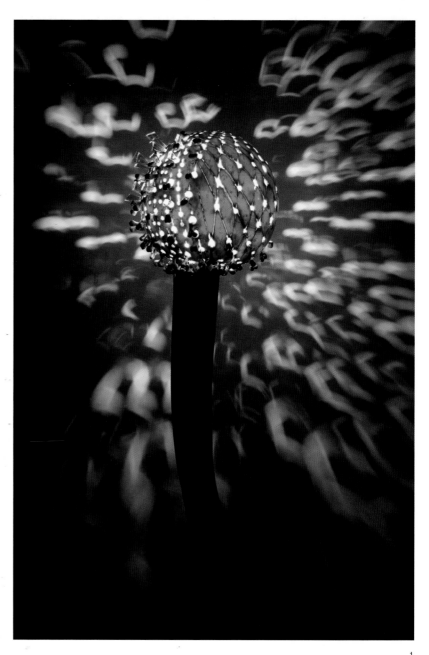

1

1 *Leek Flower Lamp 1,* 2005
porcelain and glass
92 cm
photograph by Just Lovely
2 *Detail of Seed Head Lamp,* 2006
porcelain
26cm

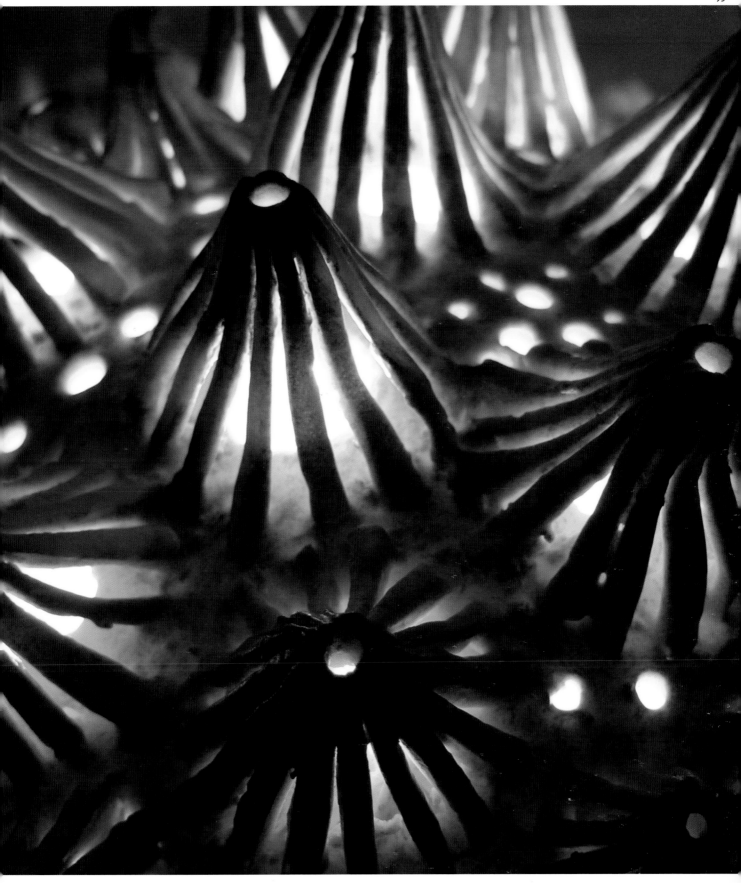

1

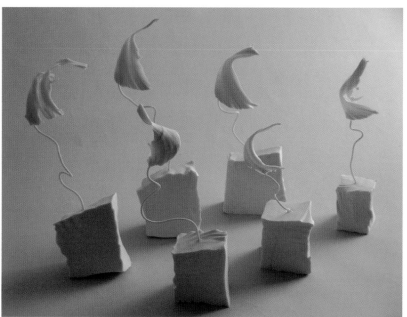

Suzanne King

Based in the historic spa town of Bath, Suzanne King aims to "demolish the barriers between craft and painting" following a method that she describes as "drawing in clay". As such, King does not suppose that she can completely master her material but instead seeks to allow the clay to keep some of its mystery, its unfulfilled potential, and allow the medium itself to make its own impression on the final shape. This is coupled with a frenetic approach to work, making numerous pieces quickly and discarding a large number of them. This commitment to spontaneity, to capturing the movements and gestures of the artist in the moment of creativity, reflects King's background in dance. Her pieces are reminiscent of the leaps and turns of a dancer in motion, and capture the same fusion of grace and speed. King's interest lies not just the visual characteristics of a dancer—her pieces are abstracts rather than figurative representations—but the sense of freedom involved in dancing itself, of being what she calls "transported", the rush of "those moments in time when one feels more intensely alive", and her work conveys the complex mix of emotions that the dancer communicates to those looking on.

In *Turning*, for example, the horizontal stripes of colour, makes the piece seem like a lump of stone, seamed with threads of flint, and at the same time, the sweeping curves of the clay create a sense of movement. This paradox of massivity and grace lies at the heart of King's pieces; the forces of nature—gravity, physicality—versus the ethereal flight of the soul.

2

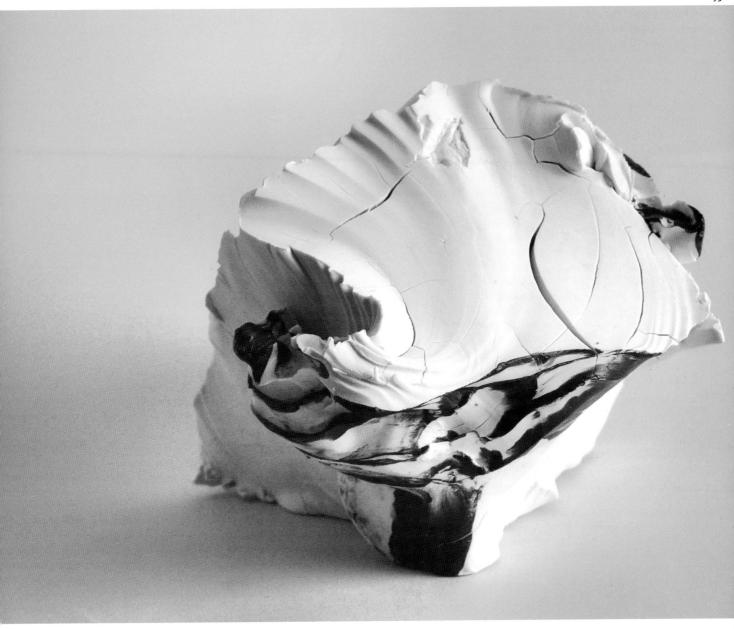

3

1 *Small Dancers*, 2005
porcelain
17 x 5 cm
2 *Silence*, 2005
porcelain
28 x 20 cm
3 *Turning*, 2005
porcelain
19 x 17 cm

Margaret O'Rorke

Potter Margaret O'Rorke utilises the translucent nature of high-fired porcelain to create delicate, minimalist lighting installations from her business studio, Castlight. O'Rorke takes inspiration from the societies and natural environments that she has encountered in her extensive travels around Scotland, Japan, Denmark, India and Australia. Nature permeates her work, from the direct replications of *Bamboo Wall* and *Stack of Sea Forms* to the more subtle use of organic lines and forms seen in *Waves*, and her work radiates the vitality and movement of these inspirations. Using artificial lighting to illuminate them from within, the porcelain gives off an ethereal glow, with the result that the structures become at once natural and other-worldly.

This connection between the material (porcelain) and the immaterial (light), allows her work to project softly beyond its physical limits and form a reciprocal relationship with its surroundings. The place in the room from which the viewer observes the piece changes the effect that the piece commands, which itself further changes the way the room is perceived. This is what O'Rorke describes as "a sense of adventure with light and space", a playful bond between art and its surroundings.

O'Rorke's work has won wide acclaim and she has exhibited at Galerie Besson and Sotheby's Galleries and in the 2007 *Collect Show* at the Victoria and Albert Museum in London.

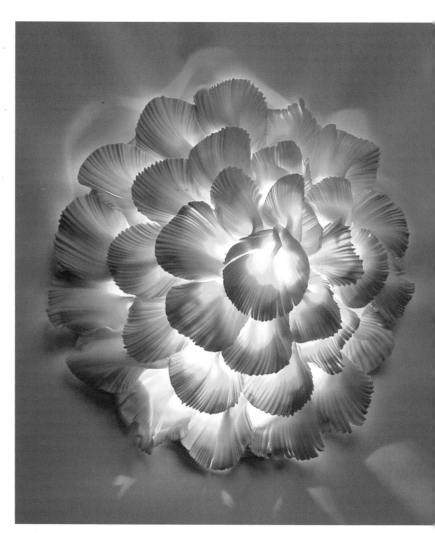

1

1 *Stack of Sea Forms*, 2004
unglazed porcelain forms thrown on the potter's wheel,
cut and reformed
photograph by James Crabbe
2 *Waves*, 2003
porcelain
photograph by James Crabbe
3 *Bamboo Wall*, 1994
porcelain
photograph by Michael Harvey

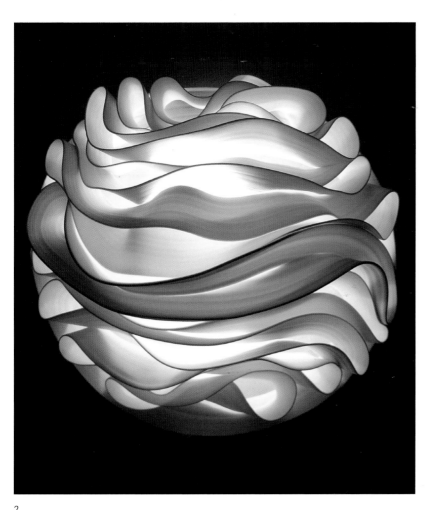

2

3

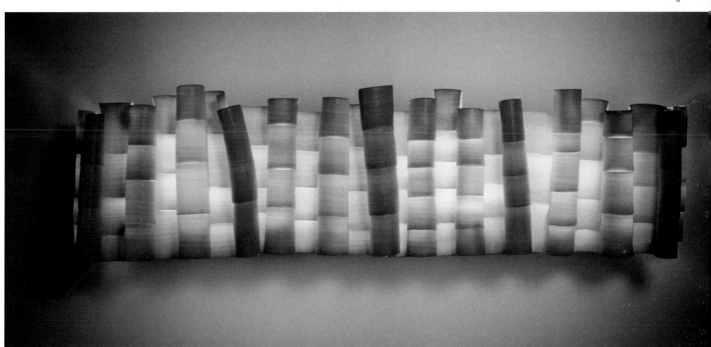

Deborah Sigel

Inspired by science and mathematics, Deborah Sigel's work explores concepts of pattern, order and containment. In pieces like *Crushed Time* and *Stratum,* for example, she explores the concept of time—what is it? How is it measured and recorded? In *Crushed Time,* tall tubes of coloured clay gravel represent the divided layers of sediment that in nature one would find settling in horizontal strata—the layers of stone representing layers of personal history. *Stratum* is a similar exploration, comprising three hypothetical core samples of a colour palette that have accumulated over a period of nine years.

There is an intrinsic physicality to Sigel's work. The way in which the pieces inhabit the space and the way they then relate to the viewer is not static, but dynamic. The forces of nature—gravity, velocity, pressure, growth are always present, forcing the viewer to consider whether or not the sculpture has a function, and if so, what that may be.

Sigel works with Egyptian paste, a modified version of the clay that the ancient Egyptians used to make funerary objects. It is a coloured, self-glazing material that is fired only once to temperatures of 1,900 degrees Fahrenheit. She then creates steel frameworks that can handle the physical demands of the scale of her pieces, and will also endure the firing process. She experiments with different structures, weights, heat and lengths of firing in a way that resembles the scientific experiment that the work often represents.

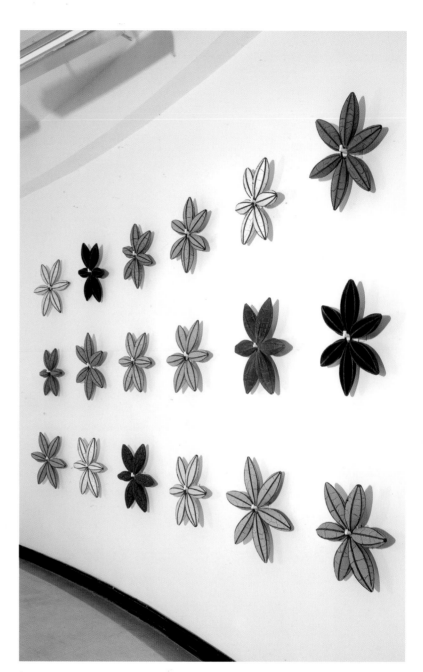

1

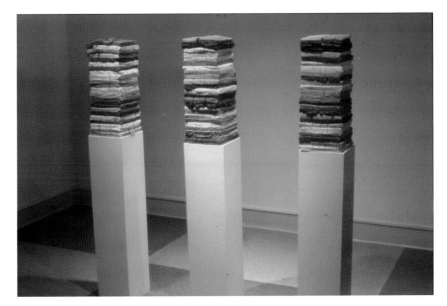

2

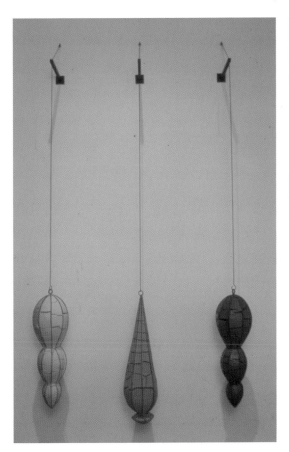

3

4

1 *Flowers*, 2007
Egyptian paste and steel
188 x 394 x 28 cm
photograph by Tsai Kun-Lung
2 *Stratum*, 2004
Egyptian paste, steel
69 x 20 x 20 cm
photograph by Scott Gordon
3 *Rotation*, 2002
Egyptian paste, steel
97 x 36 x 36 cm
4 *Crushed Time*, 2004
Egyptian paste, acrylic tube, cork
183 x 533 x 8 cm

Chris Wight

The work of artist and designer Chris Wight focuses on the continually changing effects of light filtering through bone china and the way that it plays on textured surfaces. His work ranges from vessel forms through to architectural and interior design features, such as screens, panels and window hangings. The surfaces of his pieces are designed to respond in different ways to varying intensities of light, and he utilises a broad range of techniques to fully exploit the intrinsic translucency of bone china, some of which take the material to the limits of its workability both in plastic and first-fired state. Wight uses slab rolling and slip-casting in order to create to wafer thin slivers of material, later impressing, carving and piercing the individual pieces, in what is an extremely labour intensive process with a high breakage rate.

Chris Wight describes his fascination with the "complex simplicity of nature", and this is apparent in all his pieces. The most obvious example is *Organic*, in which the panel is divided into segments each of which appears to be a massive magnification of varying cell structures. However, even in a piece like *Toys,* where the china is imprinted with figurines of toy soldiers, farm animals and cars, there is a degree to which the intricate interleaving of patterns also manages to form an organic whole that feels as though it has been drawn directly from nature. The shifting patterns of light make the pieces come alive, radiating a beautiful tranquility.

This simple purity makes Wight's work universally accessible, and his pieces have been exhibited at the Victoria and Albert Museum in London, and elsewhere around United Kingdom and Japan.

1

1 **Toys**, 2003
bone china, toughened glass, Perspex and stainless steel
2 Detail of **Organic panel**, 1999
bone china, toughened glass
3 Detail of **Polypoid Forms**, 2003
bone china, toughened glass

2

3

Annie Woodford

Annie Woodford's sculptures are concerned with the shifting boundaries between science and metaphysics, the ever-increasing pace of technological developments, and how these developments relate back to our primitive pasts. Her work is about frozen environments, about capturing a fundamental essence of humanity. The resulting pieces are often disturbing objects that appear to be hybrids of cellular organisms, torture implements, tribal tools and early medical utensils. Titles such as *Savage Trap*, *Innocent Intruder* and *Trace Shifter* heighten this sense of darkness and danger, of an encounter with some kind of primeval life form.

To create these sculptures, she uses porcelain, semi-porcelain and stoneware, in addition to body stains and oxides. She then employs various methods and extraneous materials, including hand building, slip casting, piercing, and binding using twine, wire or nylon, in order to create these delicate but quite large sculptures. Within the surfaces of the pieces, she often hides runes constituting an esoteric symbolism. She then exhibits the works in groups, on their own or occasionally in Perspex or glass containers, thus creating environments of fragility and isolation.

Woodford trained at the Royal College of Art under the tutorship of Eduardo Paolozzi, and one can see the influence of the artist's primitivist sculptures on Woodford's work.

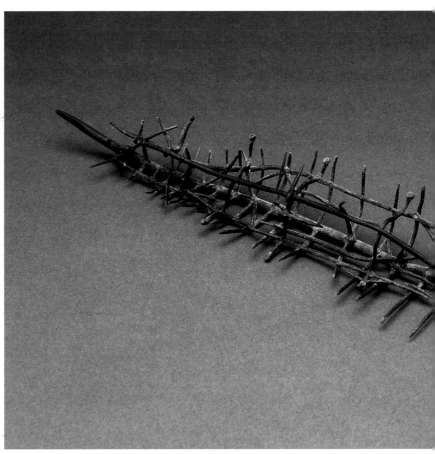

1

1 *Savage Trap*, 2005
ceramic
5 x 30 x 7 cm
photograph by Stephen Brayne
2 *Trace Shifter*, 2004
ceramic, steatite, porcupine quill
11 x 44 x 22 cm
photograph by Stephen Brayne
3 *Actuator (Damage to Fragile Things)*, 2005
ceramic, Perspex
40 x 60 x 16 cm
photograph by Stephen Brayne

2

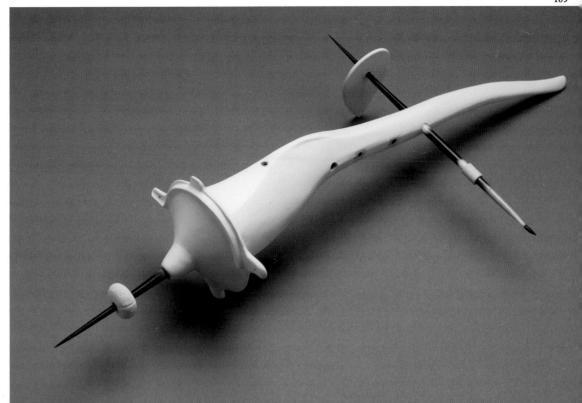

3

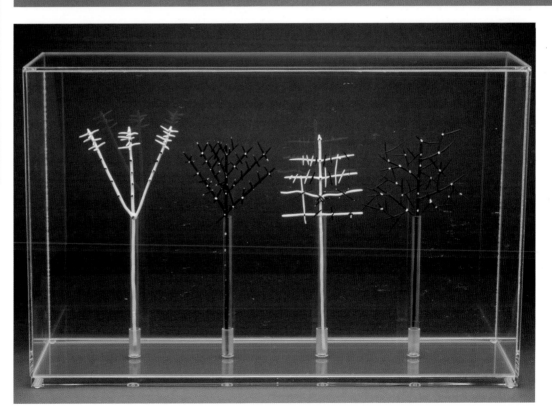

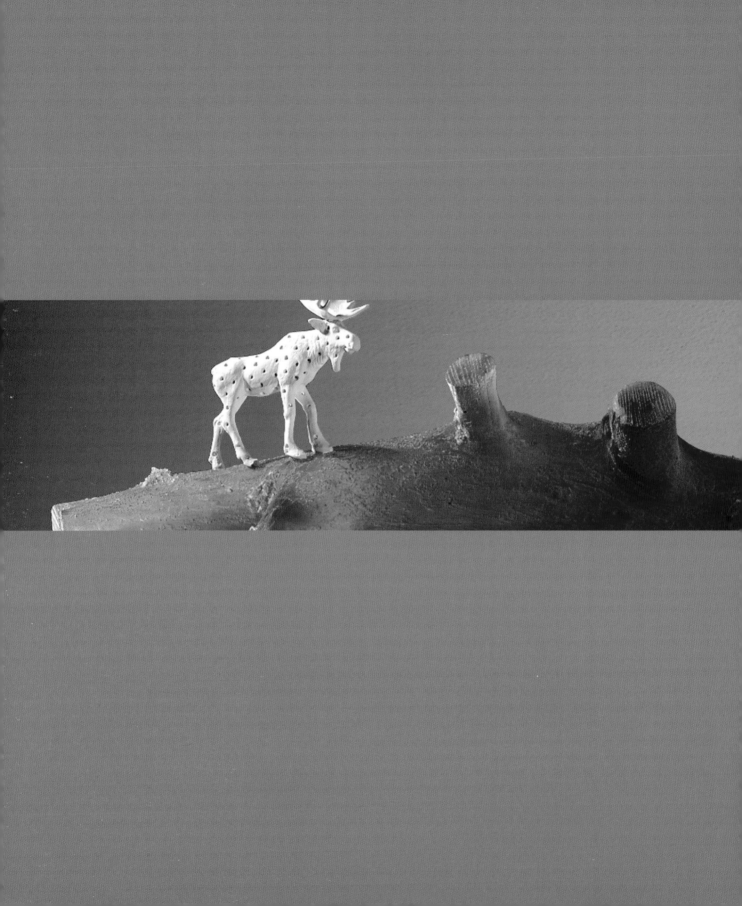

Ceramic Environments

Christie Brown
Phoebe Cummings
Keith Harrison
Marian Heyerdahl
Nina Hole
Kuldeep Malhi
Kristen Morgin
Jeffrey Mongrain
Colby Parsons
Linda Sormin
Simon Tipping
Clare Twomey

Christie Brown

Christie Brown creates representations of the human form, inspired by ancient artefacts and archaic figures from museum collections. Her human sculptures, made of brick clay and plaster, have a smooth, weathered look, as though the winds of time have worn them down. Brown maintains that her interest in the human form resonates "either as a means of discovery of our own identity and sense of self or as an exploration of the unknowable and uncontrollable Other". She chooses clay as her medium for its association with myths of creation, and its transformative nature that lends itself so well to ideas of change and metamorphosis. These concepts of transition and transformation are at the heart of Brown's work. Her pieces attempt to make sense of the links between past and present, examining and assessing the constant unfolding of history.

In her exhibition, *Fragments of Narrative,* at London's Wapping Power Station, the artist installed life-sized figures all around the space—their bodies fractured and fragmented, limbs missing, disembodied heads staring at armless torsos from across the room. The exhibition centred on characters from stories and myths including Prometheus, Pygmalion and the Golem, all of whom had associations of power and control. Brown took two years creating this response to the industrial history and rich atmosphere of the disused hydraulic power station, the pieces being sensitively designed to interact with the building.

Brown's work first came to prominence in the 1980s with a selection of human torsos. Since then she has gone on to exhibit worldwide. Her work can also be found in public collections such as the Victoria and Albert Museum, London, Musée National de Céramique, France and the Museum of Decorative Arts, Montreal, Canada.

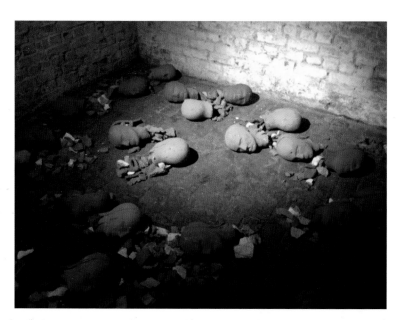

1

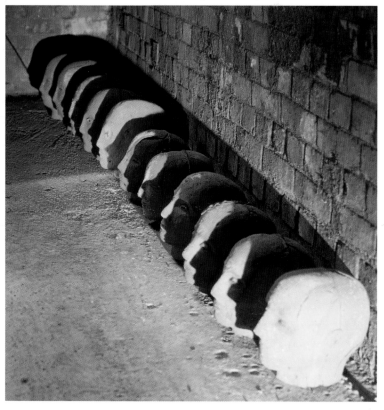

2

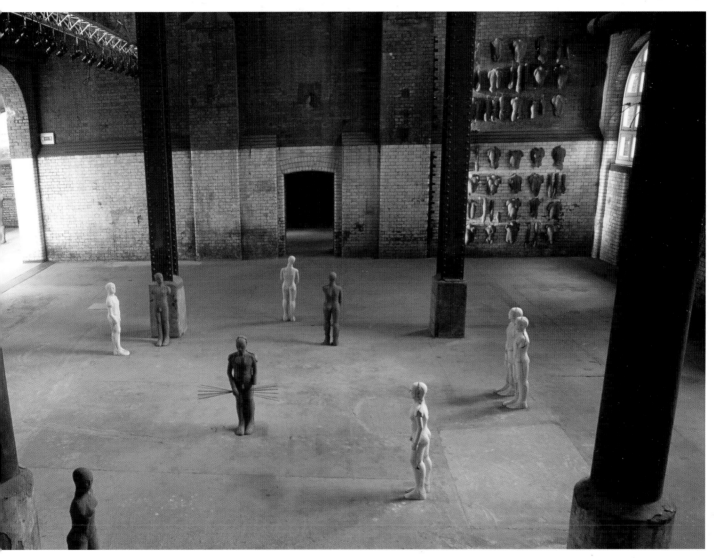

3

1 *Ex-Votos*, 2003
brick clay
25 cm each, variable layout
photograph by Edith Garcia
2 **Heads from the Glyptotek**, 2000
brick clay
22–33 cm, variable layout
photograph by Kate Forrest
3 **Fragments of Narrative**, 2000
ceramic and mixed media
variable layout
photograph by Kate Forrest

Phoebe Cummings

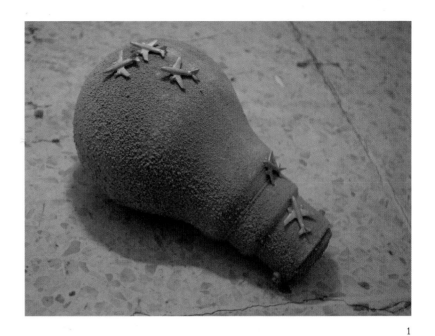

Phoebe Cummings challenges the viewers' conceptions of the form and function of everyday objects. The recent graduate of the Royal College of Art is concerned with the way in which we relate to the objects around us, and their perceived 'normal' function. In *Between*, a stoneware and porcelain installation exhibited at Madam Lillie, London, Cummings weaves raw, unfired clay into a deep carpet that runs down a set of stairs in a naturally fluid motion that belies the true fragility and inflexibility of the material. *Between* challenges the viewer by presenting him/her with an artistic dilemma—the stairs are functional objects, but to use them would involve stepping on the clay 'carpet', literal shattering the illusion. The use of clay in this instance creates a tension between expectations of softness and the imminence of breakage, provoking an awareness of ones physical body mass in relation to the surface.

In *Landscape II*, Cummings uses unfired earthenware clay to create a texturally coarse, but intricately detailed impression of a lightbulb. Upon this, she has placed tiny metal aeroplanes, like moths or flies. The contrast between the materials and the objects creates an associative impression that is not without humour. Dualities such as these lie at the heart of Cummings' work, and her temporary interventions within a space raise questions regarding how things respond and belong to one another. In her own words: "Reality meets fiction. The visible encounters invisible. Microcosm embraces macrocosm. House encompasses universe."

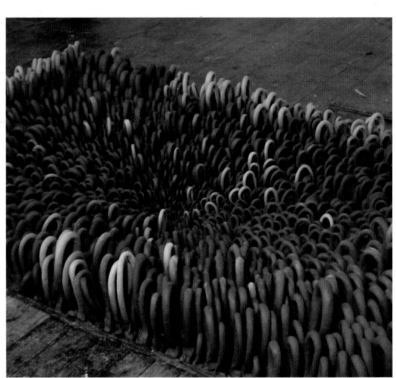

1

2

1 **Landscape II**, 2005
unfired earthenware clay, metal
approximately 12 cm
2 **Pull**, 2006
cuff clay
120 x 175 cm
3 **Between**, 2005
stoneware clay, porcelain
40 x 240 cm

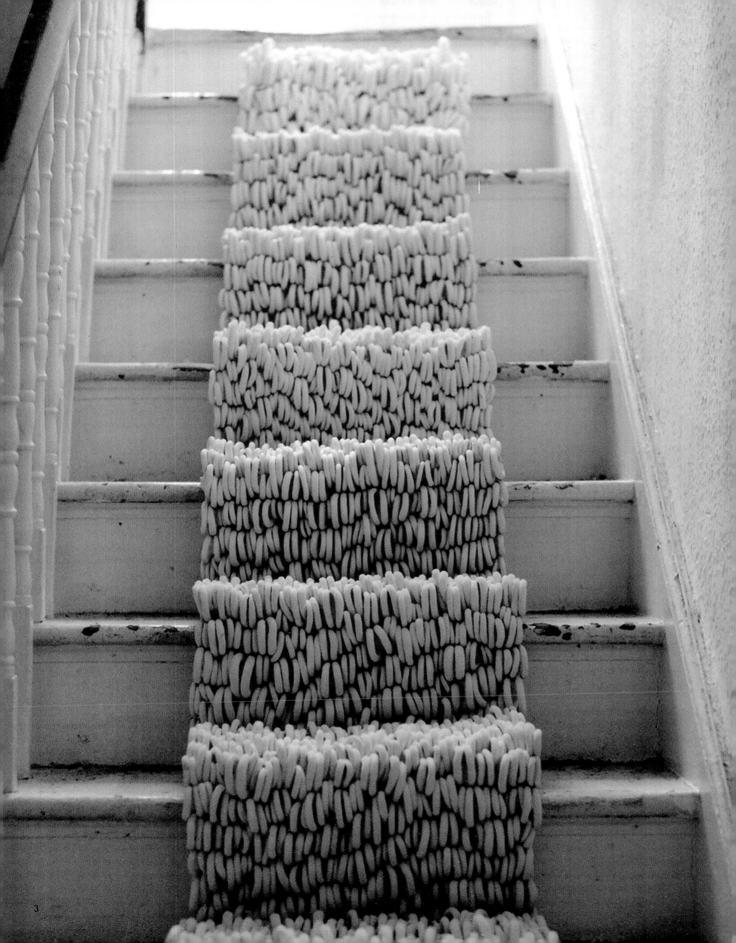

3

Keith Harrison

Keith Harrison is one of Britain's leading contemporary ceramicists, pushing the boundaries of ideas and the techniques for creating ceramics by making visible what is normally a hidden part of ceramic art, the firing process.

His current work focuses on the potential for electricity and other industrial technologies to directly transform clay from its raw state. He creates site-specific, time-based works in public places, using an architectural detail or an electrical domestic appliance as a host for the raw clay. He then modifies existing electrical heating systems, such as electric fire bars, cooker rings or boiler elements to convert the clay from its raw state. It is not the finished piece, but rather the transformation of the clay, which is the heart of Harrison's work.

Harrison has received wide recognition for his unique approach—he has had 'visible firings' around Europe, including Camden Arts Centre in London, Posada del Potro in Spain, and Imperial College, London. In 2006, he created a specially commissioned piece for the Victoria and Albert Museum in London entitled *M25 London Orbital*. In this installation, he created a scale model of the M25, the motorway that encircles London, and peformed a live electric firing. As with many of his works, the momentary nature of the piece required that a film be made, and screened alongside the smouldering residue.

Harrison's work is unique in the ceramics world, crossing paths with both performance art and scientific investigation.

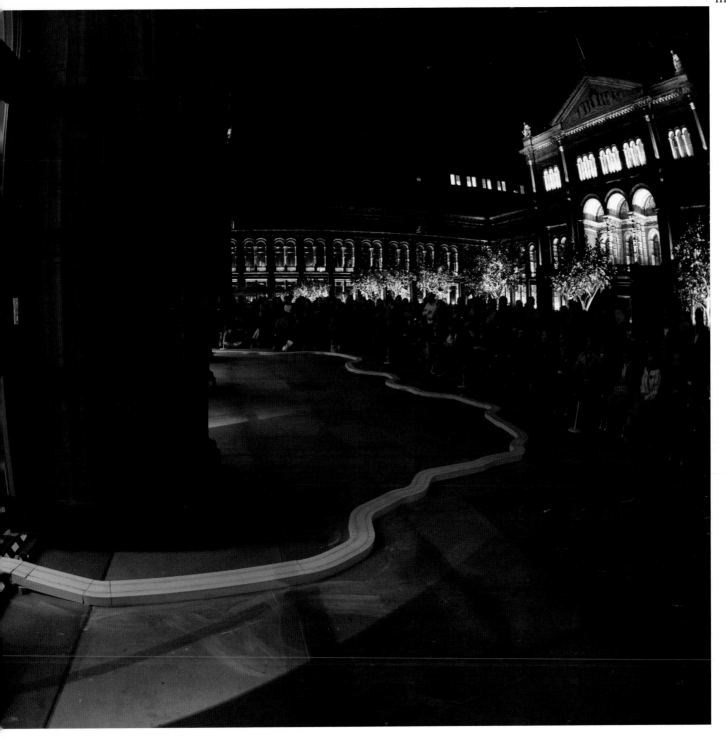

1 *M25 London Orbital*, 2006
soft borax frit, spiral heating elements, promasil/duratec
technical ceramic
photograph by Ted Giffords

Keith Harrison

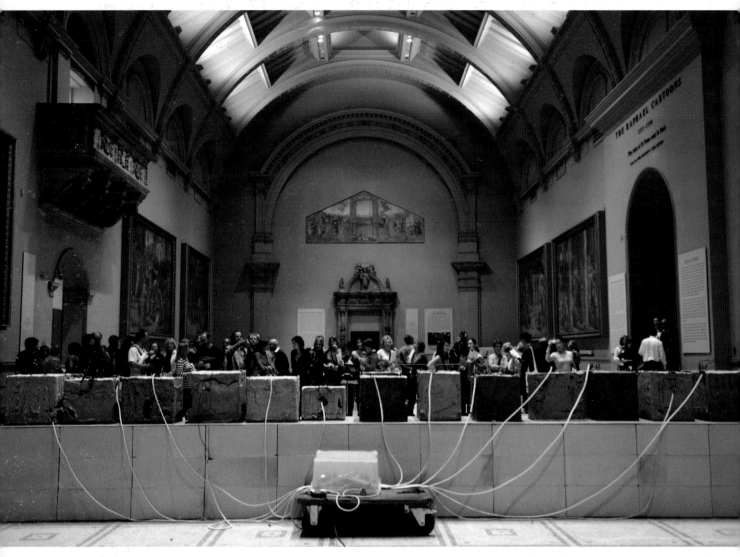

2

2 *Last Supper*, 2006
cooker elements, Egyptian paste, insulation blocks, fireproof board
photograph by Ted Giffords
3 *Festoon*, 2006
terracotta, incense, 60 watt light bulbs, festoon lighting cable

Marian Heyerdahl

For a period of three months, Norwegian artist Marian Heyerdahl was living Xian Province in north-west China, working on her *Terracotta Woman Project*. Across the road from her house, lived the farmer who initially discovered 8,099 life-sized figures of soldiers in the mausoleum of the first Qin emperor, a pivotal archaeological find, which became known as *The Terracotta Army*. Heyerdahl's project is a reinterpretation of this terracotta army, positioning the soldiers as women. An army of 57 life-sized women and children are sculpted in the same scale, texture and materials as the original Qin soldiers, with similar features and uniforms. However, in Heyerdahl's project, each has a different facial expression. Some have their mouths open, as if screaming, others have their eyes closed in fear, and others smile gently.

The figures represent the strength and the suffering of women through the ages. The fragility and power of the feminine are encapsulated in the masculine figures of the soldiers, and in the strong but brittle material. Each figure carries a story of her own—a pregnant rape victim, a mother offering up her dead babies, an amputated woman clutching a bundle of fire-arms, a woman whose breasts drip with her own blood. They raise questions about the role of women and children in war, and how we respond to the issues of rape and violence. The tragic universality of these bloody themes, and the contemporary resonance of the project bring home exactly what is meant by 'history repeating itself'.

The sculptures were industrially produced by local factories, in the same way that the originals were created in a 'production line' over 2,000 years ago. The exhibition of the figures was opened in 2007 in a massive old military factory turned gallery in Beijing.

1

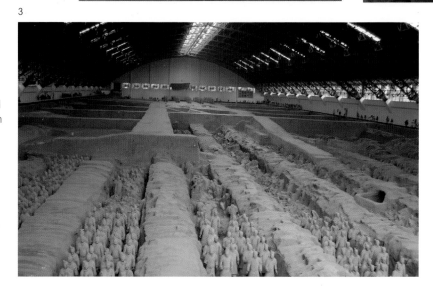

3

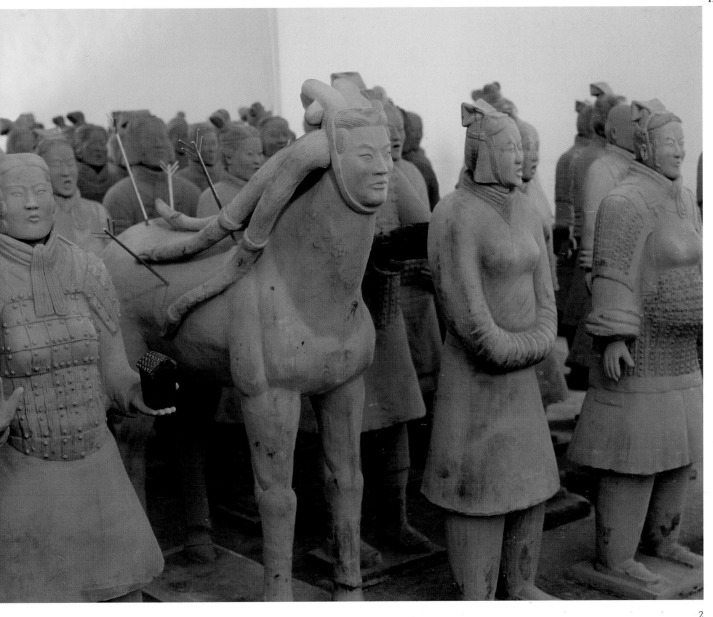

2

1, 2 From **The Terracotta Woman Project**, 2006
clay
185 cm, each figure
photographs by Tang NiHua
3 **The Terracotta Army**, third century BC
Xian Museum, China
photograph by Robin Chen

Ceramic Environments
Marian Heyerdahl

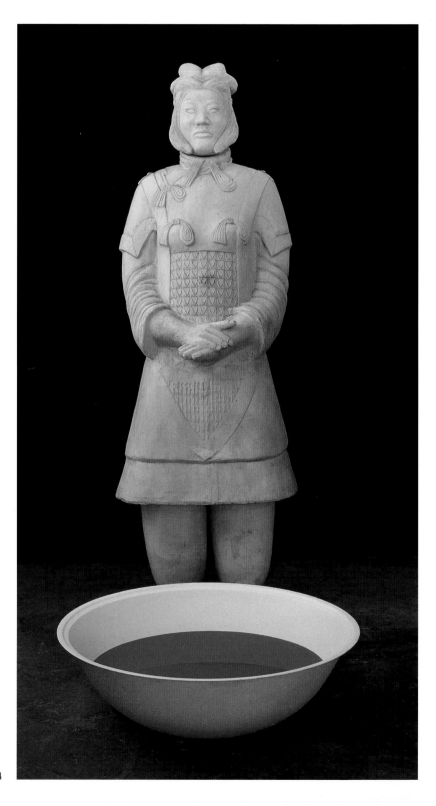

4, 5 From *The Terracotta Woman Project,* 2006
clay
185 cm, each figure
photographs by Tang NiHua

4

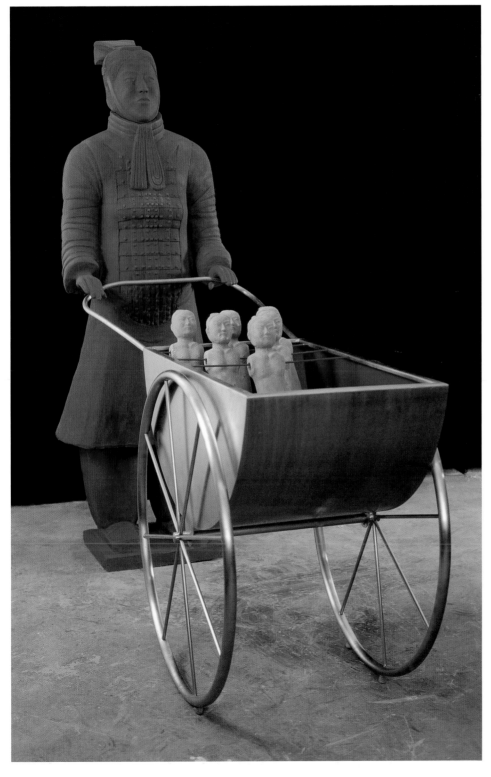

Nina Hole

Clay has a language of its own. The smell, the touch... and the process stimulates parts of the brain that in many instances lie dormant.

Nina Hole

Born in Denmark, Nina Hole moved to New York in her late 20s, returning to her homeland nine years later. The influence of both locations is clear to see, their contrasting architecture leaving a distinct impression. Her body of work is loosely divided between large, site-specific pieces and smaller studio built forms. The larger pieces are imposing, dynamic skyscrapers, whilst the smaller pieces are infused with a quiet small-town desolation. For her site-specific pieces, Hole, who describes herself as a "clay architect", developed the technique of *Fire Sculptures* in 1994. This technique involves incorporating elements of a kiln into an outdoor sculpture. Once the composition is built, it is wrapped in a fibre blanket and can be fired from within. Part sculpture, part performance, the blanket is removed as the piece is firing to reveal the flames that are baking the clay from inside. The striking image, a glowing, fiery monument, is simultaneously constructive and destructive, creating the art and destroying it in a single event. Although originally conceived and widely exhibited over 15 years ago, since 9/11, the burning skyscraper, the towering inferno, has become a vision that is both instantly recognisable and highly charged, politically and emotionally, making Hole's work more relevant than ever.

Hole has performed her *Fire Sculptures* all over the world in such diverse locations as Australia, the United States, Canada, Lithuania, Portugal and Wales.

1, 2, 3 *A House For Everyone*, 2005
before and during firing
stoneware
350 x 115 x 100 cm
images courtesy of Iiona Romule and Steve Mattison

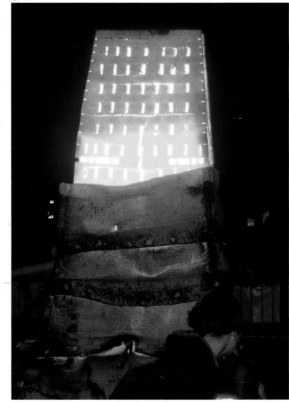

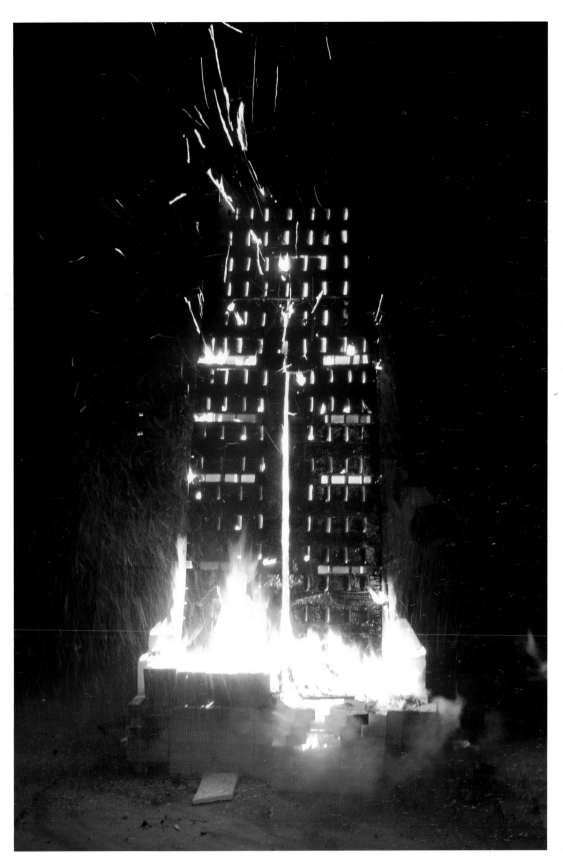

3

Kuldeep Malhi

The wall installations of emerging talent Kuldeep Malhi, cross the boundaries between ceramic art and architecture. Through use of soft round forms in repeating patterns, finished with experimental glazes, Malhi creates a tactile and deeply sensuous environment. He cites his primary inspiration to be ancient erotic sculpture found in ancient Indian temples. In work such as *Blush,* irregular phallic shapes emerge from a wall, the rich warm hues creating a sense of movement as the 'tentacles' crawl across the surface. In *Braided Blue*, there is also a sense of movement, but here it comes not from the regular honeycombed pattern but rather from a gentle gradation in colour and the piece's irregular edges.

To create this effect, Malhi creates plaster moulds to cast white earthenware slip. He then conducts a laborious process of colour testing to create the desired shade of glaze. For any one piece of work, 30 or 40 tests are conducted, from which only a fraction will be used. The glazes are applied by either dipping or spraying the individual ceramic shapes.

Malhi's work represents a meeting of Eastern and Western cultures—the erotic tactility of oriental art combined with the mechanised glossiness of the West. The dynamic installations respond to the vertical planes within architectural spaces, creating an interface between the walls and the internal space of the room.

1

1 Detail of **Braided Blue**, 2005
glazed earthenware units
500 x 110 cm
2 **Blush**, 2005
glazed earthenware
various dimensions

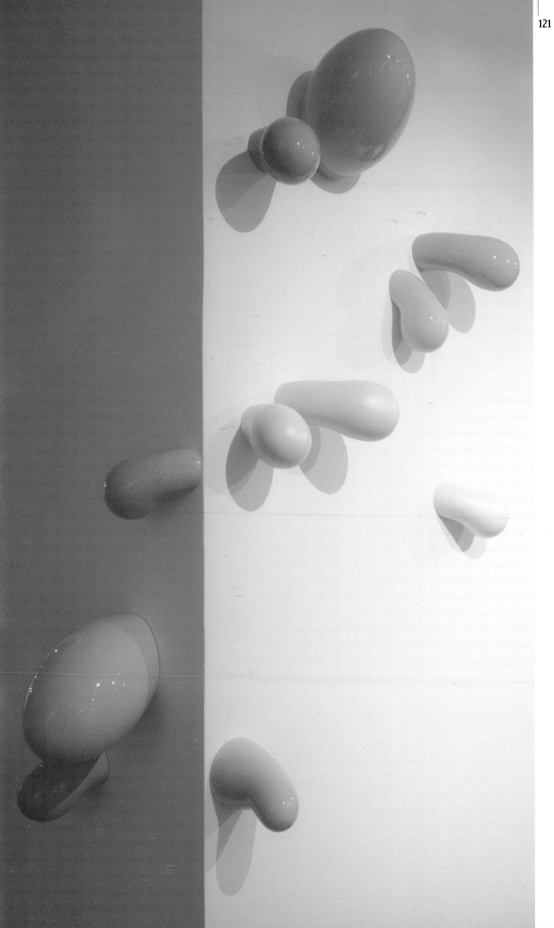

Kristen Morgin

At first glance, Kristen Morgin's sculptures look like they have been dredged out of a river and placed in a gallery. It is only upon closer examination that the rusty, skeletal remains reveal themselves to be hand-made structures of wood, unfired clay, cement, paint and wire. The sculptures are primarily of vehicles, their wheels missing, propped up on flimsy wooden struts, like the decomposing carcasses of lame beasts.

Morgin researches her subjects meticulously, reading up on her car magazines, and visiting car shows, before deciding which model to sculpt. She never works from moulds or real car parts, building everything from scratch. *Captain America* is a sculpture of an old toy car from the mid-twentieth century. Every detail of the car is meticulously replicated, from the little dashboard, to the faded paint-job of the stars and stripes. Like all Morgin's work, it evokes a melancholy nostalgia and references the fading of the American dream, calling into question the perceived indestructibility of the United States, and the shifting way in which the country relates to its own history.

As the clay is unfired, the fragile sculptures have a strictly limited life span, usually making it through one or two exhibitions before they disintegrate or are destroyed, preserved only in the artist's photographs. A memento moris of our twenty-first century consumer culture.

Kristin Morgins is based in Los Angeles, and teaches at CalState University, whilst working and exhibiting her art across the world.

1

1 *Popeye*, 2006
clay, wood, wire, paint
58.4 x 66 x 160 cm
2 *Captain America,* 2006
clay, wood, wire
50.8 x 43.9 x 121.9 cm
3 *Hearse*, 2004
clay, wood, wire, cement
223.5 x 558.8 x 165.1 cm

2

3

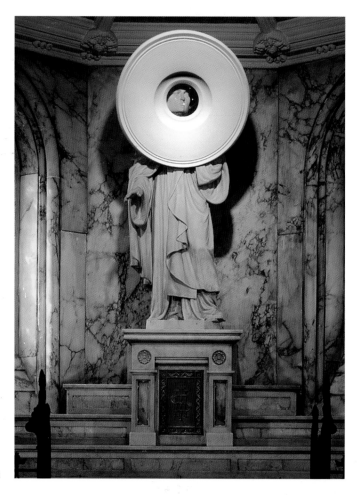

Jeffrey Mongrain

American ceramicist, Jeffrey Mongrain, cites Gothic
architecture and his education in a seminary as his
primary influences. His work is deeply imbued with
religious imagery, and he is best known as a founding
member of a group of artists who travel around spiritual
places (churches, cathedrals and synagogues) in Europe
and the United States, creating site-specific pieces. In
The Philosopher's Halo, the halo of St Thomas Aquinas,
one of the great Catholic theologians, has been moved
from the back of his head (as is traditional) to the front
of his face. An optical lens is incorporated into the
centre of the halo, distorting the viewer's perception of
St Thomas, and St Thomas's perspective of the viewer.
Mongrain's formal minimalism lends itself well to the
architectural unity of these places of worship, and
he attempts to approach each brief with the utmost
sensitivity: "I believe sited work should echo the history,
philosophy and/or architectural features... my sited
works are intentionally visually quiet, they aspire to be
architecturally harmonious and respectful of the clergy
and congregation's relationship to their place of prayer."

Mongrain's interest in the grand mechanics of existence
extends from religion to science. The work *Pierced
Bell with Threads* depicts a semi-closed bell pierced by
hundreds of holes, which hangs silently form a column
of white sewing threads, as though frozen in mid-ring.
Pierced Moose with Branch is a contemplation on the
effects of global warming, referring to the dwindling
numbers of moose in Minnesota as a result of the ever
shorter winters.

Mongrain's work aspires to physical refinement,
and the finishing of most of his pieces happens after the
last firing, in a process called cold-modelling, in which the
clay is carved in its fired state, allowing for a rigid stone-
like precision.

2

1 ***Pierced Bell with Threads***, 2000
clay and thread
47.7 x 47.7 x 35.5 cm, strings 10.1 cm in diameter
2 ***The Philosopher's Halo***
clay, optical lens
81.3 x 81.3 x 20.3 cm
3 ***Pierced Moose with Branch***, 2005
clay, resin
83.8 x 27.9 x 10.2 cm

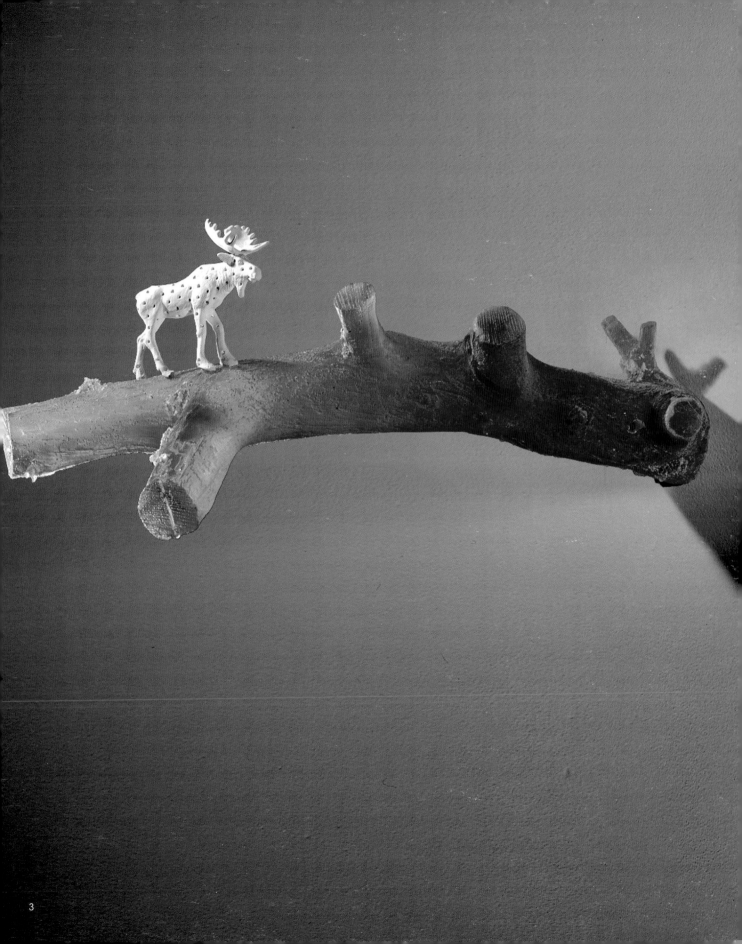

Colby Parsons

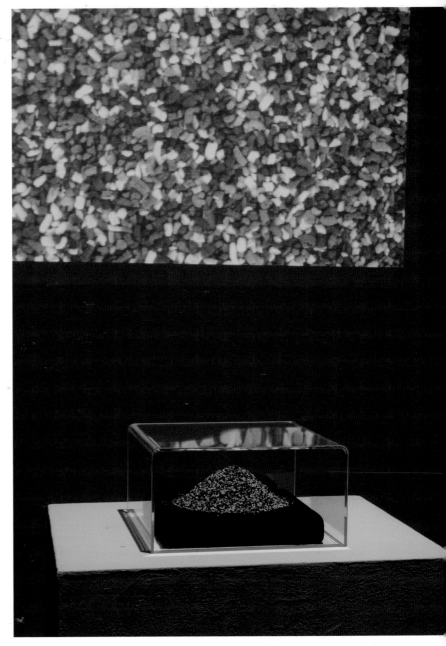

Colby Parsons' large-scale sculptures explore the juncture between physical material and digital media. By combining the traditionally static medium of clay with the movement of video projection—of film, animations and computer graphics, Parsons adds an element of interactivity and momentum to the pieces. A fine example of this is his 2006 piece *Watercube*, in which a small amount of water appears to retain a regular geometric shape independent of any vessel. The water the viewer sees, however, is merely a solid stoneware cube covered in black and white matte glazes. Onto this is projected looped footage of bright blue, swimming pool water, covering all sides of the piece using mirrors. The concept of clay as vessel is turned on its head, and the impossibility of the image that the viewer is presented with forces them to engage with the piece, questioning what it is that they are seeing.

As Parsons himself explains, "I am taking something I consider ordinary, something that is not particularly noteworthy or interesting, and turning it into a visual spectacle…. This act draws attention not only to the way we place value on certain objects or experiences over others, but also considers our visual interpretation of reality itself."

Parsons is the Head of Ceramics at the Woman's University of Texas, and has exhibited his work around the United States and Europe.

1

1 *Static*, 2005
coloured porcelain, acrylic, wood, velvet, digital video projection
2 *Liquid: Dataspace and Embodiment*, 2006
stoneware, epoxy, steel wire, digital video projection
photograph by Brian Boldon
3 *Water Cube*, 2006
glazed stoneware, wood, hardware, mirrors, digital video projection

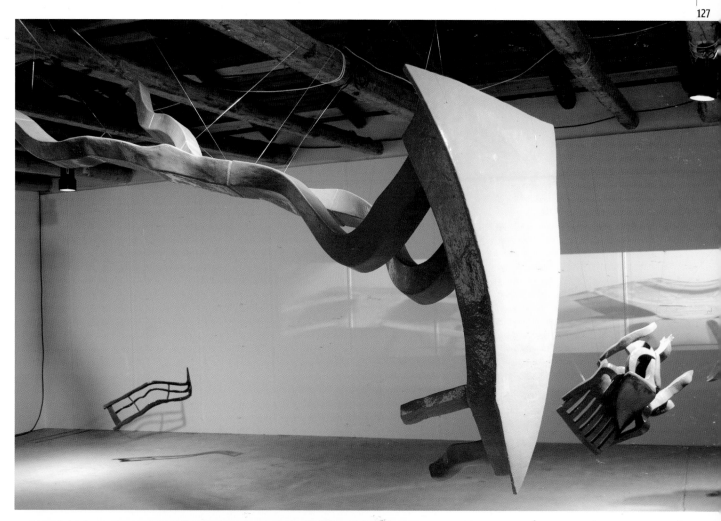

2

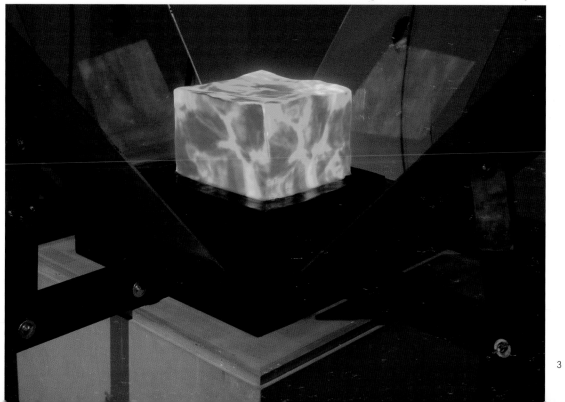

3

Linda Sormin

Born in Bangkok, and brought up in Orillia, Ontario, Linda Sormin's works are an abstract riot of colour, line and form. The viewer's eye is drawn around the piece at random, exploring thousands of potential journeys across the surface and into the interior. Intricate webs, structural pillars and disrupted solid slabs collide explosively into a boundless, energetic chaos.

Sormin uses what she describes as a "repertoire" of different ceramic techniques to create each work. These include wheel-throwing, slab-building, press-moulding and the use of found objects. Each technique functions as a different mode of expression, and fusing them in this manner results in pieces that are highly emotive. In this way Sormin seeks to "disrupt the sensible or preconceived approach to ceramic process". The clay is prodded, grabbed and attacked at all stages and takes on a presence that is at once fragile and aggressive—masculine and feminine. Her work is a meditation on the nature of paradox. The large scale of the pieces is emphasised and simultaneously undermined by the use of small cartoonish objects—figurines, test-tiles, keepsakes and toys, like miniscule beings swept up in the debris of a tornado. The work negotiates enclosure and disclosure, construction and collapse, instability and balance. There is an excitement and an energy to the pieces that comes from a fearless rejection of control, and the sense of danger that such abandon gives rise to.

Now an Assistant Professor of Ceramics at Rhode Island School of Design, Sormin's work has been exhibited internationally, in the United Kingdom, North America and the Far East.

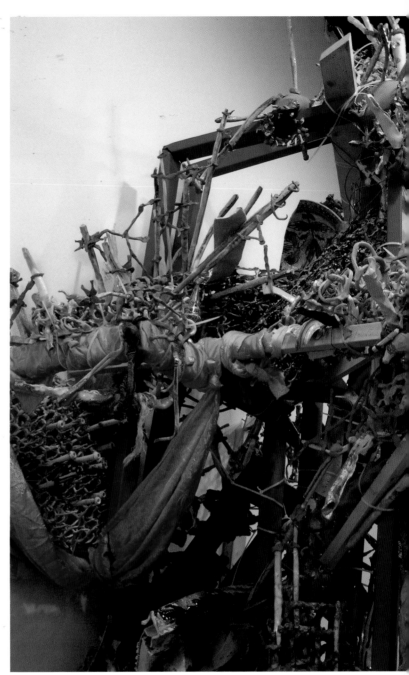

1

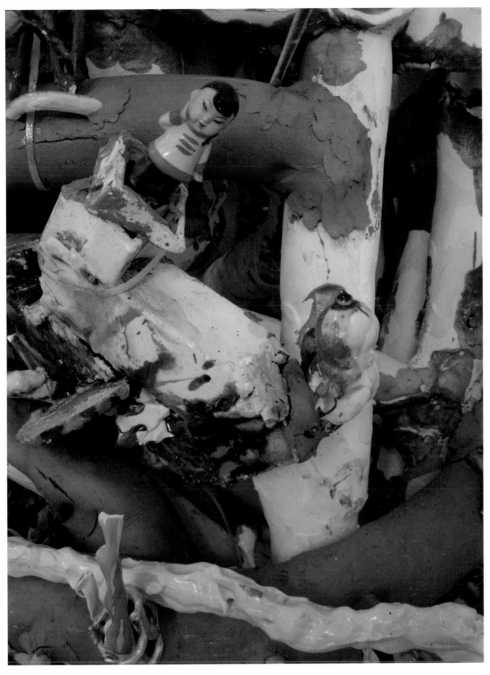

2

1 *BluMtndeer*, 2006
ceramic, found materials
2 *Celephant*, 2006
ceramic, found materials

Simon Tipping

Simon Tipping takes a spiritual, almost existential approach to working with clay. He intuitively feels the clay, building a physical relationship with the material and creating fantastical sculptures, installations and performance pieces that explore his interpretations of the five elements; fire (passion) water (emotions) earth (material needs) air (intellect) and spirit (the self). To convey this complex religiosity, Tipping experiments with different working processes. Often he uses handmade kilns such as salt, wood, paper and Raku. In some cases the kiln becomes the piece itself, such as *Men at Work, Back in 30 Minutes,* a time-based performance piece revolving around a wood kiln.

Other pieces of Tipping's work take the form of non-functional clay bowls which push the limits of conventional texture and form. Using stoneware and porcelain clays, together with other materials, such as steel, plastic, engine oil and wood, he finishes the pieces off using coloured slips and oxides and a limited use of glazes, thus creating a rich collage of textural surfaces, making his pieces as tactile as they are visual.

There is a primitive aspect to Tipping's work, and some of his pieces look like they belong in some kind of tribal shrine. However, despite the religious intentions of his work, Tipping does not aim to create idols or monuments. He states that the result of his explorations is not as important as the process itself—the personal journey he has gone through to create the product. His interest lies not in permanent pieces of work, but in time-based and site-specific installations.

Tipping's work has been exhibited across the United Kingdom and internationally in France, Italy, Lithuania, Pakistan and Poland.

1

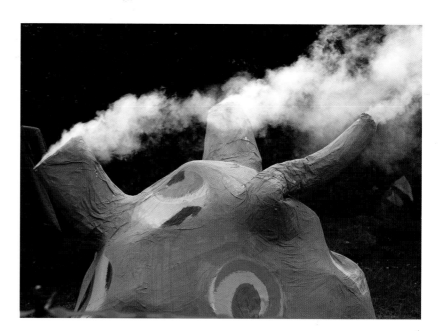

2

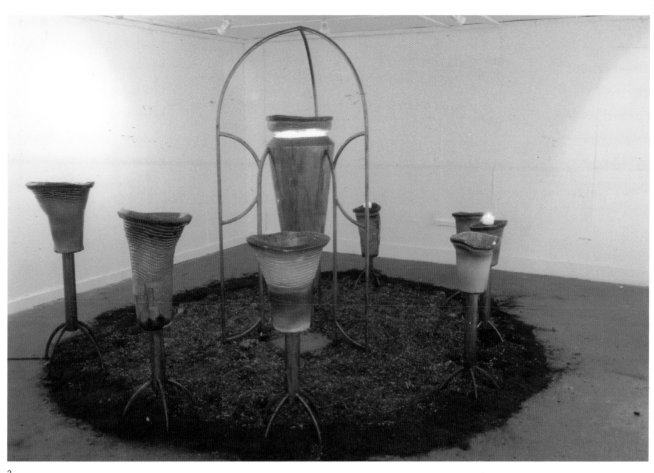

3

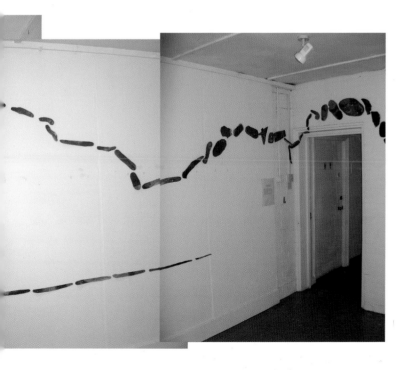

1 Detail from **Men at Work, Back in 30 Minutes**,
wood kiln, clay, DVD
2 **It's Another Fucking Line**,
Raku, smoke-fired clay
3 **City Vessel for Souls**,
stoneware pots, steel, oil, earth, candles, electric light
600 x 500 x 244 cm
photograph by Maria Barry

Clare Twomey

Clare Twomey's large-scale, site-specific ceramic installations have been exhibited around the world, to great acclaim. Her work deals with ideas of time and space, and the human interactions that the space lends itself to.

In *Consciousness/Conscience,* which appeared at the Ceramic Biennial in Korea, 3,000 hollow bone china tiles were laid on the floor. As the viewer walked into the room, the delicate tiles were crushed underfoot in a moment of sadness and exhilaration, and the viewer ceased being a viewer and became an active participant in the installation. The awareness of the act, and the ensuing sense of responsibility (or Consciousness/Conscience) changes the way the audience perceives itself in relation to the installation, and by extension to the world.

In her more recent *Trophy,* a hall at the Victoria and Albert Museum in London was filled with 4,000 sculptures of Jasper bluebirds, which were placed on the plinths of the busts, around the bases of the statues and scattered across the floor. It was as though some force of nature had driven a vast flock of birds into the traditionally sober gallery space, transforming it into a miraculous playground-like landscape. The audience was able to interact with the birds, picking them up, playing with them, and eventually taking them home as a 'trophy', thus dispersing them on a national scale.

Through Twomey's ceramic installations, the gallery spaces are reinvented, and the way we behave in particular environments is subtly altered and reviewed.

1

2

1 **Consciousness/Conscience**, 2004
Royal Crown Derby bone china
1,400 x 400 x 2.5 cm
photograph by Andy Paradise
2 **Heirloom**, 2004
porcelain
1,500 x 1,500 x 1,000 cm
photograph by Dan Prince
3 **Trophy**, 2006
4,000 units of Wedgewood Jasper Bluebirds
5 x 3 x 4 cm each
photograph by Dan Prince

3

Clare Twomey

4 **Temporary**, 2006
unfired clay, mixed media
261 x 276 x 276 cm
5 **Lost Rituals**, 2003
fired and unfired porcelain installation at the
Gibson National Trust Estate, Gateshead

4

5

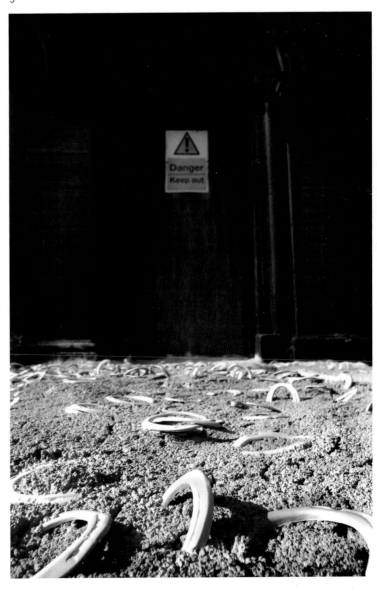

The Vessel

Rob Barnard
Emmanuel Boos
Emmanuel Cooper
Natasha Daintry
Pam Dodds
Jane Hamlyn
Grayson Perry
Wai-Lian Scannell (Soop)
Timea Sido

Rob Barnard

American potter Rob Barnard is primarily concerned with form and how it impacts on a viewer emotionally. He has always used Japanese wood-firing as his technique of choice, and for many years, presented his pieces raw and unglazed. The work is flawed, the surfaces often cracked and uneven, evidence of their ordeal in the kiln. Barnard embraces these imperfections, fascinated by the perceptions of use. Why should these pieces not serve a functional purpose? "What actually keeps us from using these pieces... are our own cultural prejudices, not any structural or formal aspect of the work itself."

Barnard studied in Japan after leaving the United States Marine Corps, and the influences of Japanese tradition are still evident in his work 30 years later. Barnard's current stoneware is painted with white slip and then covered with clear glaze. "I have found that the minimalist nature of the white slip and glaze makes form more prominent since there is little room for the natural kind of surface 'decoration' that occurs in woodfiring." The crackled effect of the glaze highlights the imperfections in the clay and occasionally creates an effect not dissimilar to concrete. There is an austere mystery to the reduced, unadorned forms of Barnard's work. Their simplicity belies a fierce passion for the medium and its rich history.

Rob Barnard is an established artist-potter working from Virginia. He has long advocated a revival of the place of pottery in society, and expresses his convictions in both his work and his extensive writings for numerous ceramics publications across the globe.

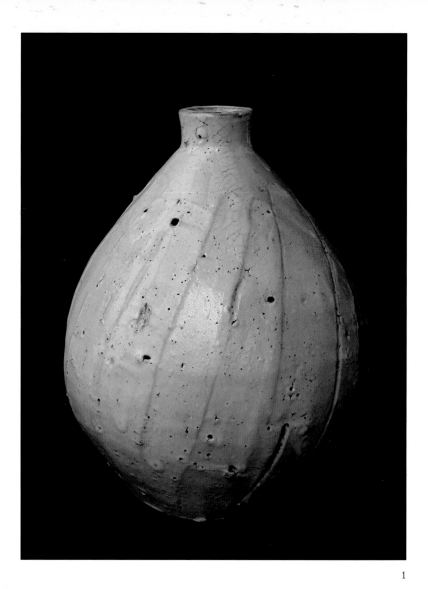

1

1 *Faceted Bottle*, 2005
stoneware with white slip under clear glaze
16 x 12 cm
2 *Crackled Vase*, 2005
stoneware with white slip under clear glaze
18 x 20 cm
3 *Bowl*, 2005
stoneware with white slip under clear glaze
11 x 18 cm

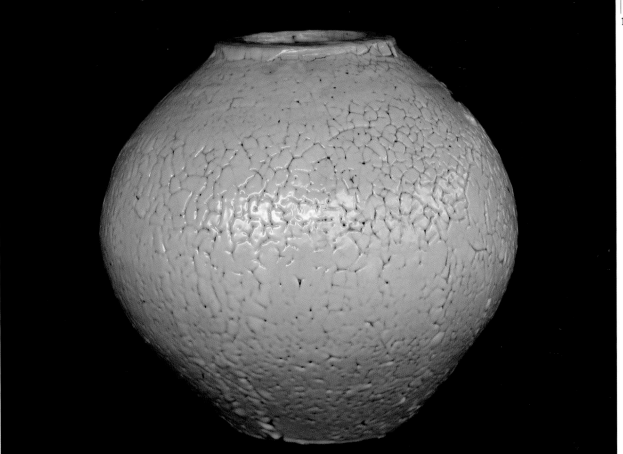

2

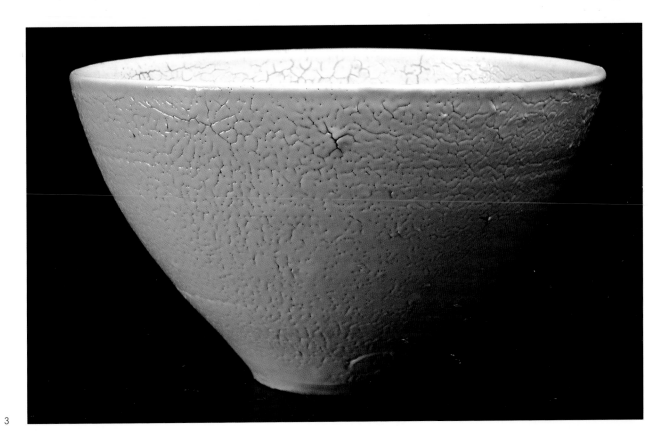

3

Emmanuel Boos

1

French ceramicist Emmanuel Boos believes in the "raw, mineral emotion" of clay. Using a variety of porcelains and glazes, which he prepares himself, he pushes the boundaries of the vessel, allowing the pieces to evolve in a random, accidental way. He practises the technique of free or fluid throwing on the potter's wheel. This allows him to engage and interact with the material, rather than dominate it, and he describes his relationship with the clay to be one of complicity and exchange. He explains that his forms are not made but born; dictated by the character and the will of the material. Likewise, his glazes go beyond mere colour and into the realm of 'free glaze'— an intuitive extension of the form of the vessel.

2

The elegance of Boos' vessels lies in their imperfections. The tears and folds in the lips of the delicate bowls and plates, are sometimes so random as to appear clumsy, but it is this very clumsy imperfection that carries the emotional weight of the piece. The work speaks of fluidity and depth, of man's relation to nature, and of randomness and control.

Boos came to ceramics late in life after a long career in business. He worked as the apprentice to 'maitre d'art' Jean Girel, and became a practising artist in 2003. Since then he has had exhibitions worldwide, and is currently living in London, studying for a doctorate at the Royal College of Art.

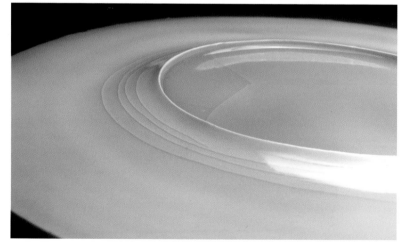

3

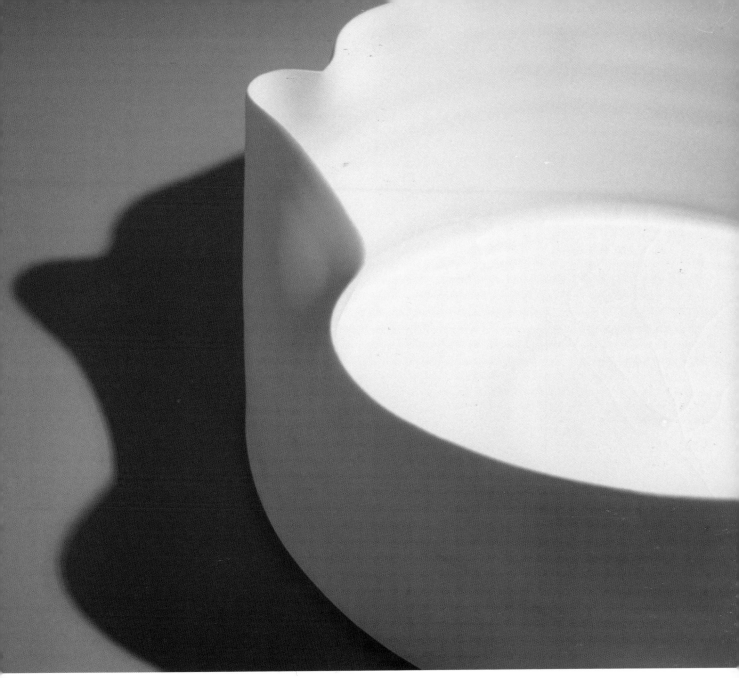

1 *Ovale*, 2005
white porcelain, white matt glaze
31 x 17 cm
photograph by be-attitude/jousseentreprise, Paris
2 ***Large Bowl with Falling Lip***, 2005
white porcelain, celadon glaze
23 x 15 cm
photograph by be-attitude/jousseentreprise, Paris
3 *Disc*, 2005
white porcelain, celadon glaze
35 x 2 cm
photograph by be-attitude/jousseentreprise, Paris
4 ***Crumpled Drum***, 2005
white porcelain, white matt glaze
29 x 11 cm
photograph by be-attitude/jousseentreprise, Paris

Emmanuel Cooper

The metropolitan environment and the baffling complexities and urban sprawl of London are a primary influence on the work of Derbyshire-born Emmanuel Cooper. The pieces he creates share the city's sense of movement and urgency as well as its precarious balance between order and chaos. Working primarily in vessel form, Cooper uses a palette of colours and textures drawn from the dirty grey architecture, the pock-marked concrete and bright neon lights of the urban street. The shapes of his pieces tend to be geometric—cones and angular lines. He then experiments with surface glazes to complement the shapes, applying layers of slip and glaze and firing and re-firing the pieces in a slow-firing cycle that allows the body, slip and glaze to interact. The manganese, iron and cobalt oxides sometimes break through the glaze's surface, creating a distinctive texture. His more recent works explore a range of smooth glazed porcelain forms in rich, saturated colours.

Cooper's works have been exhibited around Britain and Europe, and pieces can be found in the Victoria and Albert Museum in London, the Royal Museum of Scotland and many others. In addition to his artistic renown, Emmanuel Cooper is one of the eminent academics and leading voices in ceramics today. He is the editor of the acclaimed *Ceramic Review*, and is a Visiting Professor at the Royal College of Art.

1
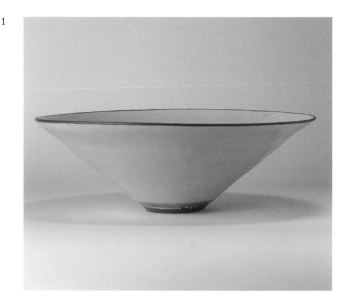

2
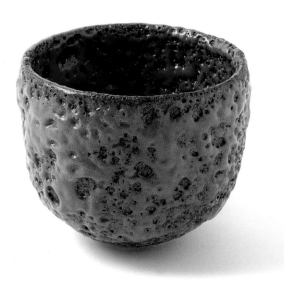

1 *Bowl*, 2006
porcelain, yolk glaze, venetian red rim and base
2 *Bowl*, 2006
stoneware, volcanic glaze
3 *Bowl*, 2006
porcelain, lime glaze, gold lustre
4 *Jug*, 2006
porcelain, slip-cast, volcanic glace

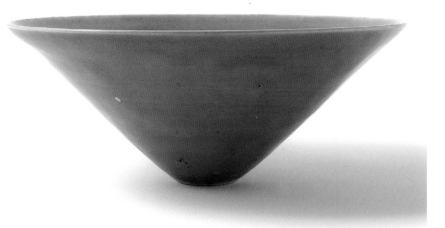

3

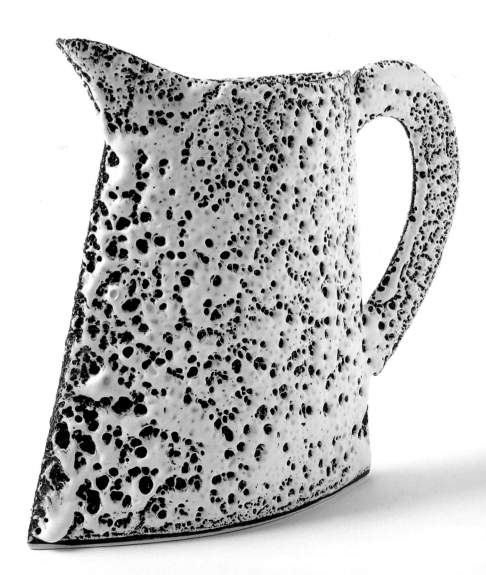

4

Natasha Daintry

The use of colour as a material is the primary focus of Natasha Daintry's beautifully understated bowls. Following in the footsteps of Yves Klein, Wolfgang Laib and Donald Judd, Daintry explores the way that colour complements form, lending it depth and substance. She experiments with hundreds of transparent glazes and industrial stains, in a constant search for that immersive quality that attacks the senses with its lucidity. Most of her pieces are straight-edged bowls in solid colours, but some pieces layer glazes and stains—a rim of red beneath an inky black, a violent yellow against a deep blue—creating a dialogue of colour. The rims of the pots are often left white, contrasting with the robustness of the colours, drawing the eye in, and down to the sensual lines of the shallow pots.

Form, and its correlation to colour is also a major concern for Daintry. In *Plug*, she fills the interior of a low cylindrical bowl with a shallow coloured disc. This disc acts as a stopper that literally plugs the interior space, making it charged and tangible. "I want to know if that luminous space inside a bowl, where the colour hovers, can increase in intensity", she says of her work. The reduction of the forms to cylinder and disc, the horizontal and vertical lines of the shallow bowls and the dialogue between the colours pushes her work into a realm of minimalist abstraction.

Daintry's pots are thrown, and she aims for an instinctive sense of the material that is reflected in the forms. "I've started throwing with my eyes closed. I'm mesmerised by that feeling of stillness within motion." The passion and immediacy that this approach lends itself to is reflected in the dynamic physicality of Daintry's vessels.

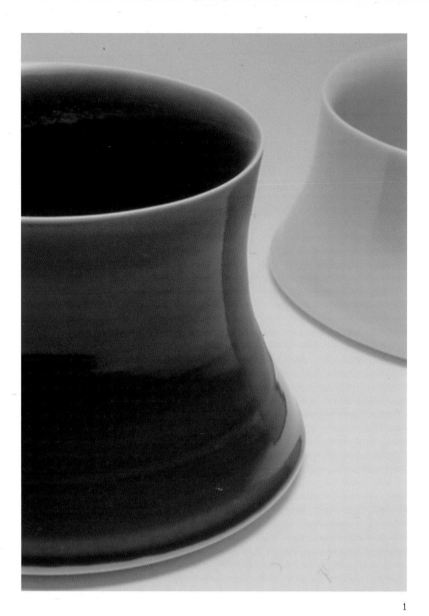

1

1 *Dark Purple Bowl With Yellow Line* and *Canary Yellow Bowl*, 2003
thrown porcelain
approximately 24 cm
2 *Tiny Dark Purple Bowl With Red Line*, 2003
thrown porcelain with dark purple and red glazes
8 cm diameter
3 *Glaze Drip* (detail), 2002
mid-purple glaze falling over canary yellow line

2

3

The Vessel **Natasha Daintry**

4

4 *Massive Plug*
thrown porcelain
50 cm diameter
5 *Drift of Colour*
approximately 4 cm each

5

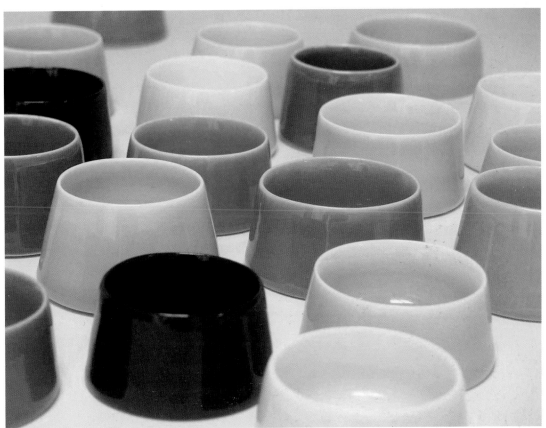

Pam Dodds

Pam Dodds describes her thrown clay pieces as quiet celebrations; "on the one hand they stand silent and still, but on the other they give a feeling of movement and almost seem to be dancing". With this she sums up the sculptural nature of her vessels, the tender but often brutal and grotesque forms, that look as though they have been torn apart by a great wind, or sucked into a swirling formation by a whirlpool. In pieces such as *Burst Out,* what starts as a delicate vessel tails up into sharp, scythe-like wisps that seem at once integral to the vessel and deeply foreign. This overt emphasis on formal qualities is further highlighted by Dodds' use of simple internal glazes, or even just black slip. This monochorome approach is intended to emphasise the radical forms, allowing no distraction from the violent energy embodied in the sharp lines.

Dodds' current work was inspired by and also reflects a very spiritual side, echoing some of her earlier work creating Eucharistic chalices, where "the clay was torn so that reference was made to the breaking of bread and the sharing of wine in one ceramic piece". Each piece is painstakingly designed and crafted. The pot is thrown and turned, then cut according to the design, and the base is inscribed with a line from a poem, hymn or anthem, before being fired. The pot is then rubbed down and an internal glaze or black slip applied, before a final firing and further rub down. She places a lot of emphasis on the significance of her working processes: "When I throw, the clay is a chaotic whirlwind, which when properly controlled becomes a wall of nothingness surrounding a still and silent centre."

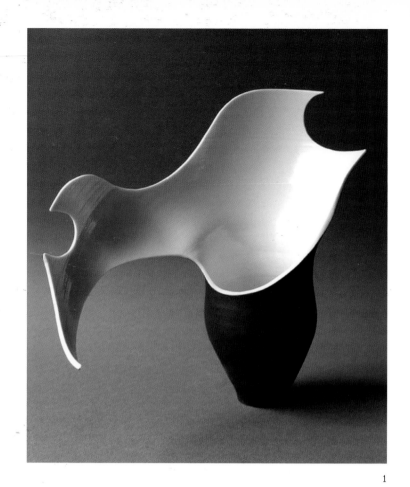

1

1 *Halfway up the Stairs*, 2006
porcelain, black slip
21.5 cm
2 *Burst Out*, 2005
porcelain, black slip
22.5 cm

Overleaf
3 *Thou True Life Giving Vine*, 2005
porcelain, black slip
20 cm
4 *It Flows Through Calm Reaches*, 2005
porcelain
23 cm

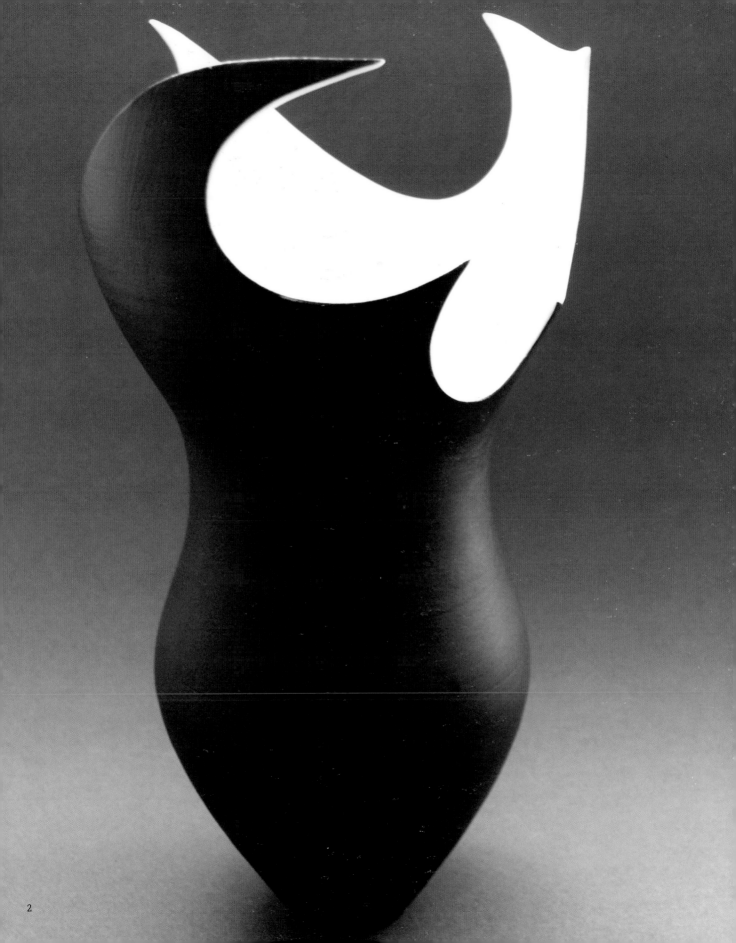

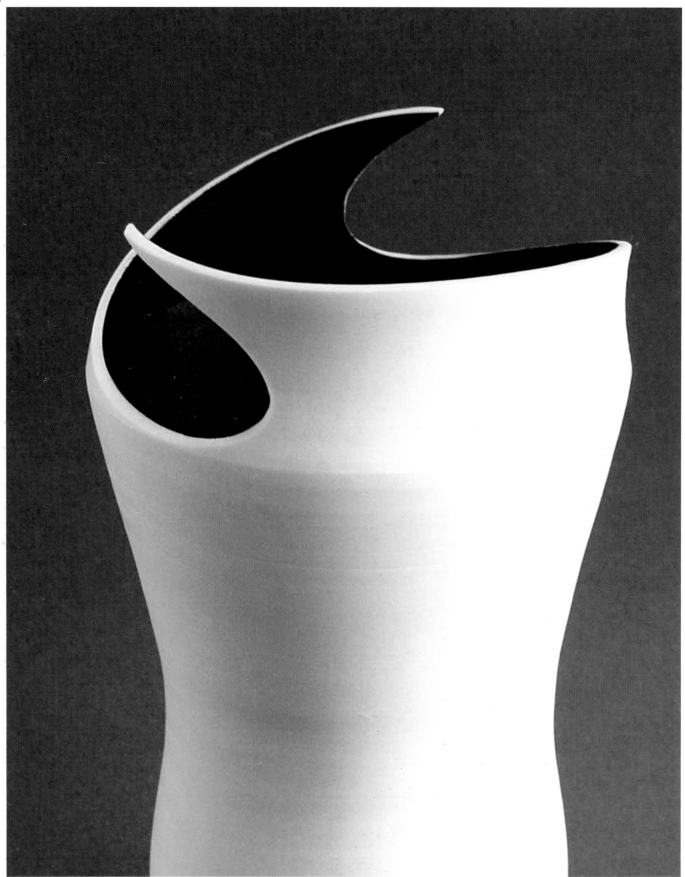

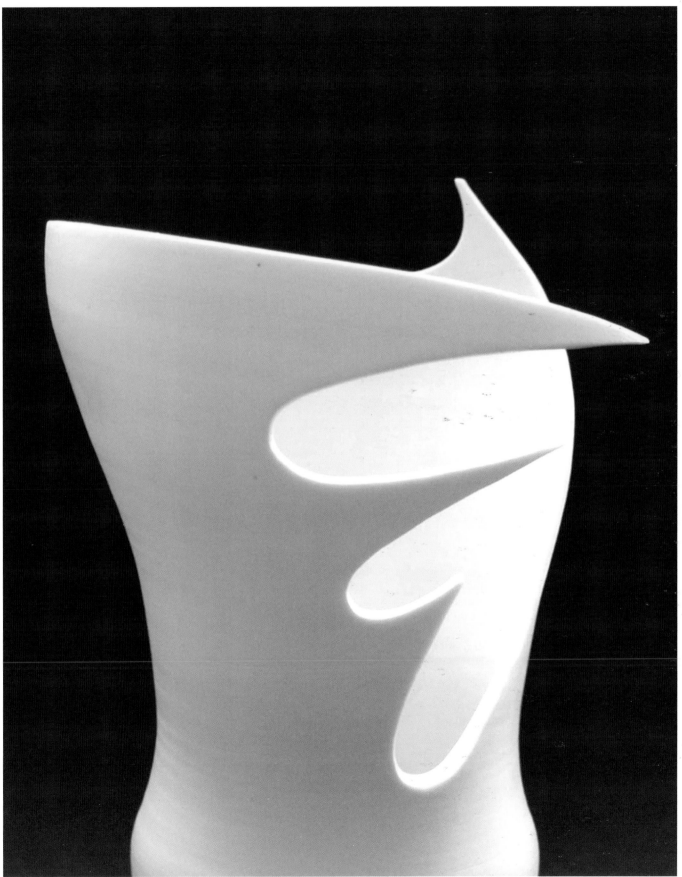

Jane Hamlyn

The plain, unembellished vessels of Jane Hamlyn are at once simple and sophisticated. The clean lines of the pots provide a striking canvas for the spectacularly coloured salt glazes that she uses. Unlike other glazes, applied to the surface of a piece, salt glazes are formed from the clay itself. Salt is thrown into a kiln, and the resulting vapour creates a chemical reaction with the surface of the clay. The colours then created have a muted, natural feel to them that is very organic to the piece. Jane Hamlyn has long been recognised as one of the foremost salt-glaze potters in Britain.

Hamlyn is a great believer in functional ceramics, relishing the way vessels can celebrate the daily rituals of life "serving and offering, giving, receiving and sharing". In recent years, Hamlyn's work has become more severe. The straightforward, almost formal clarity of her pots means they are able to create their own abstract syntax. When grouped together in pairs, trios or multiples, they become simultaneously functional objects, and a cohesive work of art. The coloured glazes have moved on to embrace warmer colours; rusts, ochres and a rich deep orange. They lean at gentle angles, adding a tactile quality to the pieces, encouraging an audience participation that Hamlyn embraces: "My pots are made to be touched... when holding a pot and considering how to use it, the user continues its creative life and fulfils its real function. I like that idea."

Hamlyn has been a successful and prominent potter since the 1970s. She exhibits her work worldwide, and it has been included in many permanent collections.

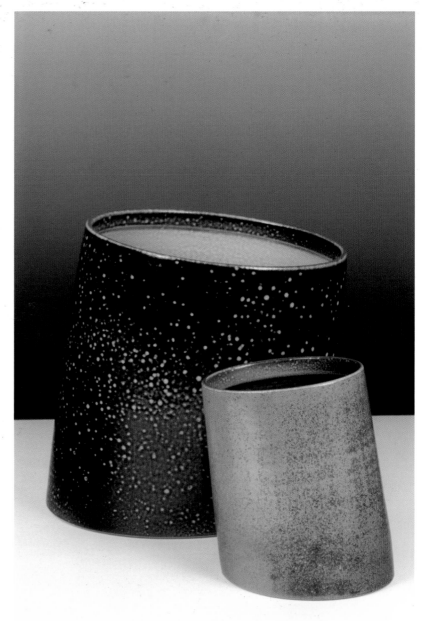

1 *Cool Duo* (from the *Empty Vessels* series), 2006
salt-glazed stoneware ceramic
25 x 25 x 21 cm and 18 x 16 x 13 cm
2 detail of *Vessels*, 2006
salt-glazed stoneware ceramic
various dimensions

2

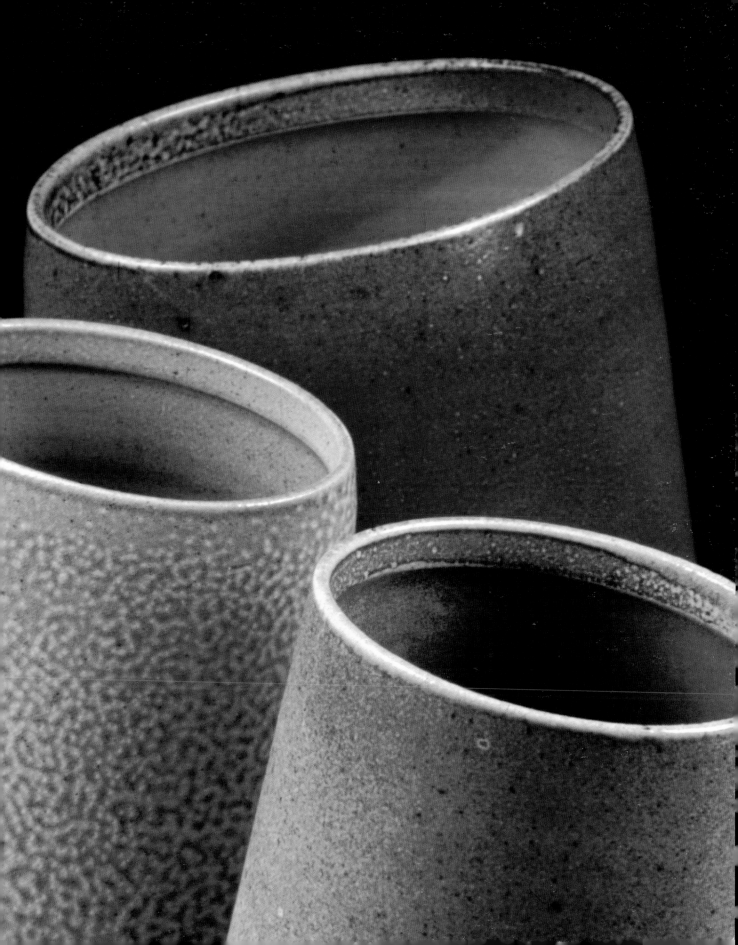

Grayson Perry

Winner of the 2003 Turner Prize, Grayson Perry is without a doubt one of the most notorious potters in the world, and the amount of public attention that his work has received has impacted massively on the larger world of ceramics. The classical lines and bright colours of his traditional urns and vases create a seductively simple canvas on which to explore the darkly controversial political and social issues that concern him. He uses this fundamental discrepancy between medium and message to engage the viewer. In his own words: "I have always had a guerrilla tactic, a stealth tactic. I want to make something that lives with the eye as a beautiful piece of art, but on closer inspection, a polemic or an ideology will come out of it."

Using photographic transfer, painting, collage and stencilling, Perry's vessels address themes of art and history, consumer culture, violence and sexual abuse, amongst others. Renowned for his cross-dressing tendencies, his female alter-ego, Claire, features heavily—a representation of the artist within the cultural context he is depicting. He is drawn to the 'second class status' of ceramics—the default perception of it as a decorative art—for the same reasons that he is drawn to cross-dressing and the perception of women as second-class citizens. His subversion of gender and art go hand in hand: "If I did something purely decorative, and I've approached that line a few times, where I've looked at pieces and thought 'that's pretty', but it's like potatoes without salt. I can't stomach it."

Perry's work has been exhibited in galleries across the world, and he has appeared in countless documentaries, articles and interviews. Alongside the controversy and fame, at the heart of Perry's work is a passionate desire to comment on the the problems of society around him.

1

1 *Precious Boys*, 2004
glazed ceramic
53 x 33 cm
ccllection Warren and Victoria Miro, London © The artist
2 *Barbaric Splendour*, 2003
glazed ceramic
67 x 35.5 cm
image courtesy of Victoria Miro Gallery © The artist
3 *St. Claire (Thirty Seven Wanks Across Northern Spain)*
glazed ceramic
84 x 55 cm
image courtesy of Victoria Miro Gallery © The artist

Overleaf
4 *In Praise of Shadows*, 2005
glazed ceramic
80 x 50 cm
collection Warren and Victoria Miro, London © The artist
5 *Quotes from the Internet*, 2005
glazed ceramic
65 x 45 cm
image courtesy of Victoria Miro Gallery © The artist

3

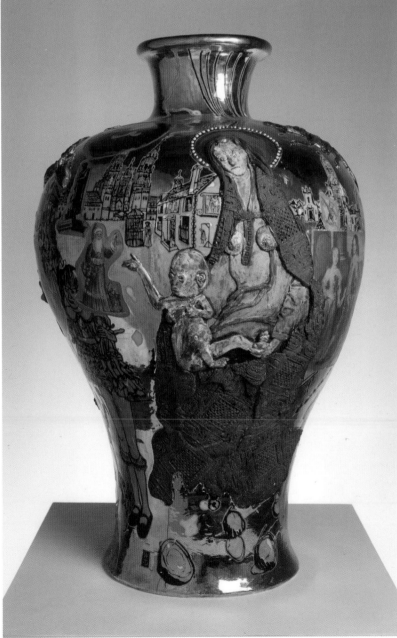

2

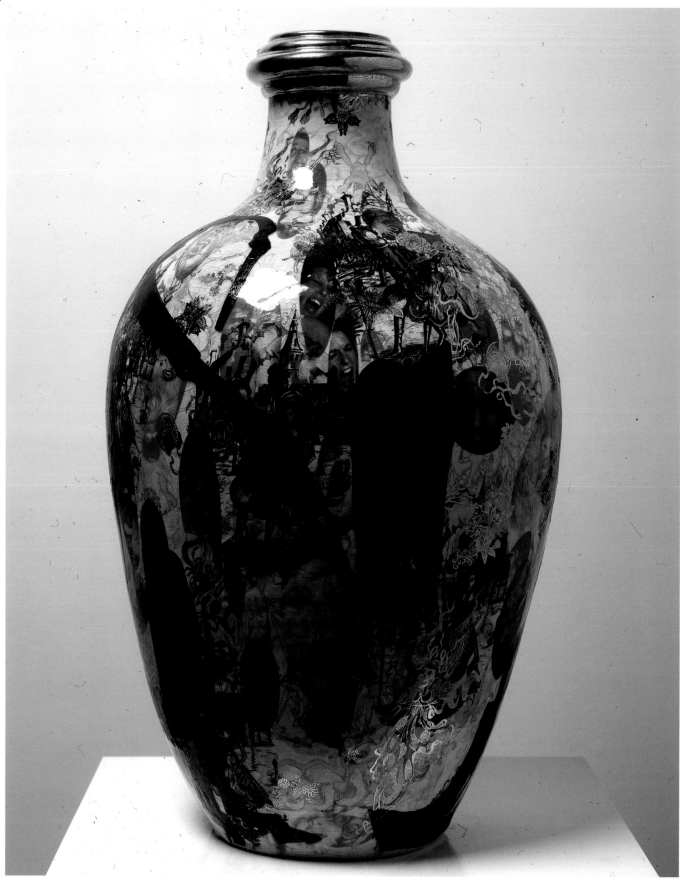

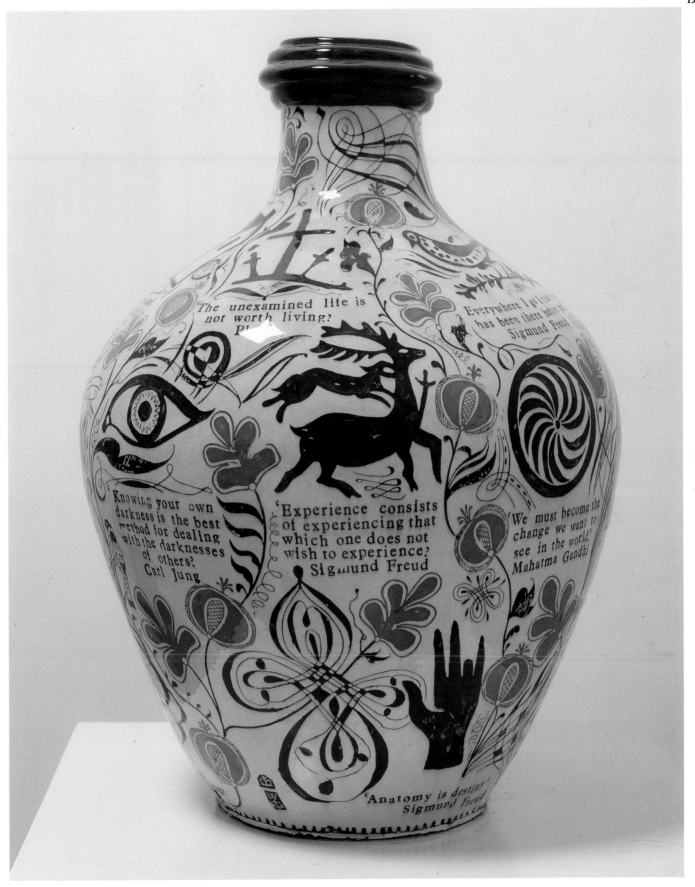

Wai-Lian Scannell (Soop)

Established in 2004, multi-disciplinary product design company Soop is the brainchild of London designer Wai-Lian Scannell. Soop's range includes a wide variety of domestic paraphernalia from vinyl stickers to small furnishings to tableware. All of Soop's products feature Scannell's kooky sense of humour and dry wit.

The set of *Duncan* mugs, designed for tea and biscuits, leave the drinker with a tea-stained shadow of their former biscuit (a choice of shortbread, custard cream or Jammie Dodger) whilst the *24 Carrot Gold* plant holders, cast from real carrots and featuring a trademark play on words, sprout whatever it is you choose to plant in them. *Pretty Nasty* plates, meanwhile are designed with what Scannell calls "the more daring or adventurous diner" in mind. What initially appears to be a decorative floral pattern is in fact a kaleidoscope of flies and other insects, which is uncovered as you eat. *Plate is for Pea,* an inversion of children's book phrase "'P' is for Plate", is a set of ceramic dinner plates with a difference: tiny, deliberately pea-sized holes. An accompanying booklet explains 18 games to play for anyone with stray peas, spare time and a spoon to use as a catapult.
Like a cartoon devil sitting on your shoulder, Soop slyly encourages you: "Go on, play with your food..."

1 **24 Carrot Gold**, 2006/7
earthenware vase
various dimensions
2 **Duncan**, 2005
set of three earthenware mugs
9.5 x 8 cm
3 **Pretty Nasty**, 2006
Bone china dinner plate
26.5 cm
4 **Plate is for Pea**, 2005
earthenware dinner plate and after-dinner party game in one
27.5 cm

3

4

Timea Sido

"A beautiful artefact needs no real function", writes young British designer Timea Sido, "just pure aesthetic elegance to captivate its viewer." A graduate of London's St Martin's School of Design, Sido makes delicate, fine white earthenware pieces individually, to design, and for manufacture and batch production. Inspired by tangled spider webs, decaying autumn leaves and other accidental, haphazard patterns found in the natural world, all her pieces feature an intricate criss-cross pattern of organic lines that has become her trademark. This is achieved through slip-trailing. She plays with ideas of control and passion by contrasting the wild tangle of the liquid slip with the smooth flawlessness of the earthenware.

Her *Tangled Web* Collection consists of three distinctive designs: *Fragile Fragment* pieces explore the connection between the tangled lines and a solid smooth surface. *Tangled in the Middle* pieces set the lines into geometric shapes within the piece, and *Tangled Web* pieces use only tangled lines to create mesmerisingly delicate structures.

Sido is currently working from the Cockpit Arts Studios in Holborn, West London. Her work has attracted much commercial attention and has been purchased by many respected establishments.

2

1 *Fragile Fragment Sphere Vessel*, 2006
white earthenware
23 x 23 cm
photograph by Colin Mundy
2 *Tangled in the Middle bon-bon box*, 2006
white earthenware
6 x 12 cm
photograph by Barbi Sido
3 *Tangled Web tea light holders*, 2006
white earthenware
7.5 x 7 cm
photograph by Barbi Sido
4 *Fragile Fragment medium bowl*, 2006
white earthenware bowl

3

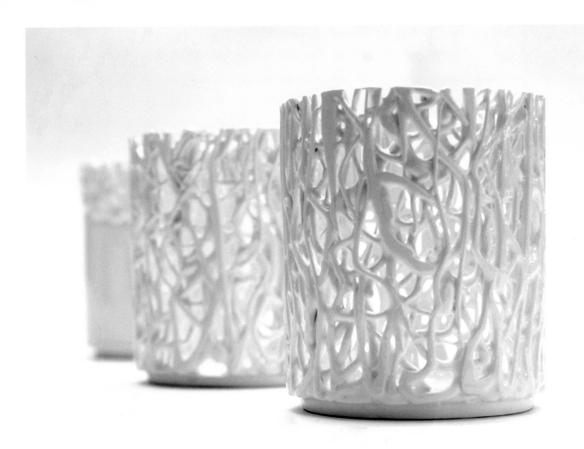

4

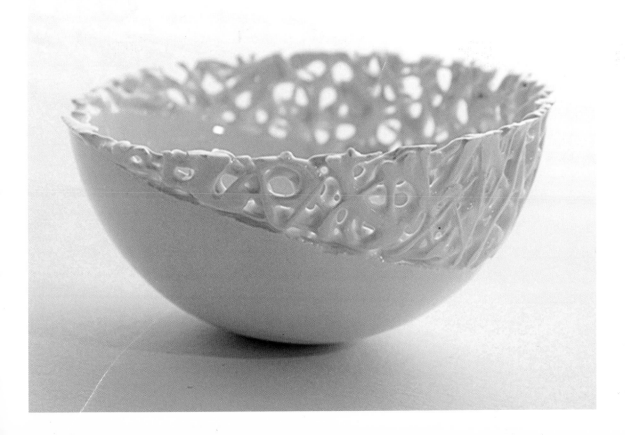

Beyond the Vessel

Gordon Baldwin
Marek Cecula
Ken Eastman
Simon Fell
Jonathan Keep
Anne Marie Laureys
Kjell Rylander
Piet Stockmans
Hans Stofer

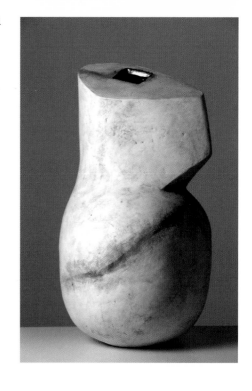

Gordon Baldwin

One of Britain's foremost post-war ceramic artists, Gordon Baldwin has been a creative force for over 40 years. One of the defining voices that shaped ceramic art today, his work can be found in the public collections of such prestigious galleries as the Victoria and Albert Museum in London, Rotterdam's Boijmans van Beuningen Museum and New York's Museum of Modern Art.

Baldwin uses the vessel as a starting point for his personal explorations. The limitations of the form allow the artist to create highly expressive works by freeing himself from immediate practical concerns, in much the same manner as a haiku poet or a blues singer use the rules of their form as a framework on which to hang their improvisations. From there a process of instinct and intuition takes over, abstracting the vessel into virtually unrecognisable forms. As Baldwin himself puts it, his work involves "an intuitive process carried on without analytical thought", which allows him to explore his own identity and what he calls "the soup of my experience". The results are bold, sculptural pots that are heavily influenced by Modernist art. In *Vessel According to Klee XII,* the influences of the radical geometries of the early twentieth century are clearly apparent.

Baldwin's work was key to the re-imagining of the vessel in ceramic studies. Now in his 70s, Baldwin's work continues to challenge and inspire. Recent pieces take on new, minimalist forms in muted subtle colours, their surfaces feel weathered, worn away by time, like pebbles on a shore. Indeed Baldwin cites a beach in North Wales as a primary source of inspiration for his explorations into "different sorts of darkness and silence".

In recognition of his outstanding contribution, Baldwin was awarded an OBE in 1992 and received an honorary doctorate from the Royal College of Art in 2000.

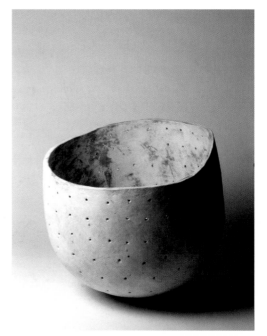

1 *Vessel According to Klee XII*, 2002
clay
64 x 36 x 36 cm
2 *Bowl*, 2005
clay
40 x 48 x 45 cm
3 *Vessel for Dark Air IV*, 2002
clay
63 x 47 x 49 cm
4 *An Alchemical Vessel*, 2006
clay 63 x 48 x 19 cm
photographs by Philip Sayer

4

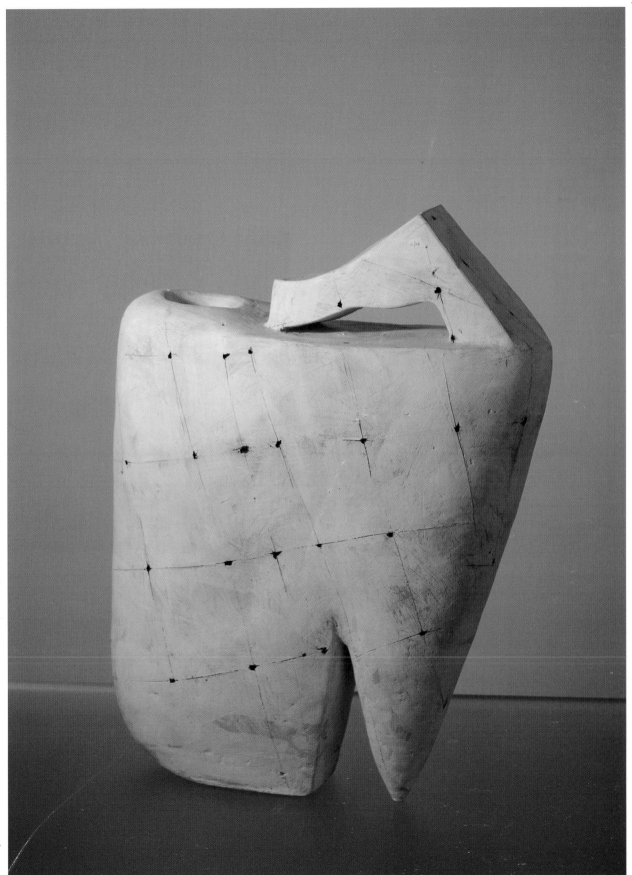

Marek Cecula

The art of Marek Cecula is deeply distinctive, and yet exceedingly hard to pin down. His varied output seems to encompass dozens of themes and concepts, and employs a broad variety of techniques. Many of his pieces indicate an interest in the blurry hinterland between art, craft and industrialisation. His pieces often highlight the disparity between various production techniques, products and the perceptions thereof. In *The Porcelain Carpet,* for example, Cecula has printed an image of a handmade Persian rug onto standard, industrially-produced white dinner plates. This is an installation of contradictions; the softness of the wool versus the hardness of the plates, the rectangle of carpet superimposed on the round surfaces, the impossibility for the viewer to walk on this fragile surface. It raises questions about form and function, decoration and utility, and art and craft.

The inspiration for much of Cecula's work comes in part from his collaborations with ceramic industries. As with *The Porcelain Carpet,* he often uses industrial products as his canvases, or alternatively, interferes with typical mass-production processes, disrupting their perfection, challenging notions of beauty and functionality. In *Burned Again,* he takes Danish factory porcelain, and fires it in Japanese-style anagama wood-firing. The resulting effect is a form that seems at odds with its surface texture, a commentary on different cultural perceptions of beauty, and how they may complement or contradict one another.

Cecula is an internationally renowned artist, with numerous solo exhibitions at the Garth Clark Gallery, New York, and in Poland and Norway. He has taught at the Parsons School of Design, New York 1985–2004, and is currently a Professor at the National College of Art and Design, Bergen Norway.

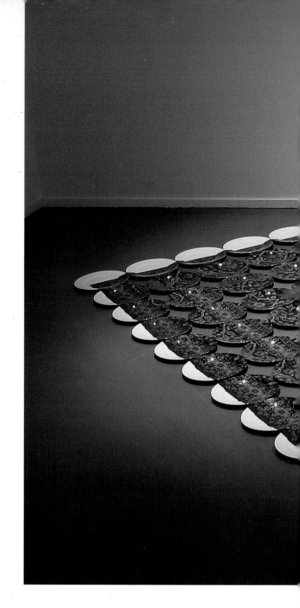

1

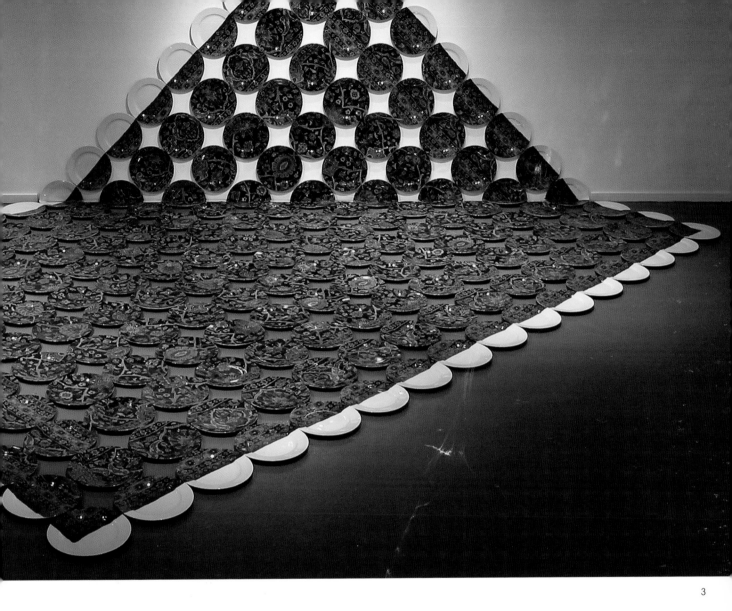

1 *Hygiene Set V,* 1995
vitreous china and chrome
50 x 38 x 32 cm
photograph by John Bessler
2 *Burned Again Set V*, 2005
sculpture, industrial porcelain and wood-fire
56 x 20 x 20 cm
photograph by Sebastian Zimmer
3 *The Porcelain Carpet*, 2002
sculpture/installation, industrial plates and digital ceramic decals
350 x 500 cm
photograph by Adam Chmielecki

Ken Eastman

Ken Eastman considers the vessel to be an object, which exists to define the empty space within its walls, and it is this that captures his imagination. He makes vessels that are not functional, but works of art, designed to be the visual expression of form and meaning. Without planning the actual structure, he jots down sketches of the ideas that he wants to engage with, and then breaks the vessel down into its primary forms. Using a labour intensive glazing process, with layers upon layers of colours, he then creates a dialogue between form and surface, two- and three-dimensions.

Operating as both a builder and a painter, he challenges viewers' expectations of a vessel, working towards an ever more abstracted essence, the powerful colours lending a poetry to the pieces that prevents them becoming a purely academic study. Using fine, undulating surfaces, and both clashing and complementary colours, pieces such as *Nobody's Business*, have a dynamic vivacity, a sense of force and movement. Eastman says of his work, "A large part of the reason for making is to see things that I have never seen before, to build something which I cannot fully understand or explain."

Trained at the Edinburgh College of Art and the Royal College of Art, London, Eastman exhibits widely, and his work is included in many collections across the world, including Japan, Italy, Australia, The Netherlands, Germany, and the United Kingdom.

1

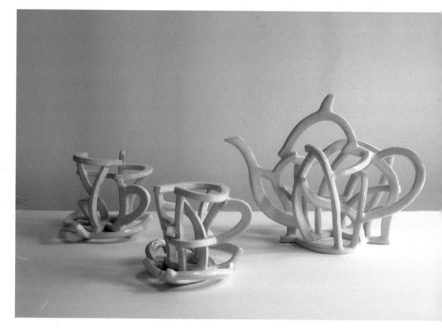

2

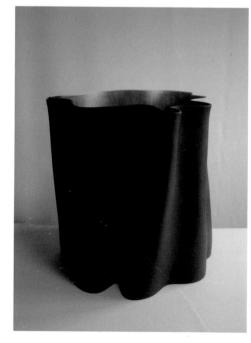

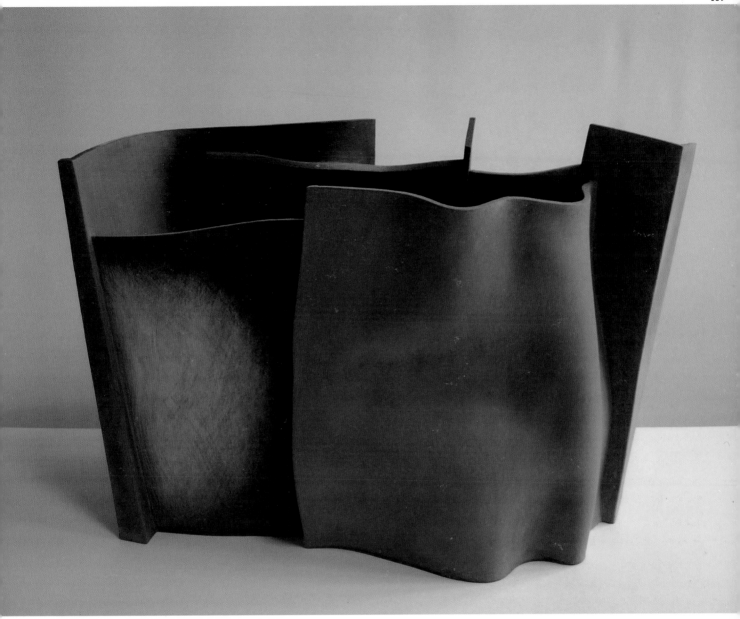

3

1 *Teapot and Cups and Saucers*, 2004
white stoneware painted wth slips and oxides
2 *Looking North*, 2005
white stoneware painted with slips and oxides
41 x 40 x 42 cm
3 *Nobody's Business*, 2006
white stoneware painted with slips and oxides
53 x 30 x 34 cm

Simon Fell

The irreverent work of London artist Simon Fell draws on an associative flow of ideas, fleeting notions and seemingly random thoughts, captured on the spur of the moment and recorded in a series of notebooks, sketchpads and on camera. Fell then works from those records, sculpting directly into clay, using slab building and press moulding techniques. The whole process is open to changes, manipulations and new ideas throughout, right up to the point that the stone or earthenware is glaze fired.

The results inhabit a menacingly surreal universe of blackened machinery, broken wheels, tanks and oversized guns. The themes of masculinity, power and transience, lend his work a playful sense of *Boys' Own* adventure and simultaneously allow him to make a powerful political statement. His figurative vessels reference the uncertainties of the twenty-first century, as well as the history of industrialisation. Fell describes his work as being both of now and of the past: "it's part of my life in the twenty-first century, but it is also part of the continuum that pottery represents". This dichotomy—between present and past—mirrors the duality in the sculptures between boyishness and manhood.

Fell's sculptures have the precise geometry and sinister simplicity of an animated computer game—no coincidence, as he also works with computer graphics. Although the vessel is not an immediately apparent motif in his work, there is an underlying sense of the vessel in many of his pieces, and whilst he admits "I'm not making cups and saucers here", he also acknowledges the persistency of this theme, as apparent in *Carafe*, a sculpture that is at once a cannon and a vessel.

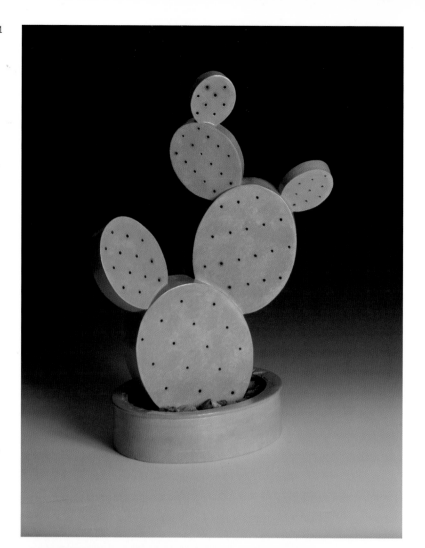

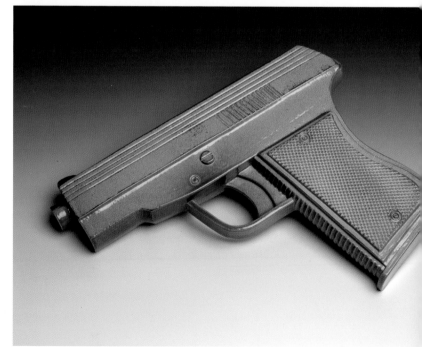

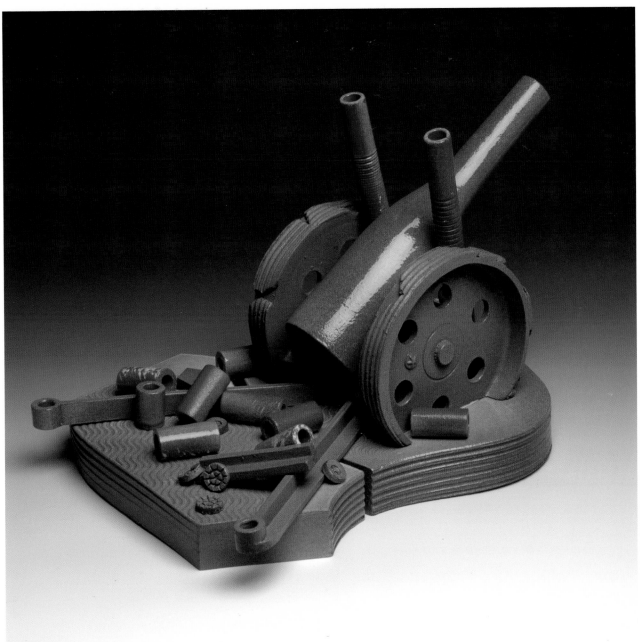

3

1 *Cactus*
stoneware sculpture
photograph by J Mason, www.photoarc.co.uk
2 *Potgun 1*
earthware sculpture
18 cm
photograph by J Mason
3 *Carafe*
earthenware sculpture
20 cm
photograph by J Mason

Jonathan Keep

South African ceramicist, Jonathan Keep, has been working in the field for over 30 years. Keep's main interest focuses on the physical form of his vessels. He sees them as sculptures, to be approached and looked at from different viewpoints and continually explored. The structures of his objects are different from every angle with no apparent symmetry, inviting the viewer to move around the vessel and engage with its personal, inner language.

His pieces deal with the biology of emotion—the way in which an object can elicit a universal gut-reaction. It is this universality that draws him to vessel forms. The global familiarity of the vessel is a great equaliser for viewers. Using the pot as a metaphor for the human body, he creates a dialogue between the 'skin', or the exterior of the pot, and the emotional interior. When he throws his pots, he attempts to work from the inside out, intuitively finding the form of the internal shape and then creating the pot around it. In *Listening Pot II,* for example, the bulbous pot has both a sensuality and a calmness at its heart, a clear personality that does not judge or demand, but exists nonetheless.

The object itself is not as important to Keep as how it can communicate what he calls "the pleasure of natural order", the pattern, symmetry, structure and process of creation of the object. Keep's philosophy is based on the connection between art and nature, and the primary elements associated with the formation of ceramics—earth, fire and water.

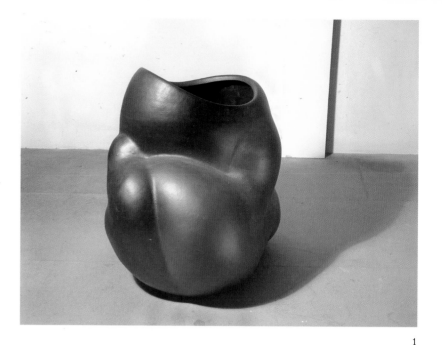

1

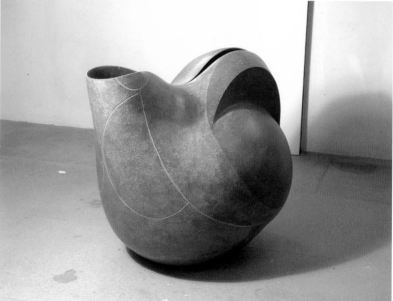

2

1 **Black Floor Pot**
vessel/sculpture, stoneware clay and glaze
75 x 68 x 80 cm
2 **Floor Pot**
vessel/sculpture, stoneware clay and glaze
60 x 55 x 92 cm
3 **Listening Pot II**
vessel/sculpture, porcelain clay and glaze
44 x 36 x 46 cm

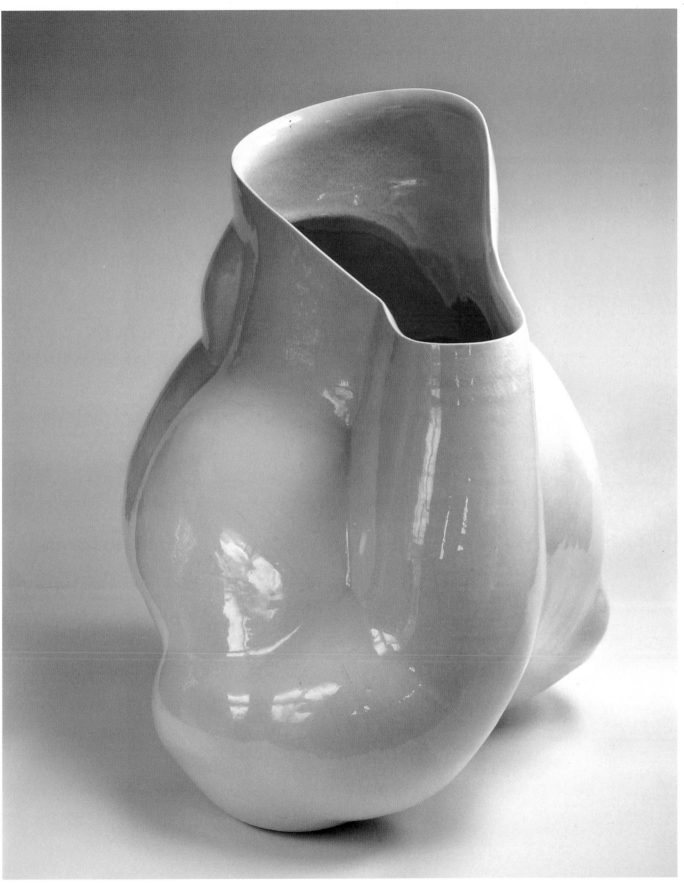

Beyond the Vessel

1

Anne Marie Laureys

The tactile pots of Belgian potter Anne Marie Laureys have a dynamic sensuality that makes the most of the malleability of the ceramic medium. The final product maintains the essence and the plasticity of the wet clay and the result is a highly emotive form, with fleshlike folds and unmistakable connotations of female genitalia.

Laureys starts her process by throwing a classic, symmetrical pot. Whilst the clay is still soft and wet, she pulls at it—folding, pinching, pushing and puncturing it, the tension of the clay underneath her fingers dictating the way the folds will take shape. She describes this process as: "a physical exploration of action, reaction and interaction between hand, mind and material". Although the pieces seem to have a random quality, Laureys takes her time finding the shape of the bowl, remoulding and refolding the clay over and over again. No two pots are the same, and in this she takes her inspiration from the work of British ceramicist George E Ohr, "the mad potter of Biloxi", and his 'no-two-alike creations'.

In her earlier work, Laureys completed the process with multi-coloured glazes that accentuated the interior and exterior of the pieces, creating shell-like, or leaf-like organisms. Her more recent work uses powdery clay-glazes, their granular quality adding another level of tactility to her work.

2

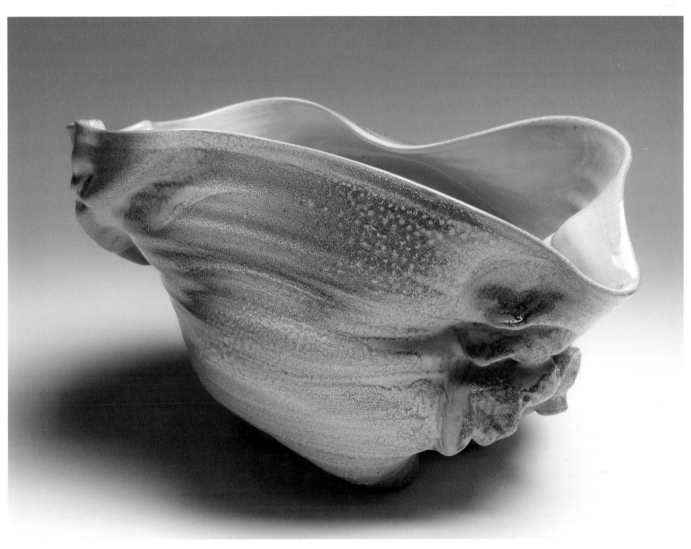

3

Kjell Rylander

Swedish ceramicist, Kjell Rylander, uses found, ready-made ceramics to construct his quirky creations, cutting and pasting the shapes together into surreal Frankenstinian cup-saucer hybrids, that are instantly recognisable as household objects, but whose function has been subverted or undermined. Mugs with five handles are fused to monstrous, cloud-like saucers. In *Resistance,* a series of plates have had their centres removed, leaving nothing but the decorative edging, like floating halos.

Before studying ceramics, Rylander worked for ten years as a construction carpenter, and this has left a distinct impression on the way he approaches his art. Deconstruction and reconstruction are essential elements in his work, making visual the process of creation. The pieces are social commentaries, challenging our perceptions of what makes 'proper' tableware, and by extension, what makes a proper society. The mutation of familiar forms conjures up images of disfigurement and disability and the importance we attribute to 'normality' is made uncomfortably apparent.

There is a humour and irreverence to Rylander's work, directed at the rich design heritage of his native Sweden, and many of his pieces make use of Swedish design classics. He advocates this type of iconoclasm, calling for a "more open and radical attitude and a broader understanding of clay". His playful approach is best illustrated in *Vent No. 4.* At first glance this piece appears to be an air vent, but upon closer examination, it turns out to be a rectangle of plate edges adhered to the wall, the shadows they cast creating an optical illusion of depth beyond the surface.

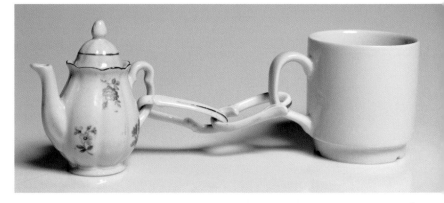

1

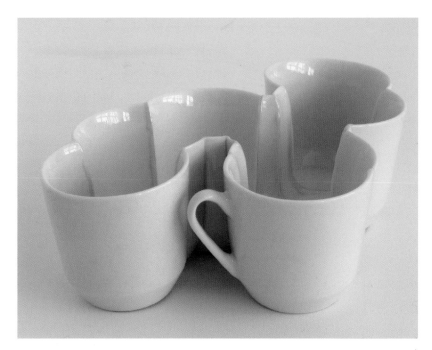

2

1 **Between**, 2000
porcelain and glue object
119 x 13 x 6 cm
2 **Untitled**, 2000–2001
porcelain and glue object
10 x 24 x 8 cm
3 **Vent No. 4**, 2005
porcelain and glue wall object
60 x 29 x 4 cm
4 **Resistance**, 2001
plate rack and porcelain object
55 x 34 x 31 cm

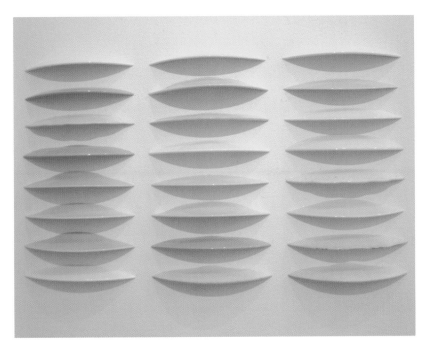

3

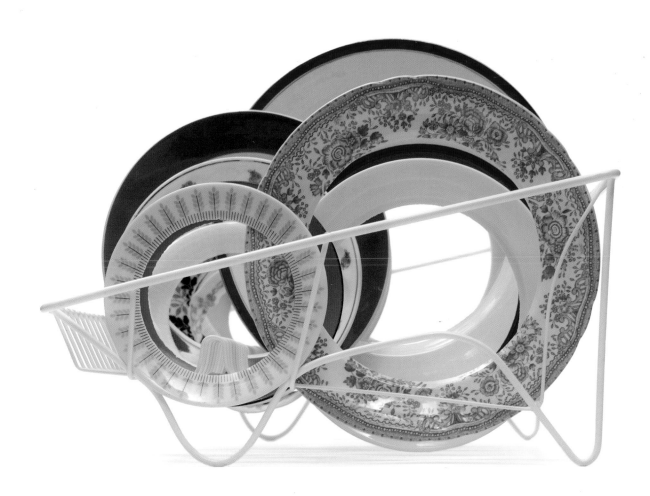

4

1

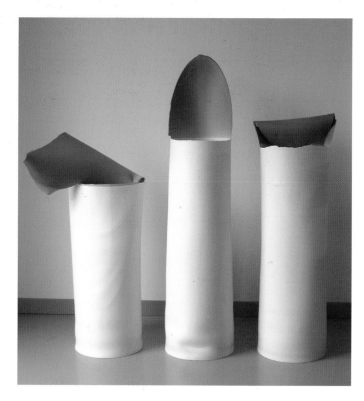

Piet Stockmans

Ceramicist, artist and industrial designer Pieter Stockmans believes that it is direct action not conscious thought that best stimulates the creative process. Action, Stockmans argues, is "a quest for simplicity, peace and physical well-being", in which ideas occur spontaneously and decisive choices are made on instinct. Working almost exclusively with porcelain slip and blue dip, he has created for himself an art of limitation, finding an endless variety within the self-imposed restraints. His work often deals in repetition, which he feels opens up a different kind of consciousness.

Stockmans has been working with porcelain since the mid-1960s. Initially he felt an urge to break with traditional imagery and the clichés associated with the material, by defunctionalising tableware, and then moved onto installations with porcelain on walls and floors. In *Three Vases,* vases with the matte white clarity of eggshells, stand over a metre tall, their blue rims skewed at random angles, illustrating the moment of contact between artist and object, as they are taken out of the plaster mould, still wet. *Folded-Out Vase* takes the deconstruction of the utilitarian object one step further, literally unfolding the vessel, exposing its cobalt innards.

Over a 40 year career, Stockmans has been generous with his experience, teaching in Holland and the United Kingdom as well in as his native Belgium. He has exhibited widely in cultural centres across Europe, including London, Paris, Rome, Berlin, Amsterdam and Brussels.

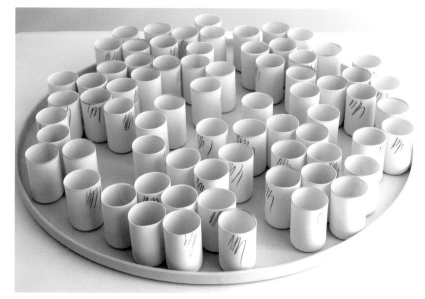

2

1 ***Three Vases***, 2004
porcelain sculpture
3 x 30 x 130 cm
2 ***Dish with Glasses***, 2005
porcelain sculpture
52 x 8 cm
3 ***Folded-Out Vase***, 2001
porcelain sculpture
25 x 32 cm

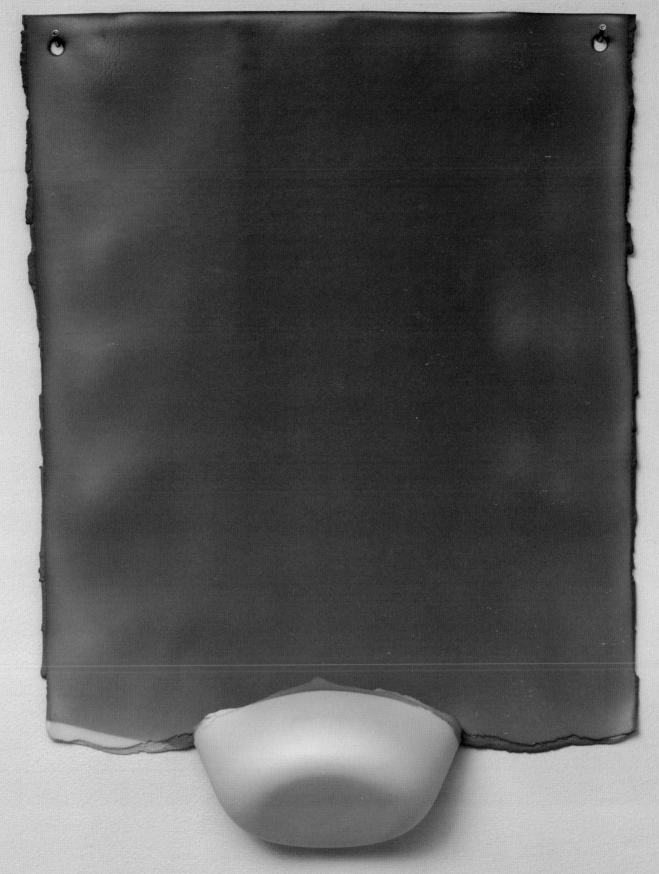

3

Beyond the Vessel

Hans Stofer

Hans Stofer brings a child-like excitement and enthusiasm to his art. A great believer in the beauty of imperfection, he plays with conventional perceptions of good design, minimalism and disorder. His *Resident Aliens* series is a tribute to the joys of domestic clutter, and a statement about the preciousness of objects that are often cast aside as 'useless'. Using found ceramic vessels, alongside wire and metalwork, Stofer's gentle wit alerts us to the fragility of our environment and ourselves. *It's Difficult To Clean* comprises a white ceramic bowl containing the shards of a broken plate, implying that the owner has preferred to smash the plate rather than clean it.

Other pieces in the series are broken bowls, plates and cups, reconstructed with the aid of glue and wire. The cracked shards extend the pattern and become part of it. In *Robin Hood,* the broken edge of the bowl is highlighted in gold, lending value to the fracture, which has allowed us an unobstructed view of the removeable robin figurine within.

Born in Switzerland, but now based in London, Hans Stofer is something of a polymath, well-known for his jewellery-making, silversmithing and metalwork as well as his work with ceramics. In all he does, he takes a spontaneous, instinctive approach: "I decided to become a designer-maker because I was tired of being told what to do", he says. "Now, although most of the time I do not know what I am doing, I am happy that I can get up in the morning, look into the mirror and get on with the day."

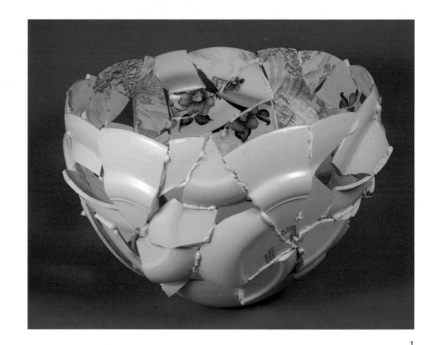

1

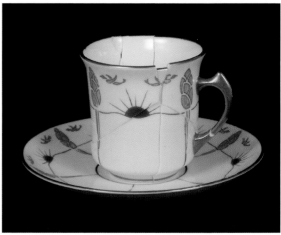

2

1 *Rose*, 2005
silicone, ceramic bowl
28 x 16 cm
2 *Jane's Cup Really Badly Glued Together*, 2005
glue, porcelain cup, saucer
6 x 8 cm
3 *Robin Hood*, 2006
gold leaf, porcelain bowl, removable bird
11.5 x 23 cm
4 *It's Difficult to Clean*, 2006
porcelain bowl, ceramic, glue
25 x 10 cm

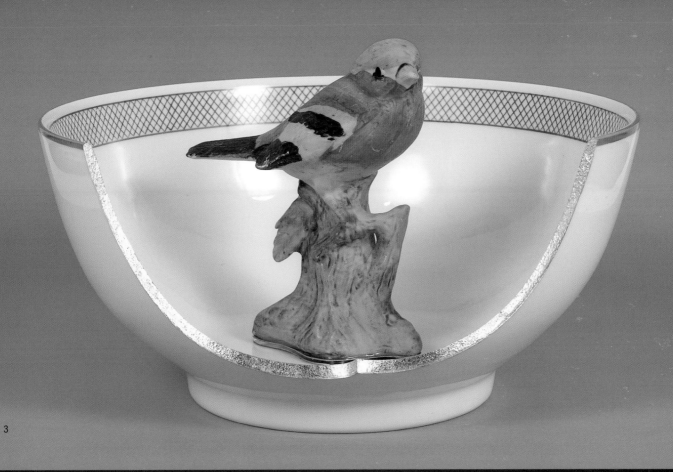

3

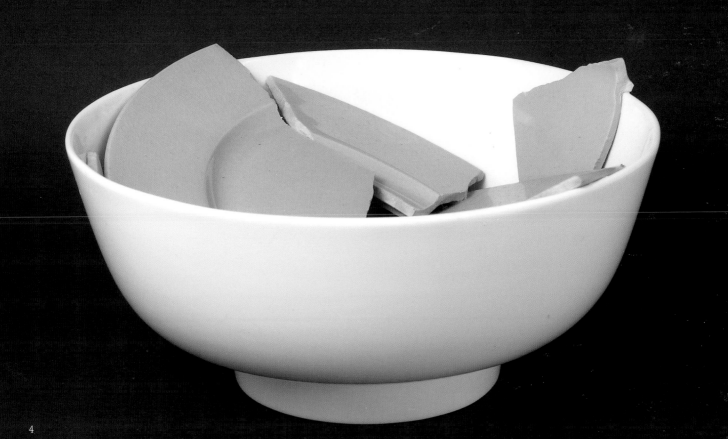

4

Surface Pleasures

Nichole Cherubini
Lubna Chowdhary
Robert Dawson
Stephen Dixon
David Rhys Jones
Ole Lislerud
Carol McNicoll
CJ O'Neill

Nicole Cherubini

A discussion of excess and formalism is at the heart of Nichole Cherubini's extravagantly adorned vessels. Based in America, Cherubini addresses what she perceives as the apathy of the society around her. Her vessels are resolutely non-functional. They have no bottoms, numerous handles, none of which can support the weight of the large forms, their necks are not attached and they are riddled with holes. They are then covered in an outrageous selection of fake jewellery, rabbit fur, wire, twigs and crystal ice. Ceramic gems come out of the lips, turning the vessels into vast barnacle structures. They are simultaneously disturbingly vulgar, and gorgeous in their complete lack of restraint.

The sculptures are a forceful comment on the decadence of American culture in the twenty-first century—the emphasis placed on affluence, and the issues of social status that result. They challenge the viewer to consider the way they relate to issues of consumption, class, gender and sexuality. The pedestals they rest upon are part of the sculptures. In stark contrast to the ornate vessels, they are surprisingly simple, often unpainted, and usually made of plywood or MDF. They elevate the sculptures to a higher level, the plinths of ignorance supporting the idols of extravagance.

Cherubini uses coiling to make her vessels, building them up layer by layer. The glaze is also applied in layers to create a dazzling richness of colour on the outside, whilst the interiors remain unglazed. Her pieces have been exhibited widely across the United States.

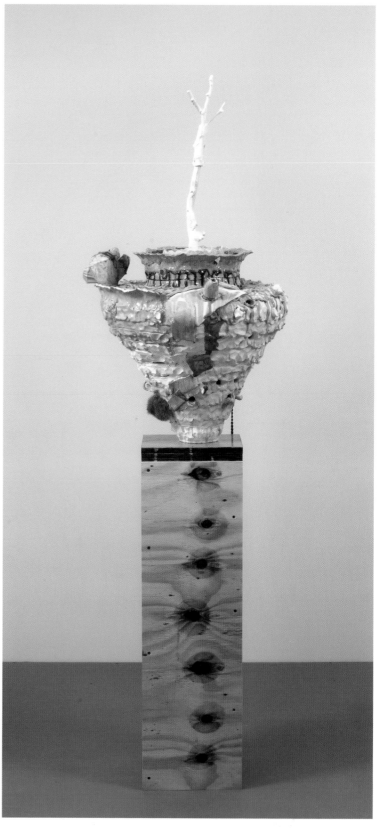

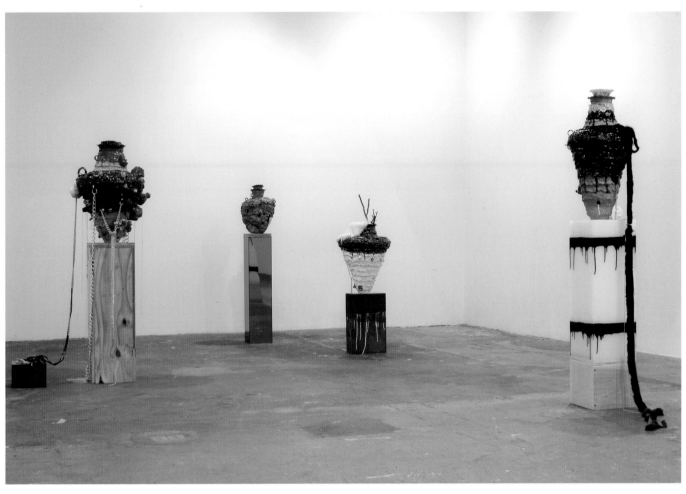

2

3

1 *Vanitas no 6*, 2006
mixed media
63.5 x 70 x 203 cm
photograph by Jason Mandella
2 View of Cherubini's installation at Klemens Gasser and Tanja Grunert
Inc, New York, 2006
mixed media
photograph by Jason Mandella
3 *White With Handle* (detail), 2006
mixed media
91.4 x 76.2 x 160 cm

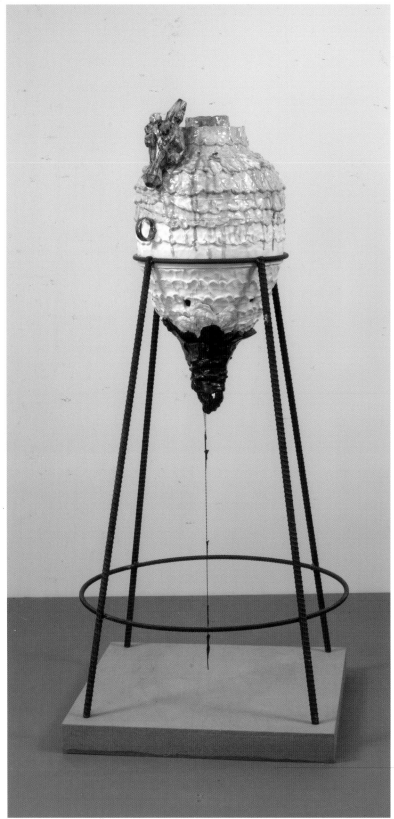

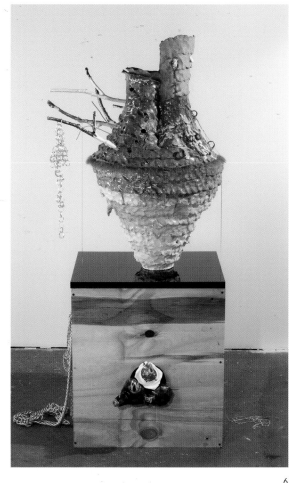

6

5 *G-Pot/Kalpis*
mixed media
photograph by Jason Mandella
6 *G-Pot, Green with Branches*, 2006
mixed media
photograph by Jason Mandella
7 *Nicole Cherubini* installation view, Institute of
Contemporary Art, Pennsylvania, 2007
mixed media
photograph by Aaron Igler

5

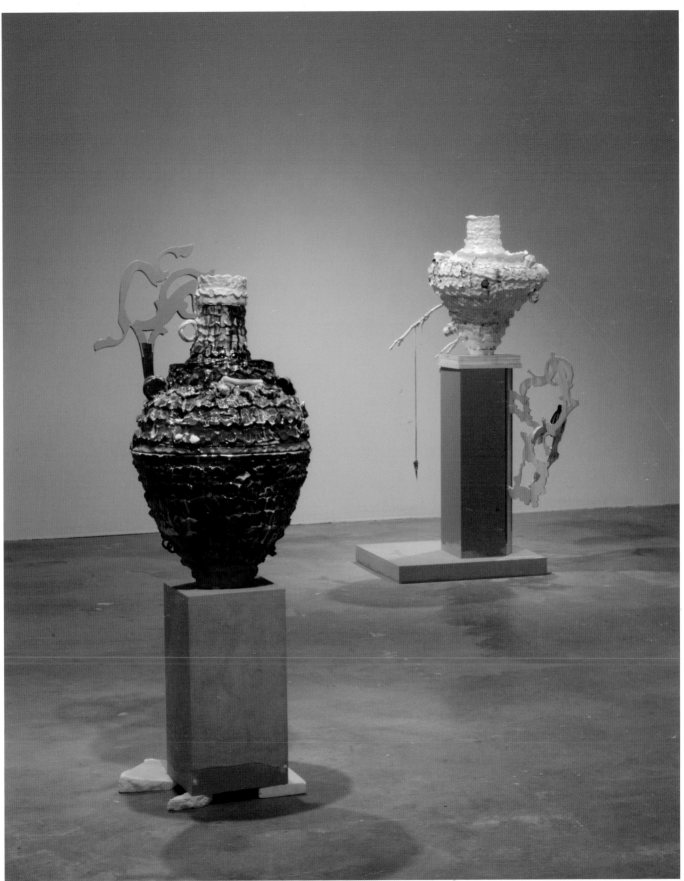

1

Lubna Chowdhary

Lubna Chowdhary's work deals with accumulation and colour. Her pieces are collections of things—objects or tiles that echo the noisy energy of modern life. In *Metropolis*, Chowdhary created approximately 1,000 small ceramic figurines. These minute sculptures are both familiar and strange. They represent objects from the past, the present and an imagined future—each one a commentary on the production, consumption and obsolescence of technology and popular culture. Together they form an anthology of contemporary Western culture, like a museum collection of colonial artefacts. It is a work of art that is never completed. New objects are continually created and added to the piece, and it grows organically—a diary of visual responses to the world around us.

The graphic intensity of Chowdhary's work is influenced by her multi-cultural upbringing. Born in Tanzania to Pakistani parents, she grew up primarily in London, and much of her work is an exploration of this mixed identity. In her vibrant tilework, Middle-Eastern and Indian influences are clearly identifiable. The bright colours and busy compositions reflect the restlessness of the immigrant existence, the inclusivity of rootlessness.

To create the dazzling colours of her work, Chowdhary blends the glazes in her studio and paints them in multiple layers and through multiple firings, pushing the limits of glaze technology.

2

1 *Metropolis*, 1996–2005
multi-object ceramic sculpture
8 x 8 x 8 cm each, 1,000 pieces
photograph by Nick Higgins
2 *Seven Sisters*, 2005
ceramic tiles
20 x 20 cm
photograph by Nick Higgins
3 *Script*, 2005
ceramic tiles
200 x 100 cm
photograph by Nick Higgins

Robert Dawson

"I want to make something that I hope will look good", reads Robert Dawson's strikingly simple and undogmatic statement of artistic intent. To do so, Dawson believes, requires "some kind of gentle violation of expectation". Dawson's gentle subversions often appear more like an all out war, an attack on the easy familiarity of traditional decorative patterns. And this is a war he wages on a variety of fronts. Dawson twists and warps familiar shapes, fades designs into blurred oblivion, adds unusual perspectives and covers the comforting regularity of traditional British pottery with frenetic abstract formations. In *In Perspective Willow*, he uses a traditional Willow pattern, and prints it at the angle that one would view it at eye level. In *Willow Pattern with Uncertainty*, the willow pattern is blurred and milky, as though it has bled into itself as a result of too many washes. Similar distortions of perspectives and clarities are evident in *Floor Tiles* and *You Too Can Be Confident*, both pieces witty reinterpretations of traditional Victorian tiles. The warped print creates a wavy grid that interacts with the rigid grid of the tiles that it is printed on, enhancing the sense of optical illusion, playing with the viewer's perception of surface and interior space. This approach is best summed up by the name of Dawson's website: aesthetic sabotage.

And yet, due to his use of such recognisable forms, Dawson's experimentation remains resolutely accessible. The references are not so abstracted as to be unidentifiable, and as such, it is not an attempt to completely break from the past. It is more a re-examination of that past, an exploration of an artist's relationship with those who have come before him. This approach has won him many private and public commissions, and his work can be seen in venues around London.

1

1 *Untitled* (detail)
ceramic floor tiling
2 *You Too Can Be Confident* (detail)
printed ceramic tiling

Surface Pleasures
Robert Dawson

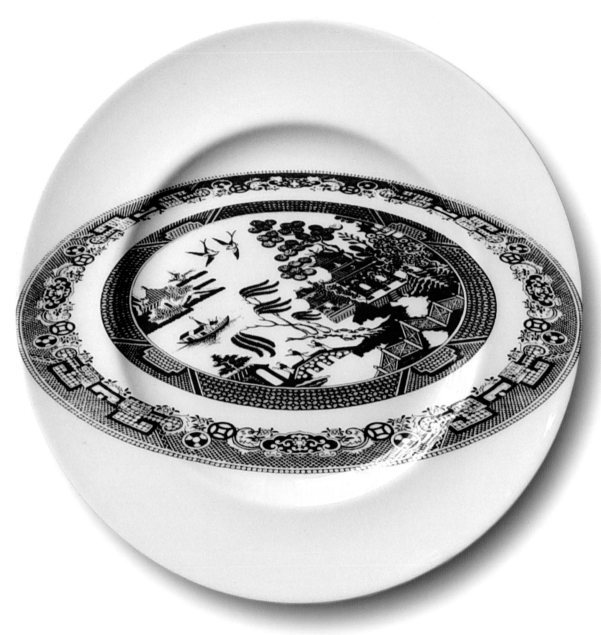

3

3 *In Perspective Willow*
printed bone china dinner plate
4 *Willow Pattern With Uncertainty*
printed bone china dinner plate

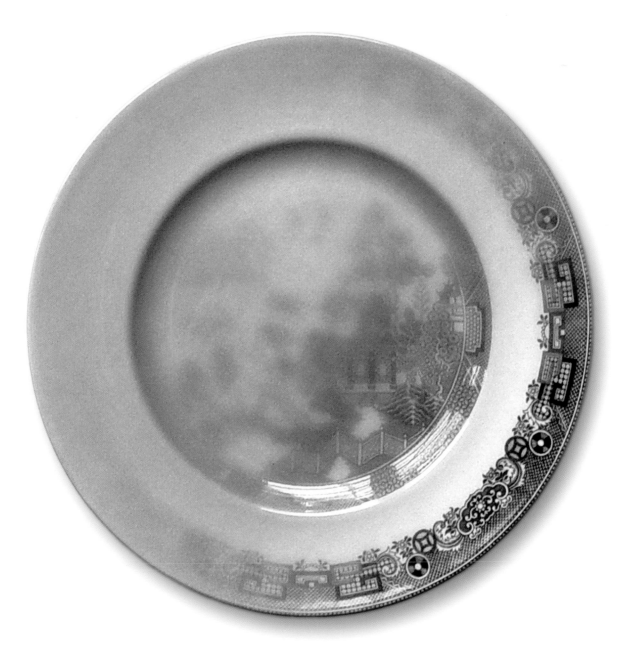

4

1

Stephen Dixon

Aligning himself with a lengthy tradition of openly political ceramic art, County Durham born Stephen Dixon appropriates the images and iconography of traditional English pottery and combines them with punk DIY aesthetics and up-to-the-minute political commentary. His work has much in common with that of Carol McNicoll and Grayson Perry, in that traditional forms—tea pots and decorative plates—are adorned with extreme, often absurd combinations of imagery—a fighter jet ploughing through the head of Frankenstein's monster (*The Sphinx Teapot*), or George Washington, his wig dripping with red glaze, juxtaposed with a pistol (*21 Countries: Plate 5*). The style is reminiscent of early twentieth century German Expressionism, and contemporary caricaturists simultaneously. Small figurines adorn the surfaces of the pots, their distorted poses are at once amusing and repelling. The layering of the old and new—sharp lines on faded shades of yellow, careful calligraphy with glaze splatters—highlights the parallels between current political issues and those of the colonial past. Dixon's language is one of paradox and dry wit, and has never been more pertinent than in these uncertain times.

Dixon has been working in ceramics since the mid-1980s. He first established a reputation in Britain and later in America, with solo exhibitions in St Louis and in New York. His work features in the Victoria and Albert Museum, San Francisco Museum of Fine Arts, and the Museum of Arts and Design, New York. In addition to this, he is an academic in the field of ceramics, investigating political narrative and the contemporary printed image.

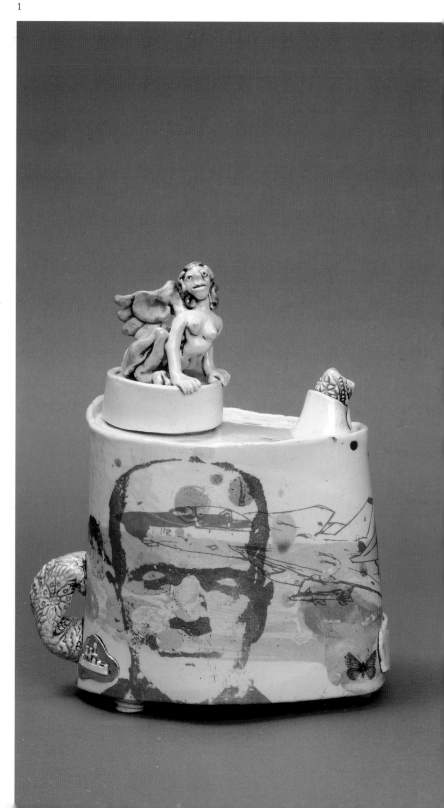

2

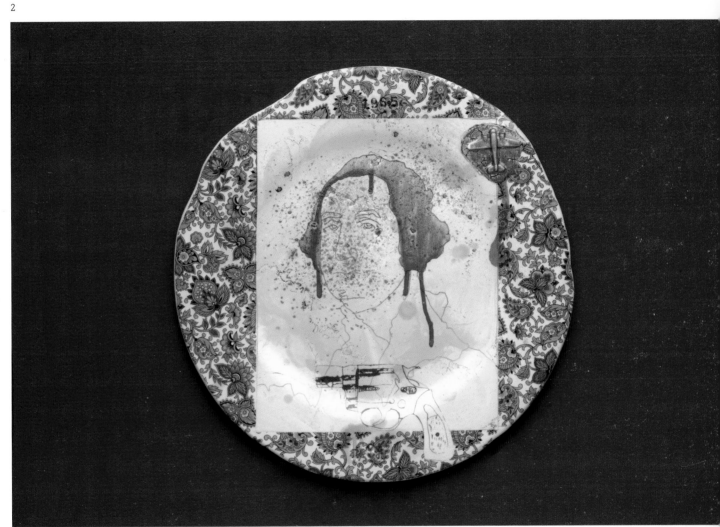

1 *The Sphinx Teapot*, 2003
glazed earthenware
22 cm
image courtesy of Joel Fildes
2 *21 Countries: Plate 5*, 2003
glazed earthenware
30 cm
photograph by Joel Fildes

David Rhys Jones

1

David Rhys Jones' work is the result of a culmination of imagery collected from journeys around and about London, which are subsequently transferred to architectural objects made in the ceramic medium. He takes as inspiration Baudelaire's concept of the 'flâneur' (a character who wandered the streets of nineteenth century Paris, detachedly observing his surroundings as affected by industrialisation), and transposes this philosophy of detached observation onto the streets of London.

Using digital transfers, he reproduces photographs, buildings, architectural detail and urban landscapes onto geometric slip-cast porcelain shapes which in themselves form a kind of architectural puzzle whose possible combinations are limitless. Wide shot images and close up details are juxtaposed one on top of the other, forcing us to reconsider the way we view the metropolis around us. The viewer is invited to re-arrange the objects as they wish, creating their own interpretations of the city—taking control of their own environment.

Encouraging such combinations of spaces which do not ordinarily exist, is a deliberate attempt by the artist to emanate something of the experience of living in the city itself: "this work provides a social documentary—recording the mix of architecture and cultures and the way they co-exist in an ever changing world."

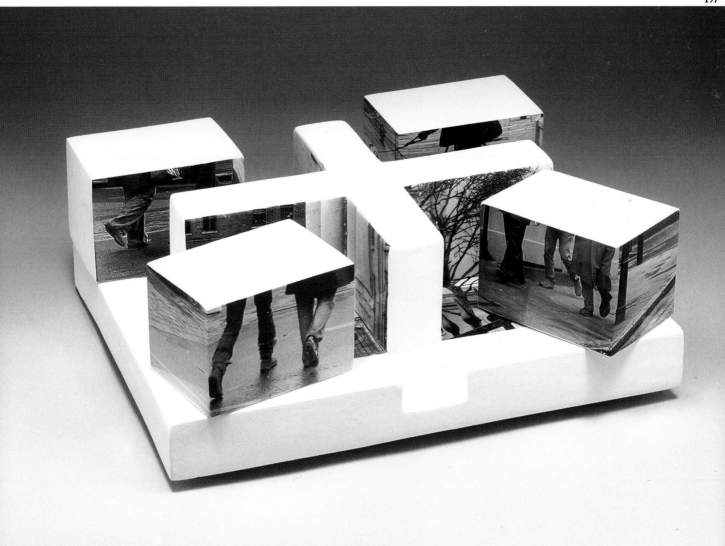

4

3

1 **Cross**, 2005
slip-cast earthenware with digital ceramic printing
32 x 25 x 12 cm
photograph by Stephen Brayne

2 **Shift Series**, 2005
slip-cast earthenware with digital ceramic printing
25 x 25 x 9 cm (each piece)
photograph by Stephen Brayne

3 **Cross**, 2005
slip-cast earthenware with digital ceramic printing
32 x 25 x 12 cm
photograph by Stephen Brayne

4 **Transfiguration**, 2005
slip-cast earthenware with digital ceramic printing
30 x 11 x 7 cm (each piece)
photograph by Stephen Brayne

Ole Lislerud

Ole Lislerud's primary interest lies in ceramics as they can be used in architecture. The incorporation of ceramic sculptures and tiled walls into urban environments allows ceramics to be realised on a very large scale, defining new perspectives for the medium.

Lislerud's ceramic murals are based on a combination of computer manipulation, large scale tiles and traditional ceramic techniques. He develops his work in collaboration with architects, seeking out a balance between his artistic statement and the context of the building. The projects are always site-specific, drawing meaning from the physical and conceptual surroundings of the building—commenting on the power of advertising, the freedom of speech and the confrontation of Eastern and Western cultures. Markings, signs, calligraphy and graffiti play a large part in his work, the idea of identity and signature ever present. He combines this contemporary graphic motif with archaic images like the intricacy of Islamic architectural tilework, adding a sense of tension and surprise to his work.

Ole Lislerud's themes and approaches are universally accessible, and his installations are featured on and in buildings across Norway, and more recently in China as well. His smaller pieces have been exhibited worldwide.

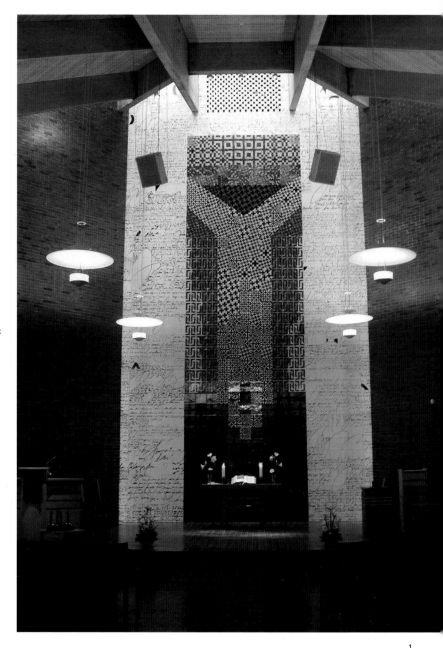

1

1 *The Cross Portal at Madlamark Church, Stavanger, Norway*, 2004
silkscreen on porcelain
25 x 10 m
2 *The Huaxia Arch, Foshan, China*, 2003
steel construction with porcelain tiles
5 x 5 x 5 m
3 *The Ignis-Bybrann Monument, Sksekaia, Aalesund, Norway*, 2005
cement columns with silkscreened porcelain tiles made in Jingdezhen, China
400 x 100 x 30 cm

2

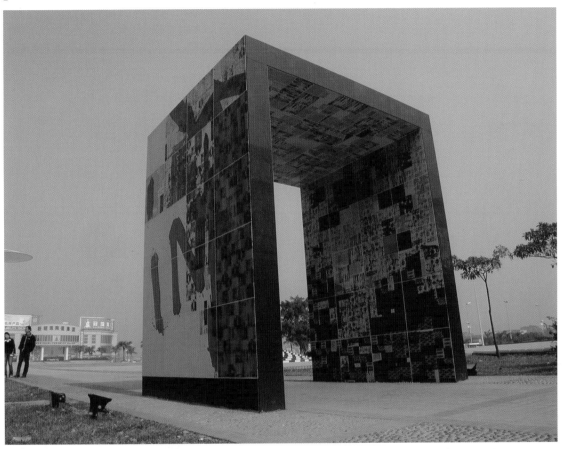

3

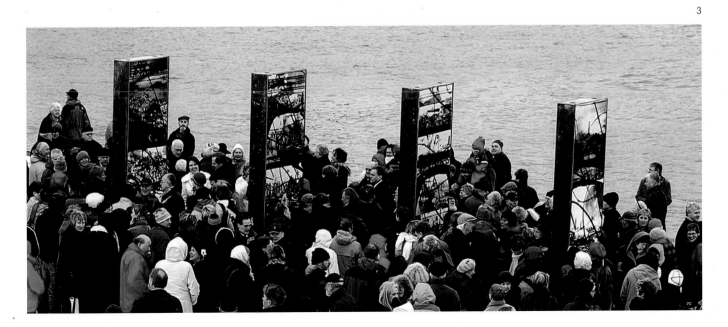

1

Carol McNicoll

Working primarily in vessel form, the art of acclaimed ceramicist Carol McNicoll is often surreal, but always maintains an everyday purpose. This attempt to create extraordinary versions of ordinary, day-to-day utensils lends McNicoll's work a darkly humorous edge, akin to the flamboyant, absurd humour of Lewis Carroll. A circle of Dalmatian covered ladies lean back to create a fruit-bowl, uniformed soldiers support a precarious jug using their heads. In her own words: "I am excited by the possibility of making everyday objects that make people think, providing a moment of delight when it is least expected." A celebration of surreal British eccentricity, her work draws heavily on the influence of traditional patterns and themes of English decorative pottery. It is no surprise then, that the teapot is such a prevalent motif.

Using slip-casting as her method of choice, McNicoll is also highly concerned with pattern (which she once described as "the best thing in the world"). Her work is often wildly adorned with a rich mixture of colours and imagery, created using glazes, stock transfers and her own transfers. The resulting effect is somewhere between a mosaic, a Victorian ornament and a Persian carpet. Her rejection of the minimalist elegance of Bernard Leach and his contemporaries in the 1970s, caught the eye of the public, and she is one of the most established international ceramicists working today.

McNicoll was awarded the Jerwood Prize for ceramics in 2001, and her pieces feature in public collections in Australia, The Netherlands and the United Kingdom.

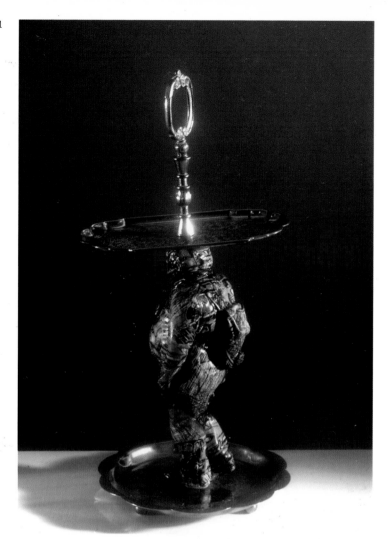

2

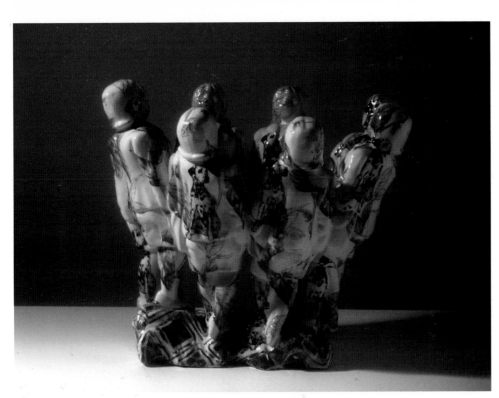

1 *Driving through Morocco*, 2004
clay and found metal objects
41 x 21 x 19 cm
photograph by David Cripps
2 *Secure Jug*, 2005
clay
44 x 18 x 16 cm
3 *Ladies Fruit Bowl*, 2002
clay
22 cm
photograph by David Cripps
4 *Tea for One*, 1998
clay and found cup
22 cm
photograph by David Cripps
5 *City Dreams*, 2002
Clay
28 cm
photograph by David Cripps

3

5

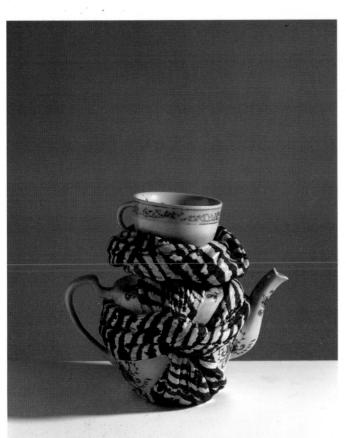

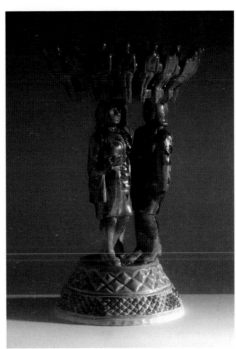

4

CJ O'Neill

CJ O'Neill is an Irish artist and designer, whose work deals primarily with pattern and surface texture, and who is unique in her use of both vintage ceramics and her own handmade creations. In her lighting range, she moulds slipcast bone china pieces, which she then pierces, creating a soft, uneven dispersal of light. She decorates these creations with simple geometric and organic transfers on both sides of the china, so that invisible patterns become literally illuminated when the light is turned on. Her tableware uses a different technique. Starting with vintage ceramic pieces from charity shops and car boot sales, she layers her patterns onto the existing ones in complementary or contrasting designs. She also uses industrial processes of waterjet cutting to remove material in the patterns of birds, numbers, and meaningful phrases.

O'Neill's work emanates a sense of nostalgia; a quiet contemplation of childhood memories. The layering of deeply traditional patterns using techniques and combinations that are contemporary and modern, references the accumulative nature of memory and experience. In her recent *Feeding Desire* range, O'Neill replaces the traditional floral imagery with contemporary urban scenes; manhole covers, tower blocks and signs reading "London Drugs" or "The heart is above all things deceitful". The dichotomous references lend a subtle humour to the pieces, and highlight the modest beauty and remarkable thoughtfulness of O'Neill's work.

1 **Feeding Desire** tableware, 2006
vintage, found, donated ceramics
18–26 cm
photograph by Ade Hunter
2 **Feeding Desire** lighting, 2006
slip-cast bone china with decoration in gold, orange and black
18, 25 and 37 cm
photograph by Ade Hunter
3 **New Heirlooms** tableware, 2005
vintage, found, donated ceramics
9–26 cm
photograph by Ade Hunter

FEEDING *Desire*

2

3

Web Directory

You can find contact details and further information on the ceramicists profiled in his book on the websites listed below. Those not listed do not to date have websites set up.

Surreal Geometries

Rebecca Catterall	www.rebeccacatterall.com
Isobel Egan	www.isobeleganceramics.com
Stine Jespersen	www.stinejespersen.com
Christin Johansson	www.christin.dk
Mimi Joung	www.mimijoung.com
Tae-Lim Rhee	www.taelimrhee.com
Anders Ruhwald	www.ruhwald.net
Richard Slee	www.richardslee.com
Maxim Velcovsky	www.qubus.cz

Human Interest

Daniel Allen	www.danielallen.net
Barnaby Barford	www.barnabybarford.co.uk
Tiziana Bendall-Brunello	www.tizianab-b.co.uk
Claire Curneen	www.clairecurneen.com
Edith Garcia	www.nenadot.com
Justin Novak	www.justinnovak.com
Damian O'Sullivan	www.damianosullivan.com
Conor Wilson	www.conorwilsonceramics.co.uk

Earthly Inspirations

Elaine Hind	www.axisweb.org
Suzanne King	www.suzanne-king.co.uk
Margaret O'Rorke	www.dycella.dircon.co.uk
Deborah Sigel	www.deborahsigel.com
Chris Wight	www.cone8.co.uk
Annie Woodford	www.anniewoodford.co.uk

Ceramic Environments

Christie Brown	www.christiebrown.co.uk
Phoebe Cummings	www.axisweb.org/arist/phoebecummings
Marian Heyerdahl	www.mheyerdahl.com
Nina Hole	www.ninahole.com
Kuldeep Malhi	www.kuldeepmalhi.com
Jeffrey Mongrain	www.jeffreymongrain.com
Colby Parsons	www.colbyvision.com
Simon Tipping	www.norcottarts.co.uk
Clare Twomey	www.claretwomey.com

The Vessel

Rob Barnard	www.rob-barnard.com
Emmanuel Boos	www.emmanuelboos.com
Emmanuel Cooper	www.ceramicreview.com
Natasha Daintry	www.natashadaintry.com
Pam Dodds	www.cga.org.uk/pamdodds
Jane Hamlyn	www.saltglaze.fsnet.co.uk
Grayson Perry	www.victoria-miro.com
Wai Lian Scanell	www.soop-group.com
Timea Sido	www.timeasido.co.uk

Beyond the Vessel

Gordon Baldwin	www.bmgallery.co.uk/baldwin
Marek Cecula	www.marekcecula.com
Ken Eastman	www.keneastman.co.uk
Simon Fell	www.simonfell.co.uk
Jonathan Keep	www.keep-art.co.uk
Anne Marie Laureys	www.centrumgoedwerk.be
Kjell Rylander	kjell.rylander@comhem.se
Piet Stockmans	www.pietstockmans.com

Surface Pleasures

Nicole Cherubini	www.nicolecherubini.net
Lubna Chowdhary	www.lubnachowdhary.co.uk
Robert Dawson	www.aestheticsabotage.com
David Rhys Jones	www.davidrhysjones.com
Ole Liselrud	www.olelislerud.com
Carol McNicoll	www.bmgallery.co.uk/mcnicoll
C J O'Neill	www.cjoneill.co.uk

Acknowledgements

Many people were involved in the production of this book. Thanks first and foremost to the artists and potters who so kindly agreed to take part. Their generosity with images, time and information is greatly appreciated.

Sarah Terkaoui for initiating the research process and bringing her own knowledge of ceramics to the process.

Sally McHugh and Guy Reder for their invaluable support throughout, and for their help with artists' texts, picture research and input to the project.

Shumi Bose, Alistair Coe and Charlotte Craig for their help with artists' texts and additional research.

Sebastian Boyle, Halsey and Alice North, Robert Yellin, Sam Jornlin at Voulkos and Co, Robert McKeever and James McKee at The Gagosian Gallery and Juliana Barrett at The Barrett Marsden Gallery, for their help with images.

The writers of the esssays; Natasha Daintry, Rob Barnard and Clare Twomey, for their time and ideas. Their commitment to the book was really encouraging, and their input was immensely helpful.

Picture Credits

Cover; Kjell Rylander, *Circle 40 x 26 x 6 cm,* photograph by Ancci Gustafsson
p. 38; Maxim Velcovsky, *Eggoist,* photograph by Gabriel Urbanek
p. 68; Damian O'Sullivan, *Elderly Lady with Porcelain Eyepatch*, photograph by Adrian van der Ploeg
p. 92; Elaine Hind, *Detail of Seed Lamp*
p. 104; Jeffrey Mongrain, *Pierced Moose with Branch*
p. 136; Emmanuel Boos, *Large Bowl with Falling Lip,* photograph by be-attitude/jousseentreprise, Paris
p. 162; Kjell Rylander, *Untitled,* photograph by Ancci Gustafsson
p. 182; Robert Dawson, *Decorative Ceramic Wall Tiles with Sovereignity and Action*

© 2007 Black Dog Publishing Limited, the artists and authors
All rights reserved

Essays by Rob Barnard, Natasha Daintry and Clare Twomey

Editor: Cigalle Hanaor
Assistant Editor: Blanche Craig
Artist texts and research by Sarah Terkaoui, Guy Reder, Sally McHugh,
Alistair Coe and Charlotte Craig

Designer: Matthew Pull

Black Dog Publishing Limited
Unit 4.4 Tea Building
56 Shoreditch High Street
London
E1 6JJ

Tel: +44 (0)20 7613 1922
Fax: +44 (0)20 7613 1944
Email: info@blackdogonline.com

www.blackdogonline.com

All opinions expressed within this publication are those of the authors and not necessarily
of the publisher.

British Library Cataloguing-in-Publication Data.

A CIP record for this book is available from the British Library.

ISBN 10: 1-904772-76-5
ISBN 13: 978-1-904772-76-7

Black Dog Publishing is an environmentally responsible company. *Breaking The Mould* is printed
on Fedrigoni Symbol Freelife Satin, an environmentally friendly, wood-free paper, with 50 per cent
virgin fibres, 40 per cent recycled pre-consumer wood free fibres, and ten per cent recycled, post-
consumer, de-inked fibres.

architecture art design
fashion history photography
theory and things

www.blackdogonline.com